粉墨中国

京昆折子戏选介

刘丽丹 著

华东师范大学出版社
·上海·

图书在版编目（CIP）数据

粉墨中国：京昆折子戏选介 / 刘丽丹著 . -- 上海：
华东师范大学出版社，2023

ISBN 978-7-5760-4195-8

Ⅰ.①粉… Ⅱ.①刘… Ⅲ.①京剧－折子戏－基本知
识②昆曲－折子戏－基本知识 Ⅳ.① J821 ② J825.53

中国国家版本馆 CIP 数据核字 (2023) 第 188632 号

粉墨中国：京昆折子戏选介

著　　者　刘丽丹
策划编辑　许　静
责任编辑　乔　健
英文审读　王　晶
责任校对　林小慧　时东明
装帧设计　卢晓红　郝　钰

出版发行　华东师范大学出版社
社　　址　上海市中山北路 3663 号 邮编 200062
网　　址　www.ecnupress.com.cn
电　　话　021-60821666　行政传真 021-62572105
客服电话　021-62865537　门市（邮购）电话 021-62869887
地　　址　上海市中山北路 3663 号华东师范大学校内先锋路口
网　　店　http://hdsdcbs.tmall.com

印 刷 者　上海中华商务联合印刷有限公司
开　　本　787 毫米 × 1092 毫米 1/16
印　　张　16.25
字　　数　158 千字
版　　次　2023 年 12 月第 1 版
印　　次　2023 年 12 月第 1 次
书　　号　ISBN 978-7-5760-4195-8
定　　价　88.00 元

出 版 人　王　焰
（如发现本版图书有印订质量问题，请寄回本社客服中心调换或电话 021-62865537 联系）

目 录　Contents

序

京剧和昆曲流传已有数百年，是最早进入世界非物质文化遗产名录的代表性中国戏剧。自上世纪二三十年代梅兰芳先生率团访问日本、美国、苏联后，更成了世界人民熟悉的中国"国粹"。至今在中外各种文化交流活动中，都可见到京剧的身影。

用外语传播京剧也有了很久的历史。据我所知，已有的传播方式大致可分三种：第一种是专门著作，概论性的全面介绍。最早的似乎是中国人民的老朋友、新西兰作家路易·艾黎（Rewi Alley）写的 *Peking Opera*，于 1957 年出版、1984 年修订重版。目前比较通行的是著名京剧学者徐城北编著、陈耕涛英译的 *Peking Opera*（2003）。此外，酷爱京剧并以此写出博士论文的澳大利亚汉学家马克林（Colin Mackerras），也在香港的牛津大学出版社出版了一本 *Peking Opera*（1995）。第二种是剧本翻译。早在六七十年代，英文版《中国文学》（*Chinese Literature*）杂志就连续刊登了从《红灯记》《沙家浜》到《海港》《龙江颂》等所有现代京剧的英译。近年来孙萍教授主持的《中国京剧百部经典英译系列》则将传统京剧剧本的英译推向了一个高潮。这个系列计划出书 100 部，已经出版了《贵妃醉酒》《打渔杀家》《空城计》《断桥》《拾玉镯》《秋江》等，每部除全剧英译外都附了"京剧艺术概述"。第三种则是演出现场发放的英文说明书和演出时的英文字幕。记忆中较早的说明书翻译大约还是我做的，那是在 1988 年上

1

海京剧院演出《曹操与杨修》的时候，内容并不多，不知怎么找到了我。使用英文字幕印象较深的，是2010年上海世博会期间关栋天主演的《关圣》，我也在现场看了。现在这本双语版的《粉墨中国》，采用的方式似乎与前面几种都不同，也许可称为第四种。跟前面几种比，它没有第一二种那么庄重严肃，比第三种又正式些，增加了点知识性内容。从总体看，这本书有两个显著的特点：

第一，有个比较巧妙的架构。它选了京、昆各5个折子戏，不求多，不求全，而又有一定的代表性。体现在戏不多但戏种较多（文戏、武戏、做工戏、唱工戏、舞蹈戏）、角色较全（生旦净丑甚至包括细分的老生、武生、小生，青衣、花旦，昆曲的小生、巾生等），"四功五法"的基本表演技巧体现较全面。整本书由浅入深、由易到难的顺序似乎是按"四功"的次序展开的。只不过"唱念做打"倒了个次序，是"打做念唱"，《三叉口》是"打"，《拾玉镯》是"做"，后面几折是"念"和"唱"。而"手眼身法步""五法"则穿插在"演出赏析"的具体过程中，结合具体剧目、具体角色及具体演员来进行。这似乎是有意的安排，作者是用了心的。

第二，介绍中注意到理论和实践的结合。所选的每一出戏都包含了四个部分。一，简介，包括戏目简介、剧情简介、人物简介，这大体相当于前文说到的第一种方式的简化；二，除第一出之外，其余九出都有"唱词"，还有对白（如《十五贯》），这相当于前文说的第二种方式的简化；三，演出推荐，每出戏都推荐优秀的舞台演出版本。这等于把前文说的第三种方式端到了眼前。当然，它没有提供现场字幕，

但这完全可在教学中补充；四，演出赏析，这部分可说是本书的特色。针对每出戏、相关角色的表演特色进行点评，可说把各出戏乃至其背后的中国戏曲的精华和盘托出，端到了观众前面，更能使不懂中国戏曲的外国人领略到中国戏剧的妙处。

这两个特点的结合，使得本书非常适合作《京剧欣赏》《戏曲赏析》之类课程的教材。凭借本教材，教师既可在事先介绍京剧和昆曲的知识背景，又可以利用教材推荐的视频，在与学生一起观赏的过程中细致地欣赏中国戏曲表演的艺术技巧。中英双语的形式则使得它在国内国外都可使用。

本书作者刘丽丹并不是戏曲专业人士，她于华东师范大学研究生毕业后，在上海戏剧学院工作多年。因工作需要接触了中国戏剧，由欣赏而产生了深深的热爱。更在与外国留学生接触和教学的过程中产生了向外国学生介绍中国戏剧的想法，并在实践中运用本书的方法进行了多次尝试。这本书可说是她多年来实践的一个小结。尽管在内容的提炼上和英文的表述上还可有进一步完美之处，但不失为一部有用的好书。

是为序。

华东师范大学终身教授 潘文国

2023 年 8 月 8 日于沪上

Introduction

Beijing Opera and Kunqu Opera have been circulating for hundreds of years and are the earliest representative traditional Chinese theater recorded in the world's intangible cultural heritage list. Since Dr. Mei Lanfang led a delegation to visit Japan, the United States, and the Soviet Union in the 1920s and 1930s, Beijing Opera has become a well-known Chinese "quintessence" among people all over the world. Up to now, Beijing Opera can be seen in various cultural exchange activities between China and foreign countries.

The dissemination of Beijing Opera in foreign languages has a long history. As far as I know, the existing modes of it can be roughly divided into three types. The first type is specialized publications that provide comprehensive overviews of Beijing Opera. The earliest one seems to be the *Peking Opera* written by New Zealand writer Rewi Alley, an old friend of the Chinese people, published in 1957 and revised in 1984. At present, the most popular one is the *Peking Opera* (2003) written by renowned Beijing Opera scholar Xu Chengbei and translated by Chen Gengtao. In addition, the Australian sinologist Colin Mackerras, who had a passion for Bejing Opera and wrote his doctoral thesis on it. In 1995, his book, also entitled *Peking Opera* (1995), was published by Oxford University Press in Hong Kong SAR. The second type is script translation. As early as the 1960s and 1970s, the English version of the magazine *Chinese Literature* continuously published English translations of all modern Beijing Opera, from *The Red Lantern* and *Shajiabang* to *On the Docks* and *Ode to Longjiang River*. In recent years, Professor Sun

Ping's *English Translation Series of a Hundred Peking Opera* Classics has pushed the English translation of traditional Beijing Opera scripts to a climax. This series plans to publish 100 books, including *The Drunken Consort*, *The Fishermen's Revenge*, *The Empty-town Stratagem*, *The Broken Bridge*, *The Jade Bracelet*, and *The Autumn River* which have been published. In addition to the English translation of the entire theater, the books are accompanied by a "An Introduction to the Art of Peking Opera". The third type is the English or bilingual brochures distributed at the performance sites and English subtitles during the performances. The earliest translation of the brochure in my memory was probably done by myself, which was during the performance of *Cao Cao and Yang Xiu* by Shanghai Jingju Theatre Company in 1988. The text is not very long, and I had no idea why the Shanghai Jingju Theatre Company had approached me to translate it. The one that impressed me most with English subtitles was *Guan Yu the Martial Sage* starring Guan Dongtian during the 2010 Shanghai World Expo, which I also watched on site. And this bilingual version of Theatrical China seems to adopt a different approach from the previous ones, and may be called the fourth one. Compared to the previous few, it is not as solemn and serious as the first and the second one, but is more formal than the third one, adding a bit of intellectual content. Overall, this book has two significant features.

Firstly, there is a relatively clever framework. It has selected five different excerpts from Beijing Opera and Kunqu Opera respectively. Although it does not pursue a richer repertoire or a more comprehensive content, it has a certain degree of representativeness. This is reflected in the fact that although there are not many excerpts in this book, there are many types of them, such as literary theater, martial arts theater, acting theater, singing theater and dance theater. This book has a comprehensive set of professions, including not only the four basic

ones of Sheng, Dan, Jing, and Chou, but also Lao Sheng, Wu Sheng, Xiao Sheng, Qing Yi, and Hua Dan in Beijing Opera, as well as Xiao Sheng and Jin Sheng in Kunqu Opera. In short, the basic performance techniques of the "Four Skills and Five Techniques" are comprehensively reflected in this book, The order of the entire book, from shallow to deep and from easy to difficult, seems to be based on the order of the "Four Skills" (Singing, reciting, acting and martial arts performing). However, the order is reversed, which is "martial arts performing(fighting), acting, reciting and singing". *Cross Roads* is "martial arts performing", and *The Jade Bracelet* is "acting", while the rests are "reciting" and "singing". The five techniques, which are gestures, eyesight, postures, footwork and the patterns and methods used in these four techniques, are interspersed in the specific process of "performance appreciation", combining specific excerpts, roles and actors. This seems to be a deliberate arrangement and the author is putting her heart into it.

Secondly, emphasizing the combination of theory and practice. Each excerpt consists of four parts: 1. Introduction, including a brief introduction to the play, plot and characters, which is roughly equivalent to the simplification of the first mode mentioned earlier; 2. Except for the first excerpt, the rest of the nine all have selected scenes and dialogues, such as *Fifteen Strings of Coins*, which is equivalent to the simplification of the second mode mentioned earlier; 3. Performance recommendations, recommend excellent stage performances for each excerpt. This is equivalent to bringing the third mode mentioned earlier to reader's attention. Of course, it does not provide live subtitles, but this can be fully supplemented in teaching; 4. Performance appreciation can be said to be the characteristic of this book. By commenting on the performance characteristics of each excerpt and related roles, we can say that the essence of each excerpt and even the traditional

Chinese theater behind it can be brought to the front of the audience, so that foreigners who do not understand traditional Chinese theater can appreciate the beauty of it.

The combination of these two characteristics makes this book very suitable as a textbook for courses such as "Appreciation of Beijing Opera" and "Appreciation of Traditional Chinese Theater". With this textbook, teachers can not only introduce the knowledge background of Beijing Opera and Kunqu Opera in advance, but also appreciate the artistic techniques of Chinese theater performances in detail while watching the recommended videos in the textbook with students. The bilingual form of Chinese and English makes it usable both domestically and internationally.

The author of this book, Liu Lidan, is not a professional in traditional Chinese theater. However, after graduating as a graduate student from East China Normal University, she has been working at the Shanghai Theatre Academy for many years. Due to her daily work, she was exposed to traditional Chinese theater and developed a deep love for it through appreciation. In the process of contacting and teaching foreign students, the idea of introducing Chinese drama to foreign students emerged, and she has made multiple attempts to using the methods as mentioned in this book in practice. This book can be regarded as a summary of her years of practice. Although there is still room for further refinement in terms of content extraction and English expressions, it is still a useful and good book.

The above is the introduction.

Pan Wenguo, Tenured Professor at ECNU
Shanghai, August 8, 2023

前言

历经多年的努力，《粉墨中国：京昆折子戏选介》终于跟大家见面了。从没想过会与戏曲结缘，更没想过会写一本与戏曲有关的书。儿时，戏曲是中央电视台 11 频道的咿咿呀呀，是每年春晚的经典选段。她遥远、神秘而又与我无关，可是上海戏剧学院改变了我。

华东师范大学毕业后，我来到上海戏剧学院莲花路校区工作，有幸结识了戏曲专业的教师、学生与剧院团的演员们。他们的精彩演出让我切身感受了戏曲的现场魅力，"听戏"逐渐成为我工作之余的主要活动之一。因上海戏剧博物馆（戏曲馆与话剧馆）与中国戏曲海外巡演等的推介工作，我在文字撰写与翻译过程中，加深了对戏曲的了解，更在语言的对比中隐约触碰到了中华文化的神韵。此外，在上戏首届跨文化艺术交流学硕士留学生的日常管理工作中，我深刻体悟到中国戏曲对"他文化者"的吸引力。留学生们总能从一些意想不到的角度提出对中国传统戏曲形式、内容与内涵的思考。他们通过戏曲，感知、了解中国文化，并深受她的吸引。我校一位已参演多部影视作品的留学生曾说："如果没有对中国文化的热爱，没有传统戏曲基本功的训练，那么我可能不会得到这些机会。"因此，我常常鼓励戏曲专业的学生在学习实践中尝试把戏曲、中国传统文化与跨文化交流结合起来，探索一条以艺术（戏曲）为媒介的新的跨文化交流路径。

2022 年我受学校委派，在上海市归国华侨联合会海外联络一部挂职，其间有两项与戏曲有关的重要工作：一是举办"海外华裔青少年夏令营上海营"活动；二是调查研究"海外华裔青少年文化交流需求"。活动与调研数据再次印证了中国戏曲的丰盈。中国戏曲蕴含着中国传统文化，生动地讲述着中国人的"信仰"故事，是"他文化者"了解中国传统文化的兴趣点与有效途径。可见，接触、感受中国戏曲，是我们认识自身、了解自身文化传统、增强文化自信的有效方式，也是世界了解中国的"生动"渠道。就在这一年我完成了本书的撰写。

本书意在面向海外读者，特别是海外华裔年轻人，以期帮助他们初步了解中国戏曲的典范作品，培养华裔的民族认同感和文化认同感。本书对作品定位、剧目选排与内容规范等进行了反复推敲，最后选取京剧《三岔口》《玉簪记·秋江》《法门寺·拾玉镯》《白蛇传·断桥》《霸王别姬》与昆曲《牡丹亭·游园》《十五贯·访鼠测字》《宝剑记·夜奔》《烂柯山·痴梦》《长生殿·弹词》等。

本书所选戏曲具有代表性和典型意义，且编排循序渐进，内容涵盖考虑较为全面，中华美学精神和传统道德观念含量高、成色足。中英文结合、图文并茂的形式也有利于本书的国际推广。本书特点主要有四：

一、针对性强

本书主要针对海外受众，尤其是海外华裔新生代。目前，海外华校、大学中文院系等教育机构对中国传统文化课程与教材都比较渴求。最新研究表明海外华裔新生代（即海外华裔第二、三代华人）已经成

为海外华裔社群的主体，培养他们的"民族认同""价值认同"和"文化认同"是当务之急。本书希望通过介绍中国传统戏曲典范作品，激发海外华裔对祖（籍）国艺术、文化的兴趣，从而加强或强化他们对祖（籍）国的认同感。

二、符合"由简到难""生书熟戏"的信息接收规律

本书按照"由易到难""由简到繁"的原则进行编目，以帮助读者由外而内地熟悉并了解中国戏曲艺术，培养并提高他们对戏曲的鉴赏能力；在内容编排上，根据"生书熟戏"的欣赏习惯，将"赏析部分"放在"故事梗概""人物简介"与"戏曲节选"等内容的后面，使读者"先入为主"地接触作品，以获得与自身感受密切相关的独特"体验"。

三、覆盖全行当

本书所选曲目覆盖了戏曲生旦净丑四个行当，尽可能全面系统地向读者展示戏曲的不同行当，尽量保证了剧目选取的广度与深度。

四、极具魅力的文化内核

根据跨文化交流的一般规律，本书所选作品的文化内核具有较高的普世价值，如忠勇、仁爱、智慧等。以期读者在学习、欣赏本书曲目时，能从共性引发共鸣，在舒适的心理情境下，慢慢感受中华文化的独特魅力。

有一点细节需要说明，本书京剧、昆曲与戏曲的翻译依次为 Beijing Opera、Kunqu Opera 与 traditional Chinese theater。但剧院团名称以实际情况为准，不在此列。

本书从一点一滴的资料搜集、整理，再到撰写、翻译，直到最后

成书经历了数载春秋，前前后后进行了多次的调整与修改。今年，在各位领导、老师、同事、学生和业内朋友的指导与帮助下，终于与大家见面了。感谢我的工作单位——上海戏剧学院，没有学校的支持与鼓励，就没有这本书的顺利出版。感谢上海戏剧学院副院长杨扬教授对项目的支持。感谢博士导师王云教授给本书做的精准的定位。感谢上海戏剧学院科研处吴爱丽、支运波、蓝涛与顾宙寅四位老师的支持与提携。感谢叶长海教授在本书成书过程中给予的关心与帮助。感谢张伟品教授耐心、细致的审阅与专业的修改意见。感谢付小平教授多方联系有关专家，加速推进本项目进程。感谢李伟教授的提点与解惑。感谢姜凌副教授关于花旦戏的讲解。

感谢 Philip Boafo 先生和上戏冯聪副教授在英文写作方面给予的帮助。Philip Boafo 是上戏首届跨文化艺术交流硕士留学生，目前正在新加坡攻读博士学位。他在撰写博士论文的关键时期，仍然花费了大量时间认真校对本书的英文部分。冯聪副教授在此基础上，发挥中英文双语优势，对书稿做了全面梳理。

演出剧照是本书的一大亮点，它们不仅能帮助读者理解文字，更能增添阅读的生动性与趣味性。为了获得剧照版权，我们做了很多努力，最终在各位老师的无私帮助下，得以成功实现。感谢吉林大学出版社蔡玉奎老师在图片查找与版权问题上给予的专业指导。感谢摄影师卢雯老师提供演出剧照一百余张，并帮助推进版权事宜的落地。感谢上海艺术研究中心提供服饰照片。感谢摄影师秦钟、孙晓梅提供照片。感谢戏曲演员（按剧照使用顺序排列）郝帅、郝杰、赵宏运、潘梓健、

严庆谷、刘韩希烨、虞伟、李文文、杨楠、王盾、张鑫、郜巍、牟元笛、戴国良、陈申越、鲁肃、朱何吉、贾喆、熊明霞、金喜全、毕玺玺、炼雯晴、杨东虎、凌珂授权。感谢郭文华、赵群、朱锦华、翟月琴、李莉、朱志钰等专家老师与骆易萌同学在图片查找与版权签署方面给予的有力帮助。

感谢戏导专业杨星宇同学 2020 年以来为本书所做的大量工作，如资料图片的搜集整理、内容讨论及联络专家与咨询等。他的全流程参与是本书创作的有力保障。

感谢华东师范大学终身教授潘文国老师为本书做序。在华师大求学期间，我曾修学潘老师的翻译课程。潘老师治学严谨，使我们受益良多。毕业多年后，怀着忐忑的心情交"作业"，幸得潘老师厚爱。

最后，感谢华东师范大学出版社许静与乔健两位老师。作为插图类中英文双语图书，本书在图片选择、文字编辑与版面设计等方面均涉及很多细节与需要解决的实际困难。若无两位老师专业、细致的工作，就没有本书的顺利付梓。

由于本人能力及水平有限，本书尚有许多不足之处，还请大方之家不吝赐教。

刘丽丹

2023 年 6 月 7 日

Preface

After many year's hardworking, *Theatrical China: Selected Excerpts of Beijing Opera and Kunqu Opera* has finally been published. I never thought about getting to know traditional Chinese theater, let alone writing a book related to it. When I was a child, traditional Chinese theater consisted of a variety of singing styles on CCTV Channel 11 and included some classic excerpts performed at the annual Spring Festival Gala. Chinese theater appeared distant, mysterious, and unrelated to me, but Shanghai Theatre Academy (STA) changed me.

After graduating from East China Normal University (ECNU), I came to work at the Lianhua Road Campus of STA. I had the privilege of getting acquainted with the teachers and students majoring in traditional Chinese theater at STA, as well as the actors from various traditional Chinese theater troupes. Their magnificent performances allowed me to witness traditional Chinese theater firsthand and left me feeling incredibly charmed by it. As a result, "enjoying traditional Chinese theater" gradually evolved into one of my main activities after work. Due to the promotional efforts of the Shanghai Theatre Museum (Traditional Chinese Theater Museum and Drama Museum) and overseas performances of traditional Chinese theater, I was able to deepen my understanding of traditional Chinese theater through the process of writing and translating for them. Through language comparison, I also vaguely touched the verve of Chinese culture. Furthermore, in participating in the daily work of managing the first intercultural art exchange master's students at STA, I deeply realized the attraction of traditional Chinese theater to

"other culturists". International students could always come up with unexpected perspectives on the form, content and connotation of traditional Chinese theater. They perceived and understood Chinese culture through traditional Chinese theater and were deeply attracted by it. A foreign student who had participated in multiple film and television productions said, "If I hadn't loved Chinese culture and trained in the basic skills of traditional Chinese theater, then I might not have had these opportunities." Therefore, I often encourage students majoring in traditional Chinese theater to try to incorporate elements of other cultures into their learning and practice from the perspective of intercultural communication. This could aid them in exploring a new intercultural communication path using art (traditional Chinese theater) as a medium.

In 2022, I was appointed by STA to work temporarily at the First Overseas Department of the Shanghai Federation of Returned Overseas Chinese. During this period, I had two important tasks related to traditional Chinese theater. One was to organize and carry out the "Overseas Chinese Youth Summer Camp" activity. The second was to investigate and study the "Cultural Exchange Needs of Overseas Chinese Youth". The activity and research data I gathered from these activities demonstrated the abundance of traditional Chinese theater. The Traditional Chinese theater embodied traditional Chinese culture and vividly narrated the story of Chinese people's "beliefs", which is an interesting point and an effective way for "other culturists" to understand traditional Chinese culture. It can be seen that being exposed to and experiencing traditional Chinese theater is an effective way for us to understand ourselves, understand our own cultural traditions, and enhance our cultural confidence. It is also a "vivid" channel for the world to understand China. Despite my hectic schedule during this period, I prioritized completing the book.

This book is intended for overseas readers, especially young overseas Chinese. It aims to help readers get a preliminary understanding of the model works of traditional Chinese theater and also cultivate a sense of national identity and cultural identity of Chinese descents. This book rigorously considered the positioning of works, the selection and arrangement of excerpts and the content standards. Finally, it selected Beijing Opera *Cross Roads*, *A Jade Hairpin · The Autumn River*, *Famen Temple · The Jade Bracelet*, *Legend of the White Snake · Broken Bridge*, *Farewell My Concubine* and Kunqu Opera *Peony Pavilion · A Stroll in the Garden*, *Fifteen Strings of Coins · Visiting "Shu" and Telling Him Fortune*, *A Precious Sword · Midnight Escape*, *Lanke Mountain · A Delusional Dream* and *The Palace of Longevity · Storytelling*.

The selected excerpts in this book are representative and of typical significance and the arrangement is logically organized. The content covers a comprehensive consideration with a high quality of Chinese aesthetic spirit and traditional moral concepts. The combination of Chinese and English, with illustrations and text, is also conducive to the international promotion of this book. There are four main characteristics of this book:

1. Highly targeted

This book is mainly aimed at overseas audiences, especially the new generation of overseas Chinese. At present, educational institutions such as overseas Chinese universities and Chinese language departments are quite eager for traditional Chinese culture courses and textbooks. The latest research shows that the new generation of overseas Chinese (i.e., the second and third generations of overseas Chinese) has become the main body of the overseas Chinese community. It is urgent to cultivate their "national identity", "value identity" and "cultural identity". This book

aims to stimulate the interest of overseas Chinese people in the art and culture of their ancestral country by introducing exemplary works of traditional Chinese theater to strengthen their sense of identification and belonging.

2. Complying with the information reception and aesthetic laws of "from simplicity to difficulty" and "appreciating familiar traditional Chinese theater"

This book is compiled based on the principles of "from easy to difficult" and "from simple to complex", to help readers become familiar with and understand traditional Chinese theater art from the outside to the inside and to cultivate and improve their appreciation of it. In terms of content arrangement, the "appreciation section" is placed after the "story outline", "character introduction" and "opera excerpts" according to appreciation habits, allowing readers to have an enlightened perspective of the work and obtain a unique "experience" closely related to their feelings.

3. Covering the four professions of the entire industry

The selected excerpts in this book cover the four professions of traditional Chinese theater: "Sheng, Dan, Jing, Chou", and comprehensively and systematically showcase the different aspects of the four professions in traditional Chinese theater to readers by exploring the complexities and nuances of the selection as much as possible.

4. A highly charming cultural core

According to the general rules of intercultural communication, the cultural core of the selected works has high universal values, such as loyalty, benevolence, wisdom, etc. I hope that readers can resonate with the commonalities and gradually experience the unique charm of Chinese cultural in a comfortable psychological mood when learning and appreciating the excerpts of this book.

There is one detail that needs to be explained. The translations of "京剧"、"昆曲" and "戏曲" in this book are Beijing Opera, Kunqu Opera, and traditional Chinese theater respectively. But the names of the different theater troupes are subject to the actual situation and are not included.

This book has gone through several years of research, from collecting and organizing information systematically to writing, translating and becoming a book, with multiple adjustments and modifications made from beginning to end. With the guidance and assistance of leaders, teachers, colleagues, students and industry friends, this book is finally going to be published this year. I owe a debt of gratitude to my working place, Shanghai Theatre Academy, without the support and encouragement of the academy, this book would not have been successfully published. I would like to thank Professor Yang Yang, Vice President of STA, for his support of the project. Many thanks to my doctoral advisor, Professor Wang Yun, who has provided the most accurate positioning for this book. I would like to thank Wu Aili, Zhi Yunbo, Lan Tao and Gu Zhouyin from the Scientific Research Office of STA for their support. I extend my thanks to Professor Ye Changhai for his care and support during the process of writing this book. I am grateful to Professor Zhang Weipin for his patience, meticulous review, and professional revision suggestions. Thanks to Professor Fu Xiaoping for contacting relevant experts in multiple ways to accelerate the progress of this project. Thanks to Professor Li Wei for his advice and clarification. Thanks to Associate Professor Jiang Ling for her explanation of Hua Dan theater.

Thanks to Mr. Philip Boafo and Associate Professor Feng Cong for their assistance in English writing. Philip Boafo is one of the first overseas students to enroll in the Master of Arts degree program in

Intercultural Communications Studies at STA. He is currently pursuing a doctoral degree in Singapore. He is in the crucial stages of writing his doctoral thesis, but he still spent a lot of time carefully helping proofread the English part of this book. Additionally, Associate Professor Feng Cong utilized his bilingual advantages in both Chinese and English and conducted a comprehensive review of the manuscript.

The photographs of the various performances are a major highlight of this book. They not only help readers understand the text but also add liveliness and fun to the reading. In order to obtain the copyright for the various photographs, we made a lot of efforts, and ultimately successfully achieved it with the selfless help of professors, teachers, actors, and photographers. Thanks to Cai Yukui, an editor from Jilin University Press, for providing professional guidance on image search and copyright issues. Thanks to photographer Lu Wen for providing over 100 stills of the performance and for helping to facilitate the implementation of copyright matters. Thanks to the Shanghai Art Research Center for providing photos of clothing and accessories. Thanks to photographers Qin Zhong and Sun Xiaomei for providing photos. Thanks to traditional Chinese theater actors and actresses Hao Shuai, Hao Jie, Zhao Hongyun, Pan Zijian, Yan Qinggu, Liu Han Xiye, Yu Wei, Li Wenwen, Yang Nan, Wang Dun, Zhang Xin, Gao Wei, Mou Yuandi, Dai Guoliang, Chen Shenyue, Lu Su, Zhu Heji, Jia Zhe, Xiong Mingxia, Jin Xiquan, Bi Xixi, Lian Wenqing, Yang Donghu and Ling Ke (arranged in order of stills) for authorization. Thanks to experts and teachers Guo Wenhua, Zhao Qun, Zhu Jinhua, Zhai Yueqin, Li Li, Zhu Zhiyu, and Luo Yimeng for their strong assistance in image search and copyright signing.

Thanks to Yang Xingyu, who majored in directing of traditional Chinese theater, for the extensive work he has done for this book since 2020, including collecting and organizing materials and images,

discussing the content, and contacting experts and consultants. His participation in the entire process is a strong guarantee for the creation of this book.

Special thanks to Professor Pan Wenguo, a tenured professor at ECNU, for writing the introduction to this book. During my studies at ECNU, I took a translation course taught by Professor Pan. Professor Pan's rigorous academic pursuits benefited us a lot. Years after graduation, I handed in my "homework" uneasily and was fortunate to receive the great kindness of Professor Pan.

Finally, I would like to thank the editors, Xu Jing and Qiao Jian, from East China Normal University Press. As a bilingual book with many illustrations in both Chinese and English, this book involves many details in image selection, text editing and layout design, as well as practical difficulties that had to be addressed. Without the professionalism and meticulous work of the two editors, there would have been no smooth publication of this book.

Due to my limited abilities and level of expertise, there are still many shortcomings in this book. I kindly request guidance from all experts.

Liu Lidan
June 7, 2023

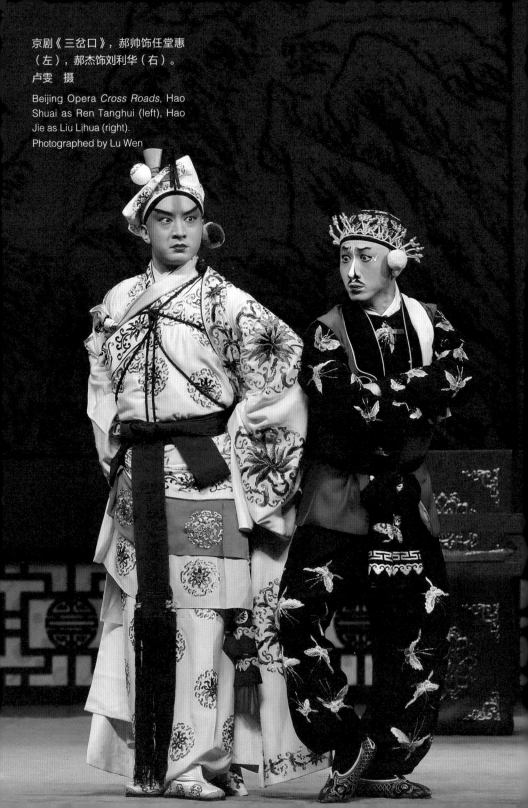

京剧《三岔口》，郝帅饰任堂惠
（左），郝杰饰刘利华（右）。
卢雯 摄

Beijing Opera *Cross Roads*, Hao
Shuai as Ren Tanghui (left), Hao
Jie as Liu Lihua (right).
Photographed by Lu Wen

京剧《三岔口》
Beijing Opera *Cross Roads*

剧目简介
Introduction to *Cross Roads*

　　京剧《三岔口》取材于中国古典小说《杨家将演义》。讲述的是宋将焦赞的故事。焦赞杀死奸臣之婿后，被发配沙门岛。仇家为置其于死地，买通解差谋害于他。元帅杨延昭为保护焦赞，命令任堂惠暗中随行。途径三岔口时，焦赞与解差等人夜宿于刘利华的客栈，店主刘利华夫妇钦佩焦赞已久，欲暗中搭救。同时任堂惠寻迹而至，向刘利华打听焦赞行踪。结果，二人误以为对方意欲加害焦赞，于是在黑夜中展开了激烈的搏斗。正当二人斗得难分难解之际，刘利华之妻从解差手中救出焦赞，四人得以会面。最终误会消除，大家同奔三关。

Beijing Opera *Cross Roads* tells the story of General Jiao Zan in the Song Dynasty. It is based on a classical Chinese novel, *Heroic Legend of the Yang Family*. Jiao Zan was banished to Shamen Island after killing the son-in-law of a treacherous official. The foe paid off the guards, who escorted Jiao Zan to the island to murder him. Supreme Commander Yang Yanzhao, sent Ren Tanghui to protect Jiao secretly. When they passed through a crossroad, Jiao Zan and the guards stayed at the guesthouse of Liu Lihua. Liu Lihua and his wife had admired Jiao Zan for a long time and hoped to help him. At the same time, Ren Tanghui came

to find out about Jiao Zan's whereabouts from Liu Lihua. However, not knowing each other, Liu and Ren harbored suspicions toward each other. They both thought that the other might hurt Jiao. In the darkness, the two were fighting inextricably. At the same time, Liu Lihua's wife killed the guards and rescued Jiao Zan. Jiao Zan arrived in time and recognized his secret guardian Ren Tanghui. Finally, and thankfully, the misunderstanding was cleared up, and the four people rushed to the "San Guan" together.

京剧《三岔口》为传统武戏[1]，目前常演的版本是 20 世纪 50 年代初张云溪与张春华改编的。与之前的版本相比，该版最大的改动是将原本谋财害命的黑店店主刘利华改写为搭救忠良的侠义之士。此外还剔除了一些脱离情节、盲目堆砌技巧和卖弄噱头的桥段。该折戏虽然篇

京剧《三岔口》，赵宏运饰任堂惠（左），潘梓健饰刘利华（右）。卢雯 摄

Beijing Opera Cross Roads, Zhao Hongyun as Ren Tanghui (left), Pan Zijian as Liu Lihua (right). Photographed by Lu Wen

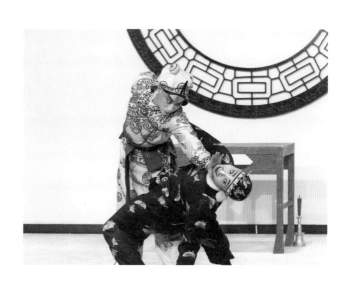

1　武戏：在戏曲中以战争或打斗为题材的剧目。

幅较短，故事简单，却有着精彩的武打场面和幽默的表演桥段，受到广大观众的喜爱，历年来一直活跃在大众舞台上。

京剧《三岔口》，赵宏运饰任堂惠（左），潘梓健饰刘利华（右）。
卢雯 摄

Beijing Opera *Cross Roads*, Zhao Hongyun as Ren Tanghui (left), Pan Zijian as Liu Lihua (right). Photographed by Lu Wen

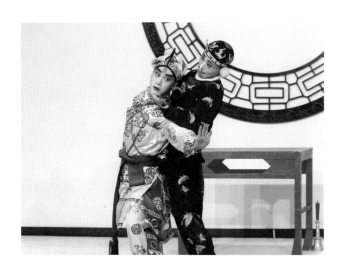

Cross Roads belongs to traditional martial arts[1] performed in the way of Beijing Opera and the version that is commonly performed today was adapted by Zhang Yunxi and Zhang Chunhua in the early 1950s. Compared with previous versions, the biggest change in this version is to rewrite the role of Liu Lihua, the owner of the black shop who originally killed people for money, into a chivalrous man who saved the loyal and good. In addition, some segments that are divorced from the plot, as well as blindly stacked techniques and show-off

1 Martial Arts theater: Repertories in Traditional Chinese theater that focus on the theme of war or fighting.

4

gimmicks, are also eliminated. Although the play is short in length and simple in story, it has wonderful martial arts scenes and humorous performance segments, and is popular with the audience. It has been active on the public stage over the years.

京剧《三岔口》，赵宏运饰任堂惠（左），潘梓健饰刘利华（右）。卢雯 摄

Beijing Opera *Cross Roads*, Zhao Hongyun as Ren Tanghui (left), Pan Zijian as Liu Lihua (right). Photographed by Lu Wen

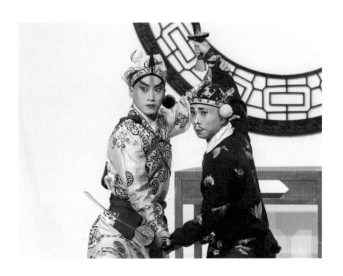

人物简介
Character Profile

任堂惠——武生。武生属于生行[1]，指擅长武艺的男性角色。武生还可分为"长靠武生"和"短打武生"，前者扎"靠"，多扮演将领，后者不扎"靠"，一般以"箭衣"、豹衣豹裤、打衣打裤等服装为主，多为英雄豪杰。任堂惠是短打武生，这一行当要求演员着短装，持短兵器，身手矫健、动作快中有稳。

Ren Tanghui: plays Wu Sheng role[2]. Wu Sheng belongs to the

1 "生、旦、净、丑"是戏曲的四大基本行当。"生"行多用来扮演不同年龄、性格与身份的男性角色。按年龄和表演特点等方面的差异，又可分为老生、小生、武生、红生、娃娃生等几个门类。除红生和勾脸的武生以外，其余一般的生行角色都是素脸，行内术语叫作"俊扮"，即脸部不勾画图案构成的脸谱。

2 "Sheng, Dan, Jing, and Chou" are the four basic types of roles in Traditional Chinese theater. "Sheng"is mainly used for male roles played by different ages, personalities and identities. According to the differences in age and performance characteristics, Sheng can be divided into Lao Sheng, Xiao Sheng, Wu Sheng, Hong Sheng and Wawa Sheng. Except for Hong Sheng and Wu Sheng, who wear painted faces, the rest of the ordinary characters of Sheng do not wear painted masks. The term in the role is called "Junban", that is, facial makeup without sketching patterns.

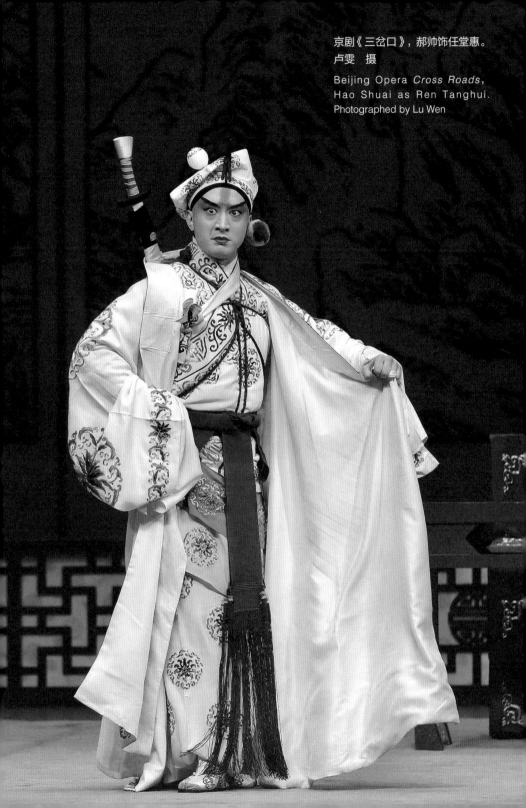

role of Sheng, which refers to male characters who are good at martial arts. According to the different costumes, Wu Sheng can be divided into "Changkao Wu Sheng" and "Duanda Wu Sheng". The former is mostly a general, wearing a flag-carrying uniform; the latter is mostly an outstanding hero, a martial man in a uniform of archer clothing, leopard clothing and pants, or fighting clothes and pants. Ren belongs to the latter. Duanda Wu Sheng requires the actor to wear short costumes, wield short weapons, and have agile and quick movements with stability.

刘利华——武丑。武丑属京剧丑行 [1]，因在鼻梁部分用白色颜料涂上形状不一的粉块而得名。武丑讲究动作轻巧敏捷，念白清脆流利。演员扮演的形象或是滑稽、活泼、乐观、富有正义感的底层劳动人民，或是阴险狡诈、卑鄙自私的反派人物。作为武丑，刘利华聪明、幽默而且功夫好。

Liu Lihua: plays a Wu Chou role. Wu Chou belongs to Chou [2], which is named for the different shapes of the white paint on the bridge of the nose. For Wu Chou, it is important to be light and agile in movements, while speaking clearly and fluently. The role of Chou could be a funny, lively, optimistic, and righteous low-level working person, or an insidious, cunning, despicable and selfish villain. As a Wu Chou, or a "martial arts clown", Liu Lihua is intelligent, humorous and good at martial arts.

1　丑行：戏曲的四大基本行当之一。

2　Chou : one of the four basic types of roles in traditional Chinese theater.

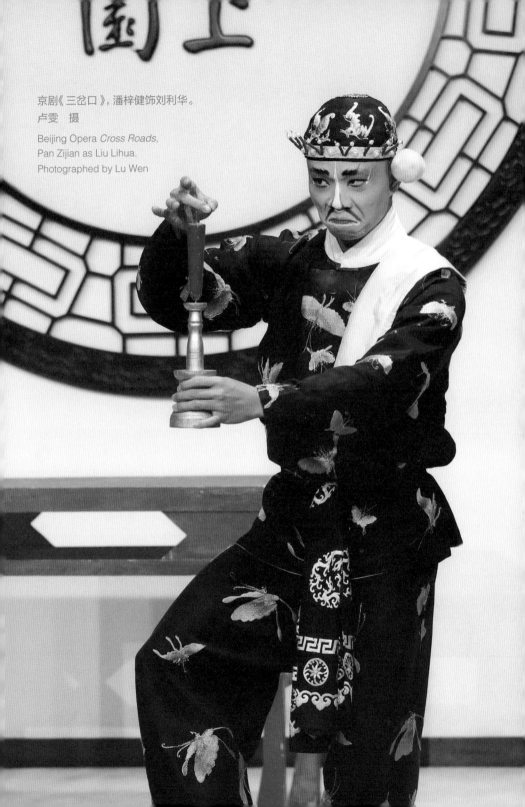

三

演出推荐
Performance Recommendation

本书推荐的视频版本为 2011 年由上海京剧院为纪念京剧表演艺术家盖叫天先生而举办的"南英北杰——盖派经典剧目习演"活动的参演剧目。任堂慧与刘利华分别由郝帅、郝杰两兄弟饰演。该版《三岔口》在服饰道具、打斗程式上别具一格，值得观赏。

The video version recommended in this book is the repertoire of the "North-South Wu Sheng: Gai School Classic Traditional Theater Practice" held by Shanghai Jingju Theater Company in 2011 in honor of the Beijing Opera performing artist Gai Jiaotian. Ren Huitang and Liu Lihua were played by Hao Shuai and Hao Jie, the two brothers, respectively. This version is unique in its costumes, props and fighting procedures, and is worth watching.

四

"做工"赏析
Appreciation of Acting

在戏曲表演中，"做工"指的是舞蹈化的形体动作或表演技巧，是演员塑造人物的重要手段。[1]包括手、眼、身、步各方面的程式动作，以及水袖、髯口、翎子、甩发等多种技法。

In traditional theater performance, "Acting" refers to dancing physical movements or performance skills, which is an important means for actors to shape characters.[2] It includes the procedural movements of the hands, eyes, body, and steps as well as various techniques such as long sleeves, artificial whiskers, plumes, and hair swaying, etc.

"做工"必须严格按照规范表演。演员在初级和中级阶段，不能随意发挥。只有在高级阶段，演员才可以结合个人体验，加以个性调整，这样既能体现角色的特征，又有利于塑造个人的表演风格，进一步体现"做工"的艺术价值。

1　戏曲表演四大基本功：唱工、念工、做工、打工。

2　The four performing techniques in Traditional Chinese theater: singing, reciting, acting and martial arts performing fighting.

These actions and techniques must be performed in strict accordance with the specifications. At the primary and intermediate stages, actors cannot play at will at all. Only at the advanced stage can actors adjust their personalities in combination with their personal experience, which can reflect the characteristics of the role and help to shape their performance styles and reflect the artistic value of "Acting" further.

《三岔口》中摸黑打斗的戏是非常经典的。在这段表演中，演员全程无台词，主要通过肢体动作（京剧程式动作）向观众传递人物的情绪。在无台词的环境下，观众的注意力通常会聚焦在演员的肢体表现上。这一出"默剧"，让观众更敏锐地捕捉到演员表演动作中的细节。"动作"成为人物情绪最直观的表达，营造了紧张、刺激的戏剧氛围。

The fight scene in the dark in *Cross Roads* is very classical. In this performance, the actors have no lines throughout the entire process. They mainly convey the emotions of the characters to the audience through their body movements and performing patterns of Beijing Opera. In an environment without lines, the audience's attention is usually focused on the actors' body expression. When watching this "mime", the audience can capture the details of the actions in the actors' performance more keenly. "Actions" have become the most intuitive expression of the characters' emotions and have successfully created a tense and stimulating dramatic atmosphere.

（一）关门、开门 Opening and Closing the Door

开门与关门的动作虽然常见且简单，但精准地体现了戏曲艺术的两个重要特征——程式性与虚拟性。戏曲表演将生活中的动作进行提炼，使其成为一种程式化的"符号"。这种"符号"在戏曲表演中极为常见，它通过演员的表演，再结合观众的想象力，可以将骑马、坐轿、行舟、上楼、下楼等具体动作和下雨刮风、沙场鏖兵等场景意象化，为戏曲舞台带来了丰富的表现力。《三岔口》中任、刘二人便是运用京剧表演中开门与关门的程式动作，表现二人先后进入"房间"的情景。

Although the actions of opening and closing the door are common and simple, they accurately reflect the two important characteristics of the art of traditional Chinese theater: stylization and virtuality. The traditional theater performance refines daily actions and makes them a kind of stylized "symbol". This "symbol" is prevalent in traditional theater performances. Through the performance of the actors and the imagination of the audience, the "symbol" can visualize the specific actions such as riding horses, riding sedans, boating, going upstairs and downstairs, as well as the scenes such as rain, wind, and fighting on the battlefield, which brings rich stage expression to the traditional theater. In *Cross Roads*, Ren and Liu use the routine actions of opening and closing the door in performance of Beijing Opera, showing they have successfully entered the "room".

京剧《三岔口》，赵宏运饰任堂惠（远），
严庆谷饰刘利华（近）（撬门栓）。
卢雯 摄

Beijing Opera *Cross Roads*, Zhao Hongyun
as Ren Tanghui (far), Yan Qinggu as
Liu Lihua (near) (Door-bolt Prying).
Photographed by Lu Wen

京剧《三岔口》，赵宏运饰任堂惠（右），
潘梓健饰刘利华（左）（开门）。
卢雯 摄

Beijing Opera *Cross Roads*, Zhao Hongyun
as Ren Tanghui (right), Pan Zijian as
Liu Lihua (left) (Door Opening Action).
Photographed by Lu Wen

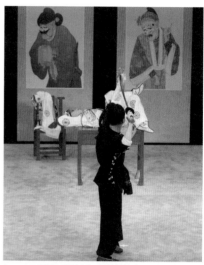

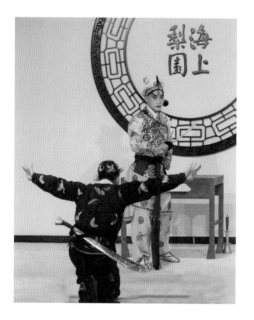

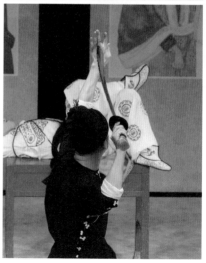

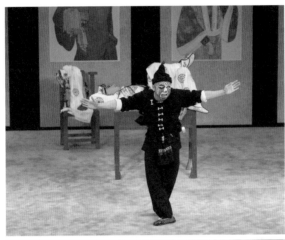

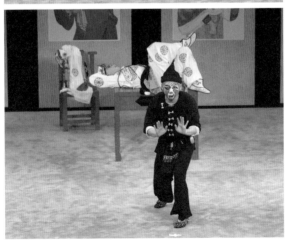

京剧《三岔口》，赵宏运饰任堂惠（右），潘梓健饰刘利华（左）。卢雯 摄

Beijing Opera *Cross Roads*, Zhao Hongyun as Ren Tanghui (right), Pan Zijian as Liu Lihua (left). Photographed by Lu Wen

（二）摸黑打斗 Fighting in the Darkness

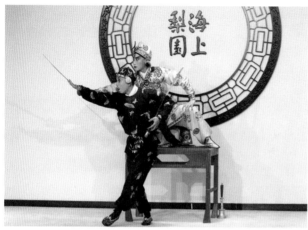

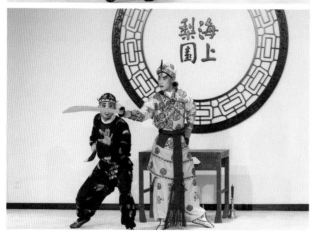

《三岔口》极具艺术观赏价值。这折戏要求演员在灯火通明的舞台上，表演一场"黑暗中"的打斗，能否说服观众，完全依赖于演员的"打"戏。两个武艺高强的人是如何在伸手不见五指的黑暗中打斗的？是如何一边隐藏自己的行迹，一边寻找对手并给他致命一击的？这其中穿插的艺术性巧合又有哪些？诸如此类的疑问，对于观众来说都非常具有吸引力。

Cross Roads is of great artistic value. It requires the actors to perform a

"fight in the darkness" on a bright stage. Whether the audience can be persuaded depends entirely on the actors' performance of the "fight". How do two people with high martial arts skills fight in the darkness? How do they hide their tracks while looking for their opponent and deliver a fatal blow? What are the artistic coincidences? Such questions are compelling for the audience.

（三）矮子步 Dwarf Step

在戏曲表演中，时常会有专门的桥段让演员结合场景展示其扎实的基本功或独门绝活，这类展示通常会获得观众热烈的掌声，从而将表演推向高潮。

In the traditional theater performance, there is often a special section for actors to show their solid basic skills or unique skills in combination with the scene. This kind of display usually gets warm applause from the audience, thus spurring the performance to a climax.

在表演中合理地融入技巧是增加演出趣味性与观赏性的重要手段。在这折戏中，刘利华经常蹲着走路。蹲着走路一般称之为"矮子步"。"矮子步"是丑行独有的步法，通常用来表现身材矮小的人物，或身负武艺之人在暗杀、密探等行动中隐藏身形的伶俐样子。这两者的根本区别在于：前者需要在表演时一直保持蹲着行走的姿态，而后者可根据需要选择蹲行或直立。"矮子步"是丑行演员必备的"行当功"，要求演员立腰、提气，行走时要保持平稳，不能上下跳动。如果训练

方法不正确，长时间蹲着走路容易导致丑行演员膝盖受损。因此，必须在有经验的教师指导下，进行正确的训练。

It is an important means for adding interest and appreciation by reasonably integrating skills into the performance. In this excerpt, Liu Lihua often squats and walks, which is generally called "Dwarf step". The "Dwarf Step" is a unique skill of Chou and is usually used to show the smart appearance of a short figure or a person with martial arts skills who hides his/her body in order to assassinate, spy and undertake other operations. The fundamental difference between the two is that the former needs to keep the posture of squatting and walking all the time while performing, while the latter can either squat or stand upright as needed. "Dwarf Step" is a necessary "acting skill" for an actor of Chou. It requires the actor to stand

京剧《三岔口》，赵宏运饰任堂惠（右），潘梓健饰刘利华（左）（矮子步）。
卢雯 摄
Beijing *Cross Roads*, Zhao Hongyun as Ren Tanghui (right), Pan Zijian as Liu Lihua (left) (Dwarf Step). Photographed by Lu Wen

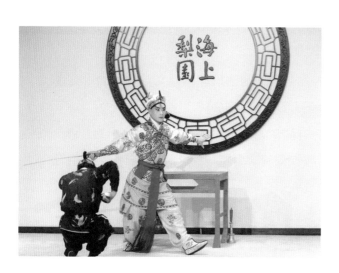

up, hold his breath, and walk steadily without jumping up and down. If the training method is not correct, squatting and walking for a long time will easily lead to knee damage for the Chou actor. Therefore, correct training must be carried out under the guidance of experienced teachers.

（四）旋子 Swirling

"旋子"是戏曲演员的基本功之一，武生、武净、武丑等行当更须见长。"旋子"多用于武打场面，能较好地体现英雄人物不畏艰险、挺身向前的气概。其动作起落轻松，旋腾姿势舒展优美，似燕子抄水，轻盈灵巧，所以在舞台表演时，常被置于突出位置。

"Swirling" is one of the basic skills of the traditional theater actors. Wu Sheng, Wu Jing, Wu Chou

京剧《三岔口》，赵宏运饰任堂惠（右）（旋子），潘梓健饰刘利华（左）。
卢雯 摄

Beijing Opera Cross Roads, Zhao Hongyun as Ren Tanghui (right) (Swirling), Pan Zijian as Liu Lihua (left). Photographed by Lu Wen

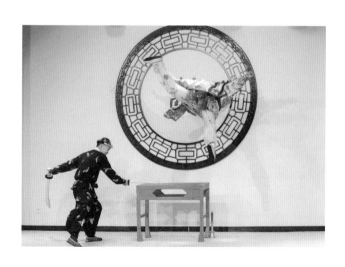

and other roles must show more proficiency. "Swirling" is mostly used in martial arts scenes, which can better reflect the courage of heroes to stand up and move forward despite hardships and dangers. It is easy to move up and down, And the spiral posture is stretchy and graceful, like a swallow skimming water, which is light and dexterous. So, it is often placed in a prominent position when performing on the stage.

舞台上，演员旋转的圈数是不确定的。通常情况下，演员会根据自身能力决定"旋子"的数量。好的演员会增加"旋子"的数量，观众在欣赏过程中也会情绪高涨，掌声不断。

On stage, the number of spins that actors perform is not predetermined. Typically, the number of circles depends on the actor's competence. Good actors will increase the number, and the audience will also be in high spirits during the appreciation process, with continuous applause.

（五）铁门槛 Iron Threshold

黑暗中，任堂惠恰巧将桌子腿压在了刘利华的脚上，刘利华痛得跳了起来，这个"跳"是京剧表演中一项技术要求很高的专门动作，我们习惯用"铁"来形容一件事物的难，所以称它为"铁门槛"。表演这个动作时，演员用右手抓住左脚脚尖，使左腿形成了一个"门槛"，右脚在这个"门槛"中反复前后跳跃。这一情节设计为紧张的打斗场面增添了不少乐趣。"铁门槛"与 "旋子"都属于纯技巧性的表演，

数量没有限制，但"铁门槛"多由丑行表演。

In the dark, Ren happened to put the leg of the table on Liu Lihua's foot, and Liu Lihua jumped up in pain. This "jump" is a special movement in Beijing Opera performances with high technical requirements. We are used to using "iron" to describe something difficult, so the "jump" is called "Iron Threshold". To perform the movement, the actor grabs the top of his left foot with his right hand, creating a "threshold" in which the right foot jumps back and forth repeatedly. This plot design adds much fun to the tense fighting scene. "Iron Threshold" and "Swirling" are both purely technical performances; there is no limit to the number of them, but "Iron Threshold" is performed mainly by Chou.

京剧《三岔口》，赵宏运饰任堂惠（右），潘梓健饰刘利华（左）（铁门槛）。
卢雯 摄

Beijing Opera *Cross Roads*, Zhao Hongyun as Ren Tanghui (right), Pan Zijian as Liu Lihua (left) (Iron Threshold). Photographed by Lu Wen

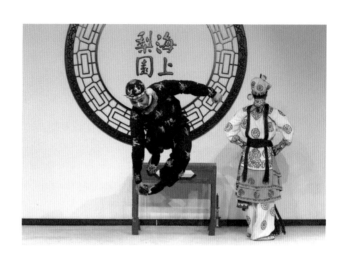

五

"打斗"赏析
Appreciation of Martial Arts Performance

"打"是戏曲表演的一个重要组成部分，其动作、套路主要源于中国武术，又在其基础上进行了美化和提炼。戏曲中的"打"由"把子功"和"毯子功"两部分组成，主要用来表现战争或打斗的激烈场面。

"Martial Arts Performance" is an important part of traditional theater performances, and its movements and routines are mainly derived from Chinese martial arts, which are beautified and refined. The "fighting" in the traditional theater is composed of two parts: "Acrobatic Fighting" and "Blanket Fighting", which are mainly used to show the fierce scenes of war or fighting.

（一）把子功 Bazi Arts（Acrobatic Fighting）

《三岔口》中，无论是使用单刀，还是赤手空拳，两人的格斗统称为"把子功"。

In *Cross Roads*, no matter whether using a single knife or bare hands, the fighting movements between Ren and Liu are collectively referred to as "Bazi Arts (Acrobatic Fighting)".

"把子"是戏曲中"刀、枪、剑、棍棒"等冷兵器的专有名称，而"把子功"是运用这些兵器进行格斗的程式组合。程式通常由两个人共同完成，他们每人手持一件武器，严格按照规定的动作打斗，由于组合方式不同，从而创造出不同的表演版本。"把子功"的动作是从"武术"发展衍变而来的，既有流畅的打斗场面，又有静止的动作造型，具有很高的观赏价值。虽然"把子功"常由两人配合完成，但是一人的单独展示和多人的对打也时常出现在戏曲舞台上。

"Bazi" is the proper name for cold weapons such as "knife, spear, sword and stick" in the traditional theater, and "Bazi Arts (Acrobatic Fighting)" is the combination of actions to fight with these weapons. These actions are usually composed of two people, each holding a weapon and fighting strictly in accordance with the prescribed movements, which can be combined in different ways to create different versions of the performance. The movements of "Bazi Arts (Acrobatic Fighting)" are derived from "martial arts", with both smooth fighting scenes and static models, which have high aesthetic value. Although "Bazi Arts (Acrobatic Fighting)" is often completed by two people, the individual display of one person and the confrontation of multiple people are often seen on the traditional theater stage.

《三岔口》中赤手空拳的打斗也在"把子功"的范畴之内。"把子功"有专门用于训练空手打斗的动作组合，初学者便是通过这类组合入门的。

The bare-handed fighting in *Cross Roads* is also within the scope of "Bazi Arts (Acrobatic Fighting)". It has a combination of movements specially designed to train for unarmed fighting, from which the beginners get started.

京剧《三岔口》把子功，赵宏运饰任堂惠（右），潘梓健饰刘利华（左）。
卢雯 摄

Beijing Opera *Cross Roads*, Bazi Arts (Acrobatic Fighting). Zhao Hongyun as Ren Tanghui (right), Pan Zijian as Liu Lihua (left). Photographed by Lu Wen

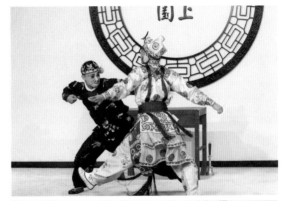

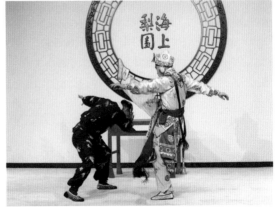

（二）毯子功

Blanket Arts (Blanket Fighting)

"毯子功"是戏曲中"翻、腾、扑、跌"等各种技巧动作的统称，包含单筋斗、长筋斗、桌子功和软毯功等多种技巧类型。因演员多在毯子上练习该类技巧而得名。

In traditional Chinese theater, "Blanket Arts (Blanket Fighting)" is a general term for all kinds of technical movements of turning, jumping, diving, falling, etc. It consists of multiple skill types such as Single Somersault Fighting, Long Somersault Fighting, Table Arts and Soft Blanket Arts. It got its name because actors often practice this technique on blankets.

六

服装赏析
Appreciation of Costume

　　戏曲素来有通过服装造型塑造人物的传统，传统戏曲服装具有明身份、寓褒贬的功能。正所谓"宁穿破，不穿错"。《三岔口》中，一个穿白衣，一个穿黑衣，一个堂堂正正，一个神秘诡谲，体现了戏曲服装直观展示人物特征的基本功能。

It has always been the tradition of traditional theater to shape characters through costume, which means revealing identities and implying praise and criticism. As the saying goes, "It is better to wear out than to wear wrong". In *Cross Roads*, the one dressed in white is dignified, while the other in black is mysterious, which embodies the basic function of the traditional theater costume to display the character's distinctive features intuitively.

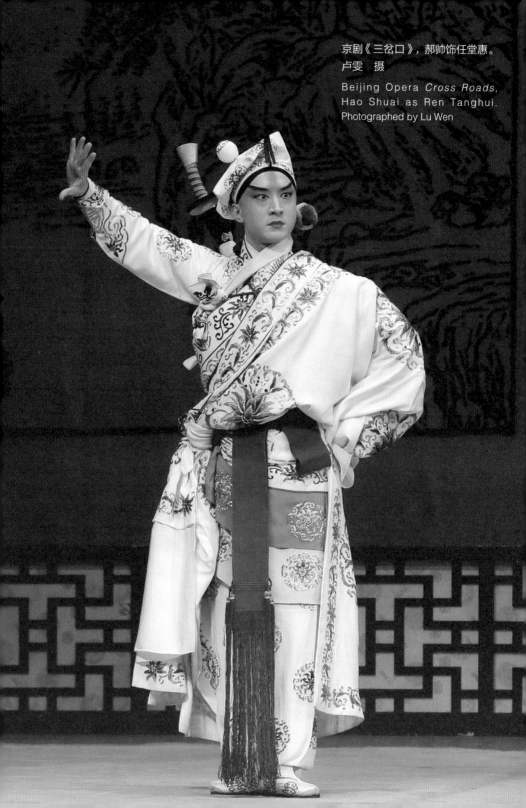

京剧《三岔口》，郝帅饰任堂惠。
卢雯　摄

Beijing Opera *Cross Roads*,
Hao Shuai as Ren Tanghui.
Photographed by Lu Wen

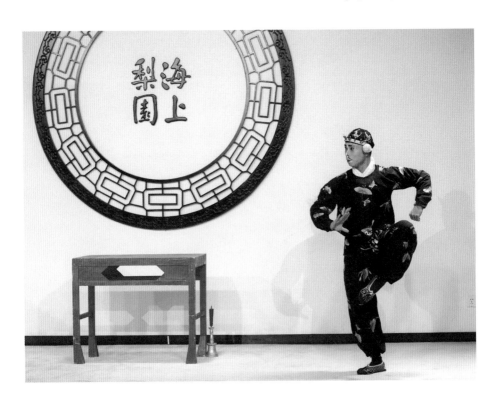

京剧《三岔口》，潘梓健饰刘利华。
卢雯 摄

Beijing Opera *Cross Roads*,
Pan Zijian as Liu Lihua.
Photographed by Lu Wen

七

音乐赏析
Appreciation of Music

　　戏曲中的打击乐器主要有板鼓、大锣、小锣、铙钹、镲等。锣鼓伴奏时声音响亮，可以根据表演需要控制节奏、调动氛围、外化心理，加强观众对戏曲的理解。《三岔口》中，演员精湛的"做工"成功营造了激烈的打斗氛围，但戏曲音乐的使用同样功不可没。

The percussion instruments in traditional theater mainly include the drum (pan-ku), the big gong, the small gong, the big cymbal, the small cymbal and so on. The accompaniment of gongs and drums is loud, which can control the rhythm, stimulate the atmosphere and externalize the psychology according to the needs of the performance, to enhance the audience's understanding of the performance. In *Cross Roads*, the actors' exquisite "Acting" successfully created a fierce fighting atmosphere, but the use of the traditional theater music contributed as well.

单皮鼓
孙晓梅　摄

A Single Skin Drum.
Photographed by Sun Xiaomei

大锣
孙晓梅　摄

A Big Gong.
Photographed by Sun Xiaomei

小锣
孙晓梅　摄

A Small Gong.
Photographed by Sun Xiaomei

铙钹
孙晓梅　摄

Cymbals.
Photographed by Sun Xiaomei

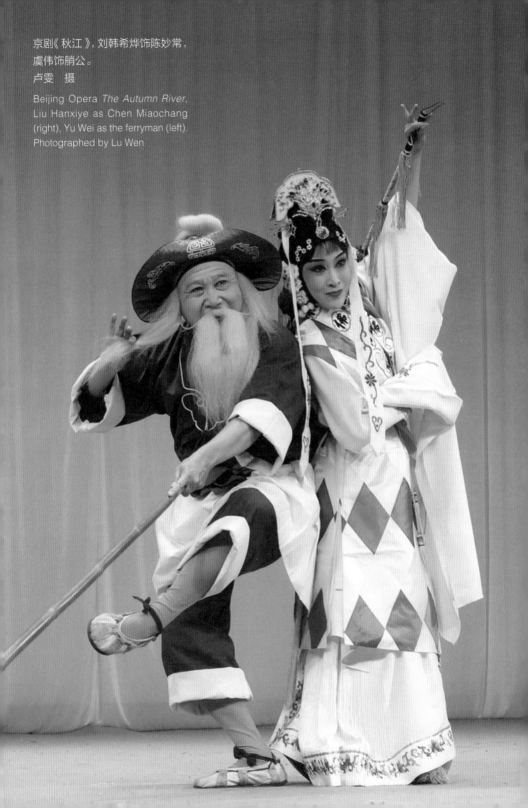

京剧《秋江》，刘韩希烨饰陈妙常，
虞伟饰艄公。
卢雯　摄

Beijing Opera *The Autumn River*,
Liu Hanxiye as Chen Miaochang
(right), Yu Wei as the ferryman (left).
Photographed by Lu Wen

贰

京剧《玉簪记·秋江》

Beijing Opera

A Jade Hairpin ·

The Autumn River

剧目简介

Introduction to *The Autumn River*

京剧《秋江》取材于明传奇《玉簪记》中的《追别》一折。该传奇为明朝万历年间戏曲家高濂所著，讲述了少女陈娇莲与考生潘必正突破封建礼制与道教教义束缚的爱情故事。

The Beijing Opera *The Autumn River* is developed from *Farewell* in *The Story of the Jade Hairpin*. *The Story of the Jade Hairpin* was written by the traditional Chinese theater artist Gao Lian during the Wanli period of the Ming Dynasty. It mainly tells the story of the young girl Chen Jiaolian and the scholar Pan Bizheng, who broke through the feudal rites and the precise rules of Taoism to fall in love.

南宋战乱时期，陈娇莲在逃难途中与母亲走散，不得已在金陵女贞观作道姑，法名妙常。此时，女贞观主的侄子潘必正因为会试落第，寄居观中。两人于观中初见，互生爱慕。此后二人借助琴声表达爱意，又在病中吐露衷情、结为同心。观主察觉到两人的情意，于是逼迫潘必正进京赶考，以拆散二人。陈妙常得知潘必正离开，追至江边，此时潘已乘船离开，她急忙雇一老翁撑船继续追赶。最终陈、潘二人相见，互赠信物，泣别秋江。故事的最后，潘必正登第得官、衣锦还乡，

迎娶陈妙常归家团聚。

During the war of Southern Song Dynasty, the young girl Chen Jiaolian was separated from her mother on the way to escape. She had no choice but to enter the Jinling Nvzhen Temple as a Taoist named Miaochang. At the same time, Pan Bizheng, the nephew of the temple's host lived in the temple after failing the metropolitan examination. They fell in love at first sight and expressed their feelings for each other through music, and later confessed their love and became a couple while Pan was ill. The temple host noticed the feelings between them and forced Pan Bizheng to go to the capital for the metropolitan examination, to break up the lovers. Knowing Pan Bizheng was leaving, Chen Miaochang chased him to the riverside, but Pan had already left by boat. In desperation, she hurriedly hired an old ferryman to chase after him. Finally, Chen and Pan met and exchanged tokens of love, with a tearful farewell on *The Autumn River*. In the end, Pan passed the imperial examination, became an official, and returned home in glory to marry Chen Miaochang.

《秋江》一折讲的是陈雇舟追赶潘的这段情节。陈妙常追至江边，得知潘必正已乘舟启程，不禁心中焦虑，匆忙中想要雇只小舟继续追赶，却不料艄翁生性诙谐，逗趣陈妙常，故意耽搁了一些时间，使得陈妙常心急如焚。好在老艄翁的船快，最终帮助陈妙常追上了潘必正。

The Autumn River is a plot about Chen hiring a ferryman to chase Pan. Chen Miaochang ran to the riverside and learned that Pan Bizheng had set off. She could not help feeling anxious and wanted to hire a small boat to continue chasing Pan in a hurry. However, unexpectedly, the old ferryman was very humorous and he wasted some time and made some

京剧《秋江》，刘韩希烨饰陈妙
常（右），虞伟饰艄公（左）。
卢雯 摄

Beijing Opera *The Autumn River*,
Liu Hanxiye as Chen Miaochang
(left), Yu Wei as the ferryman (right).
Photographed by Lu Wen

innocent jokes during the chase, which made Chen Miaochang more anxious. Fortunately, the old ferryman rowed the boat well and fast, and finally helped Chen Miaochang to catch up with Pan Bizheng.

京剧《秋江》是一出文戏[1]，移植自川剧，自创作以来深受国内外观众的喜爱。作为一出侧重于"做工"的戏，《秋江》中"水上行舟"的片段自然是表演的重点。据说扮演艄翁的演员在学戏前，需要先将河性、水性、船性、风性摸清，做到心中有河、有水、有船、有风，在熟悉了以上的环境之后，才能进一步去学习撑篙行船的传统表演程式，其间所涉及的戏曲与生活及其相互转化的关系是中国戏曲传统美学的重要课题，深受观众青睐。[2]

1 文戏：戏曲中以唱念、表演为主的剧目。具体可以细分为以唱为主的唱功戏和以表演为主的做工戏。
2 陈国福.《秋江》荡舟世界 [J]. 四川戏剧，1994(06): 27–29.

Beijing Opera *The Autumn River* is a literary theater[1], adapted from traditional Sichuan theater and has been deeply loved by audiences at home and abroad since its creation. As a theater that focuses on "Acting", the "boat on the water" segment in *The Autumn River* is naturally the focus of the performance. It is said that actors who play the role of the ferryman need to understand the nature of rivers, water, boats and wind before learning to perform this excerpt. After familiarizing themselves with the above environment and achieving a sense of rivers, water, boats and wind in their hearts, they can further learn the traditional performing procedures of poling a boat. The relationship between traditional Chinese theater, life, and their mutual transformation involved in this process is an important topic in the traditional aesthetics of Chinese theater, and is highly popular with audiences.

1　Literary theater: a theater that focuses on singing, recitation and performance. Specifically, it can be subdivided into singing theater and acting theater.

二

人物简介
Character Profile

　　陈妙常——闺门旦。闺门旦属于旦行[1]，多扮演大户人家尚未出阁的小姐。这一行当要求演员的嗓音甜美婉转，扮相端庄娴静。陈妙常这一角色与一般闺门旦不同，她敢于突破礼教，追求爱情。十八岁的陈妙常正值青春年华，情感萌动，与潘必正的相遇，孕育了她追求爱情的无限勇气。值得一提的是，在遇到潘必正之前，陈妙常曾果断拒绝其他男子的示爱，可见她的爱并不盲目，值得尊重。

1　旦行是戏曲舞台上的重要行当之一，主要扮演各种不同年龄、不同性格、不同身份的女性角色。扮演人物按年龄、身份、性格及其表演特点，又可分为正旦（青衣）、花旦、花衫、武旦、老旦和彩旦等。闺门旦是戏剧旦行的分支，昆曲《牡丹亭》中的杜丽娘形象，也是典型的闺门旦。

Chen Miaochang: plays a Guimen Dan role. Guimen Dan belongs to Dan[1], and mostly plays the role of a lady who has not yet married. The voice of Guimen Dan should be sweet and graceful, while the appearance should be demure and quiet. Unlike the introvert and shyness of the general Guimen Dan, Chen Miaochang dares to break through the restraints of ethics and pursue love. Eighteen-year-old Chen Miaochang is in her youth, with sprouting affections. Her encounter with Pan Bizheng has nurtured her infinite courage to pursue love. It is worth mentioning that before meeting Pan Bizheng, Chen Miaochang decisively rejected other men's love proposals, which shows that her love is not blind and deserves admiration.

艄翁——茶衣丑。茶衣丑属丑行。茶衣指一种短褂子，是戏曲服装中最简陋的戏服，属古代劳动者专用的服装，所以茶衣丑多扮演劳动人民。茶衣丑有的忠厚老实、热情善良，有的不务正业、好逸恶劳。但整体上人物个性鲜明，造型丰富。《秋江》中的艄翁属于正派角色，他富有幽默感且心地善良。虽年岁已高，但常年摆渡使他身姿硬朗、行动矫健，他的身上凝聚着劳动人民的优秀品质。

Old Ferryman: plays a Chayi Chou role. Chayi Chou belongs to Chou. Chayi is a kind of short gown, which is the simplest costume in traditional theater costumes. It belongs to the special costume of ancient

1 Dan is one of the important types of roles on the stage of traditional Chinese theater, mainly playing various female roles of different ages, personalities and identities. According to age, identity, personality and performing characteristics, the characters can also be divided into Zheng Dan (Qingyi), Hua Dan, Hua Shan, Wu Dan, Lao Dan, and Cai Dan. Guimen Dan is a branch of Dan, and the image of Du Liniang in the Kunqu *Peony Pavilion* is also a typical Guimen Dan.

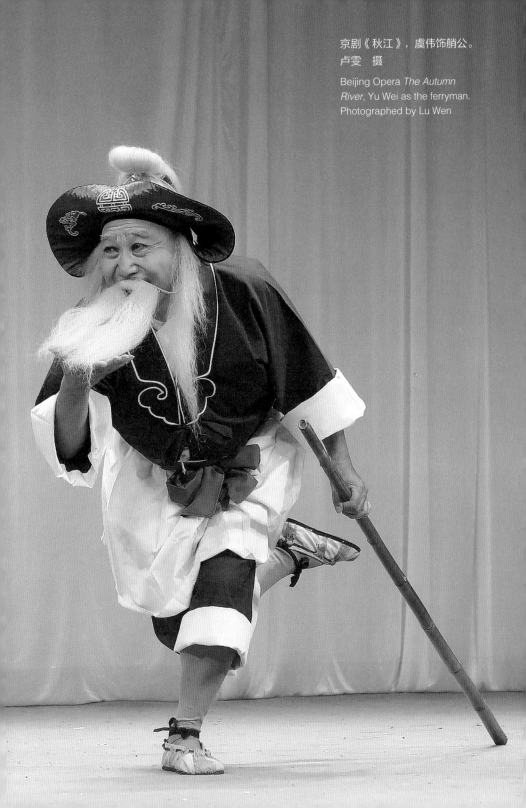

laborers, and therefore, the Chayi Chou plays the role of working people. Some of them are loyal, honest, enthusiastic, and kind-hearted, and some are careless and lazy. Overall, they have distinct personalities and rich characters. The ferryman in *The Autumn River* is a positive character, who is humorous and kind-hearted. Although he is advanced in years, he remains strong and agile of ferrying. He has the excellent qualities of the working people.

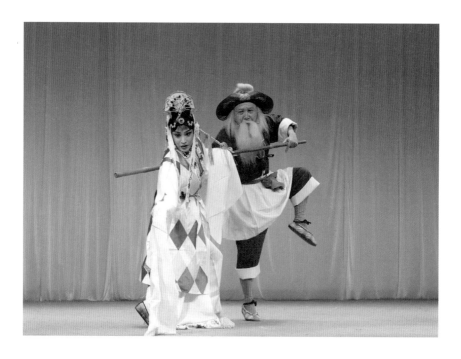

京剧《秋江》，刘韩希烨饰陈妙常（左），虞伟饰艄公（右）。
卢雯 摄

Beijing Opera *The Autumn River*, Liu Hanxiye as Chen Miaochang (left), Yu Wei as the ferryman (right).
Photographed by Lu Wen

三

选 段

Selected Scene of *The Autumn River*

陈妙常： （唱）

匆匆地私自离庵门，似雀鸟出牢笼展翅飞腾。

陈妙常与潘郎两心相印，结知音缘于一张琴。

实可恨那老庸师偏多事，顿时情海起风云。

逼他去科考，逐我意中人。

慢说他远去临安郡，纵然是海角天涯（我也）如影随形。

细雨蒙蒙衣衫渐浸，路滑坡陡步履难行。

哪管它戒律森严人潮论，急步江边我把潘郎寻。

Chen Miaochang (Singing)

I'am leaving the Taoist Temple secretly and hurriedly, like a bird flying out of its cage.

Forming a bond of love through the guqin[1], Chen Miaochang and

1 Guqin: one of the traditional Chinese instruments.

her beloved Pan being related by mutual affinity.

The old Master of the temple is meddlesome and hateful, letting the sea of love rise with wind and clouds suddenly,

Forcing him to take the metropolitan examination and expelling my love.

No mention of going to Lin'an County, even if it is the remotest corner of the world, I will also accompany him like a shadow.

The clothes are gradually soaked in the drizzle, and the road is slippery and steep, making walking difficult.

Regardless of the strict discipline, I am hurried to the riverside to find my lover Pan.

四

演出推荐
Performance Recommendation

　　本书推荐的视频版本为国家京剧院于 1996 年在长安大戏院首演的版本。其中陈妙常由张火丁扮演，艄翁由张春华扮演。该版陈妙常神态羞涩、身段优美，艄翁朴实幽默、身手矫健，是京剧舞台上的一出经典之作。

The video recommended in this book is premiered by the National Peking Opera Company at the Chang'an Grand Theater in 1996. Chen Miaochang was played by Zhang Huoding, and the old ferryman was played by Zhang Chunhua. In this video, Chen Miaochang has a shy demeanor and a graceful figure, and the old ferryman has an earthy sense of humor with aggile skills. This performance is a classic on the Beijing Opera stage.

五

演出赏析
Performance Appreciation

（一）以虚代实 Substituting the Real with the Fictitious

《秋江》中最有趣的是二人表演的登船与行舟。两位演员通过肢体动作的把控，细致、逼真地描摹出了小船在水面上滑行、起伏摇晃和破浪前行的各种姿态，而舞台上平整的地面仿佛幻化成水波荡漾的江面，一霎时境界全出，让人不禁赞叹戏曲舞台空间的灵动和诗意！

The most interesting part of *The Autumn River* is their performance of boarding and boating. Through the subtle control of their body movements, the two actors carefully and vividly depicted various gestures when the boat was sliding on the water, undulating, swaying and breaking through the waves. The flat ground on the stage seemed to be transformed into a rippling river, and the imagery appeared at once. People couldn't help but admired the spirit and poetry of the stage spare on the traditional theater stage!

演员通过对动作幅度的掌控，呈现出船在水中与人在船上两种不

46

同的形态。艄翁刚上场时，将篙一撑，脚下走起"小碎步"[1]，顷刻间生动地展现出小船在平静水面上滑行的姿态，而艄公的得意自如与矫健利落也由此刻画了出来。与艄公不同，陈妙常不熟悉水性，因此她上船时战战兢兢，而且越害怕，船晃动得就越厉害。这里演员通过大幅度地弯曲膝盖和不规律的前后挪步表现了船身的起伏摇摆以及自己在船上小心翼翼却又站不稳的窘态。之后，陈妙常和艄翁一个在船头一个在船尾，通过彼此肢体上的配合，展现出小船由剧烈

京剧《秋江》，刘韩希烨饰陈妙常（右），虞伟饰艄公（左）。
卢雯　摄

Beijing Opera *The Autumn River*, Liu Hanxiye as Chen Miaochang (right), Yu Wei as the ferryman (left). Photographed by Lu Wen

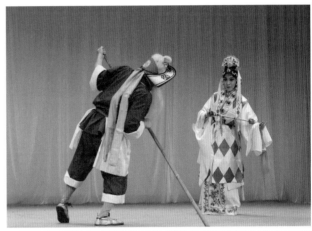

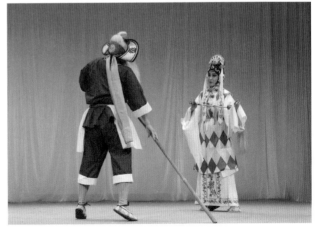

1　小碎步：一种踮起脚掌，步幅小、频率快的步法。

47

起伏到渐渐平稳的整个过程。

By controlling the range of movements, the actors presented different forms of boats in the water and people on board. When the old ferryman first stepped on the stage, he propped up the pole and took "small steps"[1], which instantly vividly showed the boat's sliding on the calm water. At the same time, the ferryman's pride, ease and agility were also depicted. Unlike the ferryman, Chen Miaochang was unfamiliar with water, so she was trembling as she boarded the boat. However, the more frightened she was, the more the boat swayed. Here the actress as Chen Miaochang showed the ups and downs of the boat and her embarrassment at being cautious but unstable on the boat by greatly

京剧《秋江》，刘韩希烨饰陈妙常（右），虞伟饰艄公（左）。
卢雯 摄

Beijing Opera *The Autumn River*, Liu Hanxiye as Chen Miaochang (right), Yu Wei as the ferryman (left). Photographed by Lu Wen

1 Small Steps: A footwork in which the feet are raised on tiptoe, with small steps and fast frequency.

bending her knees and moving back and forth irregularly. Afterwards, Chen Miaochang and the ferryman, one at the bow and the other at the stern, they demonstrated of the small boat, from violent fluctuations to gradual stabilization through their physical cooperation.

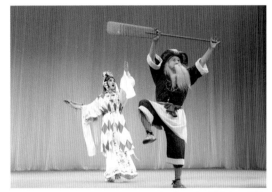

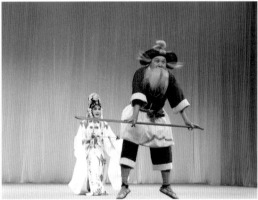

京剧《秋江》，刘韩希烨饰陈妙常（左），虞伟饰艄公（右）。
卢雯　摄

Beijing Opera *The Autumn River*, Liu Hanxiye as Chen Miaochang (left), Yu Wei as the ferryman (right). Photographed by Lu Wen

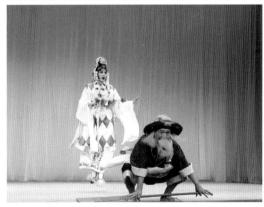

开船时，艄翁发现江水退潮，船只搁浅。气急的他，一脚踹向船头，结果力气过大，船一下子滑了出去，他又连忙抓住缆绳，将船拽了回来。这一系列动作都是无实物表演，舞台上没有真正的船和缆绳，但观众却可以通过两位演员的表演，轻松地想象出这些事物的存在。当陈妙常在渐行渐远的船上害怕得不敢动弹时、艄翁手忙脚乱地去抓缆绳时，两人的动作节奏、幅度高度一致，呈现出了一条船在水上被荡开又拉回去的动势。之后，两位演员通过位置变换，一个在前一个在后，大幅且快速地蹲下站起，以此来表现船在江中迎浪前行的姿态，既具有一种劈波斩浪的美感与气魄，又尽显陈妙常追寻至爱的柔情与果敢。

To set sail, the ferryman noticed that the river was ebbing and the boat was stranded. In a fit of anger, he kicked at the boat's bow with excessive strength and the boat suddenly slid out unexpectedly. In order to prevent the boat from rowing out too far, he quickly grabbed the rope and pulled the boat back. Of course, all these actions were performances without real objects. There was not a real boat or a rope on the stage, but the audience could easily imagine the existence of these objects through the performance of the two actors. When Chen Miaochang was too scared to move on the drifting boat, and the ferryman scrambled to grab the rope, the rhythm and amplitude of the two actors' movements were extremely consistent, showing the dynamic moments of the boat being swung away and pulled back on the water. After that, the two actors squatted and stood up sharply and quickly, while changing their positions so that one was in the front of the other to express the position of the boat cutting through the waves in the river with a sense of beauty and courage. Chen Miaochang's tender and courageous pursuit of her lover was fully demonstrated here.

（二）人物性格 Character Features

　　陈妙常和老艄翁的人物性格也是本折戏的亮眼之处。陈妙常正值桃李年华，天然纯真，情窦初开；老艄翁则值耄耋之年，诙谐幽默，热情善良。这样一老一少，自然新鲜有趣。

The characters of Chen Miaochang and the old ferryman are also highlighted in this excerpt. In the age of peach and plum, Chen Miaochang is natural and innocent, with a begining of love; the old ferryman is in his old age and is witty, humorous, warm and kind. This combination of old and young is naturally fresh and interesting.

京剧《秋江》，刘韩希烨饰陈妙常。
卢雯　摄

Beijing Opera *The Autumn River*, Liu Hanxiye as Chen Miaochang. Photographed by Lu Wen

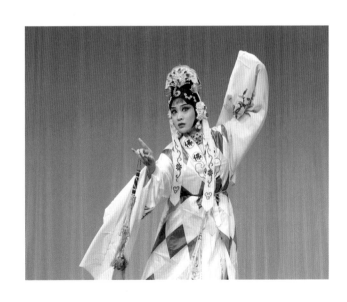

　　陈妙常雇船时，艄翁问她为何这么着急追人，陈妙常不慎脱口："我们乃是朋（友）"，友字未出口，少女欲言又止的娇羞情态已然展露。在当

时，道姑属于修行之人，是不允许与男性私下接触的。老艄翁看出了其中的端倪，故意说道："篷？是船篷？那么是风篷咯？我知道了，你看天要下雨，可是叫老汉我披上一件斗篷？"老艄翁哪里会不知道陈妙常倾心于所追之人，他只是觉得眼前的少女天真可爱，打心眼儿里喜欢她，所以才会和她开个善意的玩笑。

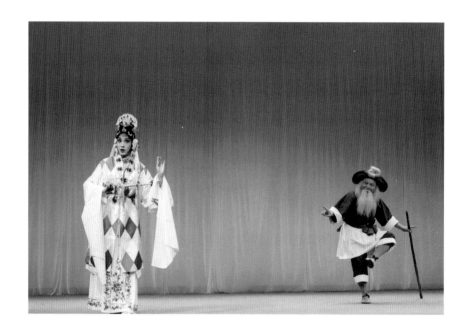

京剧《秋江》，刘韩希烨饰陈妙常（左），虞伟饰艄公（右）。

卢雯　摄

Beijing Opera *The Autumn River*, Liu Hanxiye as Chen Miaochang (left), Yu Wei as the ferryman (right). Photographed by Lu Wen

Chen Miaochang hired a boat, and the ferryman asked her why she was chasing people in such a hurry. Chen Miaochang accidentally blurted out, "We are (friends)". The word "Friends" had not yet been uttered, and the girl's shyness in being hesitant to speak was already revealed. At that time, Taoist nuns were spiritual practitioners and were not allowed privately contact with men. The old ferryman saw the clues and deliberately said, "The canopy (sounds like "friend" in Chinese)? Is it a boat canopy? Is it a wind canopy? I see. It is going to rain, so you tell me to put on a cloak (sounds like "friend" in Chinese, too)?" How could the old ferryman not know that Chen Miaochang was devoted to the man she was chasing? He just felt that the girl in front of him was innocent and cute, and he was genuinely fond of her, so he made a friendly joke with her.

上船后，老艄翁依然玩心不减，又和陈妙常开玩笑说要先回家吃饭再去追人。当陈妙常问他回家的路程有多远时，他说："不远，仅有四十里。"这可把着急的陈妙常吓坏了，于是她忙对艄翁说追到潘必正就请他喝酒吃饭。调皮的艄翁看到陈妙常如此急切天真，也不忍心再开玩笑，就载着陈妙常追赶潘必正去了。行舟于秋江之上的两人，一个摇着船说说笑笑，一个面对江景，思念情人；一个悠闲自在，一个心急如火。[1]青山绿水，鹤发红颜。让人不免觉得真切生动，余味悠长。

After boarding the boat, the old ferryman was still playful and joked with Chen Miaochang that he would go home for dinner before chasing the man. When Chen Miaochang asked how far it was, he said it was not far—only forty miles. This frightened Chen Miaochang, who was in

1 欧阳予倩. 再看川剧《秋江》[J]. 戏剧报，1959(08)：27.

1 欧阳予倩. 再看川剧《秋江》[J]. 戏剧报，1959(08)：27.

a hurry, so she quickly told the ferryman that she would invite him for a meal to drink if she caught up with Pan Bizheng. Seeing the eagerness and innocence of Chen Miaochang, the bold ferryman couldn't bear to joke anymore, So he drove Chen Miaochang away and chased Pan Bizheng immediately. The two people were boating on the Autumn River ; one was shaking the boat, talking and laughing; the other was facing the river scenery and missing her lover. One was leisurely, and the other was anxious. Green mountains and water, with the old and the young, make people feel real and vivid with a long aftertaste.

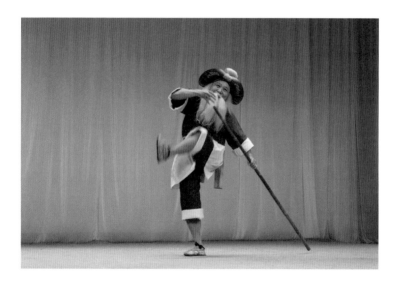

京剧《秋江》，虞伟饰艄公。
卢雯　摄

Beijing Opera *The Autumn River*, Yu Wei as the ferryman.
Photographed by Lu Wen

（三）情景交融 Fusion of Emotions and Scenes

在中国传统文化艺术中，景色的描写通常与情感的抒发有关联。这一折戏也不例外。心上人不辞而别，陈妙常冒雨匆匆追来，赶到江边却不见潘必正的身影，她内心的苦楚难以倾诉。此时，外部的景色就起到了替人物说话的作用。在原本《追别》一折中有关于情与景的描写："白云阵阵催黄叶，唯有江上芙蓉独自开。"陈妙常就好似芙蓉花，孤零零地伫立在江边。秋风袅袅，木叶摇落，秋雨绵绵，凄凄沥沥，此刻呈现于眼前的江景正是陈妙常内心的写照。

In traditional Chinese culture and art, the depiction of scenery is usually related to the expression of emotions. This is no exception in this play. When her lover left without saying goodbye, Chen Miaochang rushed to catch up with him in the rain, only to arrive at the riverbank and find no trace of Pan Bizheng. Her inner anguish is difficult to express. At this moment, the external scenery plays the role of speaking for the character. In the original, there is a description of love and scenery: "White clouds are urging leaves yellow, and only the hibiscus on the river blooms alone." Chen Miaochang stood alone by the river like a hibiscus flower. The autumn breeze is curling, the leaves are shaking, and the autumn rain is lingering and desolate. The scene of the river presented is a portrayal of Chen Miaochang's heart.

艄翁在多处喊的"号子"也为全剧增添了不少情致。如艄翁听到陈妙常的呼唤准备靠岸时，一声嘹亮悠扬的号子顿时将山水的画面勾勒出来，不由使人想起古人在山水诗中所描绘的"欸乃一声山水绿"的恬淡意境。

The "calls" chanted by the old ferryman in many places also add a lot of charm to the entire excerpt. As the old ferryman heard Chen Miaochang's call and prepared to dock, a loud and melodious chant immediately outlined the landscape, which reminds people of the tranquil mood of the "essence of a green landscape" as described by the ancients in landscape poems.

《秋江》很好地体现了中国戏曲的写意美学特征。无论是"以桨代舟"的理念与各种模仿行舟姿态的表演，还是以唢呐模仿鸟叫、小锣指代水声等音乐手法，其最终目的都是要调动观众的想象，把眼前的舞台幻化成碧水青山。这与中国传统绘画中"不着一笔却满纸是水"的美学观念是一致的，目的都是要传达言外之意、弦外之音，营造充满诗意的审美体验。

The Autumn River embodies the freehand aesthetics of Chinese theater. Whether the concept of "using oars instead of boats" and various performances that imitate the gesture of boating or musical techniques, such as using the suona to imitate the singing of birds and using small gongs to refer to the sound of water and so on, the ultimate goal is to mobilize the imagination of the audience and transform the stage into a scenery of clear water and green mountains. This is consistent with the aesthetic concept of "there is full of water without a stroke relating to

water on the paper" in traditional Chinese painting, and the purpose to convey the unspoken meaning and the implication, creating an aesthetic experience full of poetry.

京剧《秋江》，刘韩希烨饰陈妙常（右），虞伟饰艄公（左）。
卢雯　摄
Beijing Opera *The Autumn River*, Liu Hanxiye as Chen Miaochang (right), Yu Wei as the ferryman (left). Photographed by Lu Wen

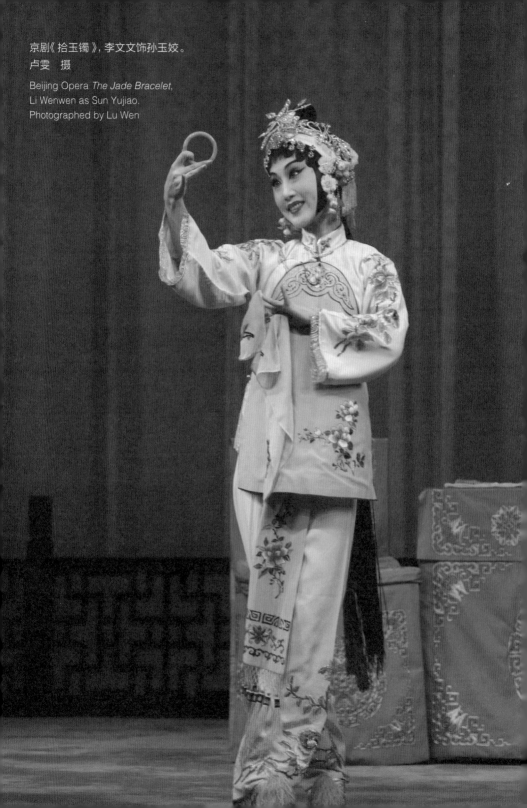

京剧《法门寺·拾玉镯》

Beijing Opera

Famen Temple ·
The Jade Bracelet

剧目简介
Introduction to *The Jade Bracelet*

京剧《拾玉镯》，李文文饰孙玉姣。
卢雯　摄

Beijing Opera *The Jade Bracelet*,
Li Wenwen as Sun Yujiao.
Photographed by Lu Wen

《拾玉镯》亦称《买雄鸡》，属于京剧传统剧目《法门寺》中的一折。主要讲述了孙玉姣与傅朋一见倾心的爱情故事。孙寡妇之女孙玉姣在门外刺绣，被偶然经过的傅朋看见。傅朋心生爱慕，便借买鸡为名与孙玉姣搭话。孙玉姣初见傅朋，对其俊朗的外貌和彬彬有礼的态度产生了好感，却羞于表达自己的情意，只敢偷偷地看着傅朋。傅朋察觉孙玉姣的心意，在离开前将一只玉镯作为定情信物，留在孙家门前。孙玉姣拾起玉镯，恰巧被经过的刘媒婆看见，于是出面为二人撮合。

The Jade Bracelet, also known as *Buying a Rooster*, is an excerpt from

Beijing Opera *Famen Temple*. It mainly tells the story of how Sun Yujiao and Fu Peng fell in love at first sight. Sun Yujiao, the daughter of widow Sun, was embroidering outside the door when Fu Peng accidentally saw her. Fu Peng was attracted by her and used the excuse of buying a rooster to strike up a conversation with Sun Yujiao. Sun Yujiao was also attracted by Fu Peng's handsome appearance and courteous attitude, but she was too shy to express her feelings and could only secretly look at Fu Peng. Fu Peng realized Sun Yujiao's feelings and left a jade bracelet as a token of their love before leaving. Sun Yujiao picked up the jade bangle and it happened to be seen by a matchmaker named Liu, who then made a match between the two lovers.

京剧《拾玉镯》，李文文饰孙玉姣（左），
王盾饰刘媒婆（右）。
卢雯 摄

Beijing Opera *The Jade Bracelet*, LiWenwen as Sun Yujiao (left), Wang Dun as Liu matchmaker (right).
Photographed by Lu Wen

京剧《拾玉镯》，李文文饰孙玉姣（左），
杨楠饰傅朋（右）。
卢雯 摄

Beijing Opera *The Jade Bracelet*, Li Wenwen as Sun Yujiao (left), Yang Nan as Fu Peng (right).
Photographed by Lu Wen

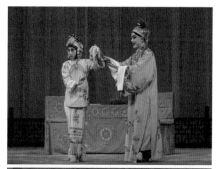

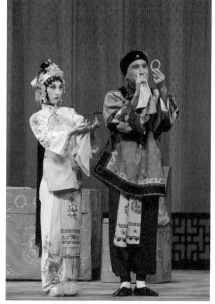

京剧《拾玉镯》是典型的做工戏，该戏主要通过喂鸡、穿针引线与纳鞋等一系列家务劳动表现年轻少女劳动时的美感，及其情窦初开，心怀爱慕，却又羞于启齿的情态。整折戏具有浓郁的生活气息，朴实清新，深得观众喜爱。

Beijing Opera *The Jade Bracelet* is a typical acting theater. It uses a series of household chores such as feeding chickens, threading needles and knitting shoes to express the beauty of young girls at work as well as the mood of young girls who are in love but embarrassed to talk about it. The simple and fresh excerpt has a strong atmosphere of real life and is deeply loved by the audience.

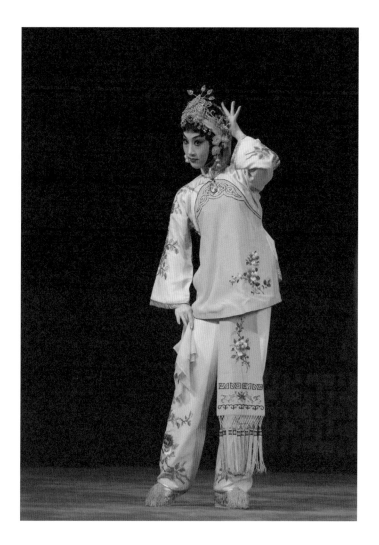

二

人物简介
Character Profile

 孙玉姣——花旦，属于旦行。京剧中，花旦可以扮演不同年龄段、不同性格的女性。该行当承担了除扮演贞洁烈女的青衣之外的绝大多数中老年女性。花旦的表演以做、念为主。在这折戏中，孙玉姣是性格开朗的妙龄少女。

Su Yujiao: plays a Hua Dan role, which belongs to Dan. In Beijing Opera, Hua Dan can play various women of different ages and personalities. This type of role acts the vast majority of middle-aged and elderly women, except for Qing Yi, a chaste and pure woman. Hua Dan's performance focuses on acting and speaking. In this excerpt, Sun Yujiao is a young girl with a cheerful personality.

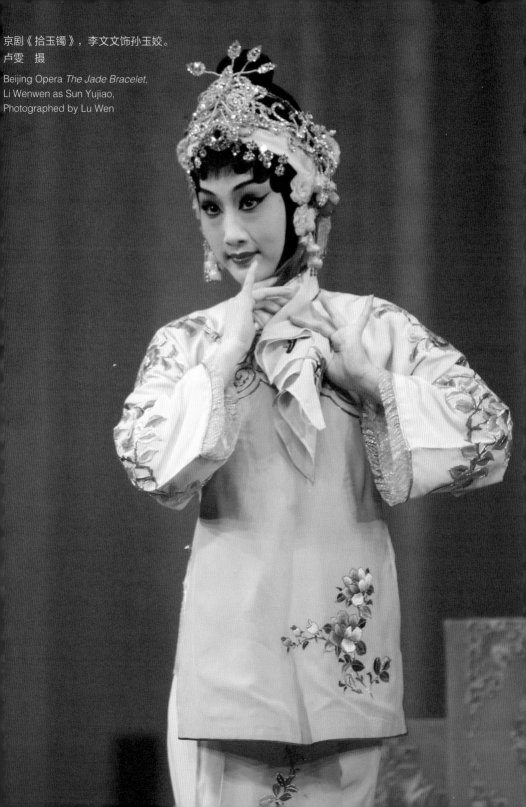

京剧《拾玉镯》，李文文饰孙玉姣。
卢雯　摄

Beijing Opera *The Jade Bracelet*,
Li Wenwen as Sun Yujiao,
Photographed by Lu Wen

三

选 段

Selected Scene of *The Jade Bracelet*

孙玉姣：（念）

　　愁锁双眉。

　　习针黹消遣白昼。

　　泪湿衣衫袖，

　　寂寞困春愁。

　　摽梅期已过，

　　见人面带羞。

　　我，孙玉姣。不幸爹爹去世，撇下母女二人，惯养雄鸡度日。母亲好善，今早往普陀寺听经去了。留我一人闷坐家中，我不免去到门首喂喂鸡儿，针黹一番便了。

　　【孙玉姣出屋门，开栅栏门，轰鸡至大门外，喂鸡。】

　　【孙玉姣搬椅子到门外，取针线笸箩，穿针引线，刺绣手帕。】

孙玉姣：（唱）

　　守闺阁独自里倚门而坐，

　　叹红颜命运薄愁多虑多！

女儿家在门前针黹绣作，

乍行船料无有什么风波。

Sun Yujiao: (Speaking)

Frowned in worries.

I practice needlework to amuse myself during the day.

Tears wet the sleeves of my clothes.

I feel lonely and trapped in the melancholy of spring.

The age of marriage has passed.

So, I am ashamed when I meet others.

I am Su Yujiao. Unfortunately, my father passed away, leaving my mother and me behind. We used to raise roosters for a living. My mother is kind. She went to the Putuo Temple to listen to the scriptures this morning and left me at home alone. Being alone at home is very boring. I'd better go to the door to feed the chickens and do some needlework.

(Sun Yujiao moves out of the house, opens the fence door and drives the chickens outside the gate to feed them.)

(Sun Yujiao moves a chair outside the door, takes a basket with thread and needles in it and begins to thread and embroider a handkerchief.)

Sun Yujiao: (Singing)

I am sitting alone in the boudoir and leaning against the door. Why do beauties always have bad fates, with so much sorrows and worries?

A woman is doing needlework in front of her house. The suddenmerchant ship tax should not raise a storm.

四

演出推荐
Performance Recommendation

本书推荐的视频为北京京剧院 2012 年演出版本。该版曾在《CCTV 空中剧院》栏目播出，至今仍可观看。常秋月扮演孙玉姣。戏中，演员通过喂鸡、做针线活、整衣与揉眼等细节展现了角色灵动的眼神、曼妙的身段与灵巧的身姿，成功塑造了孙玉姣干练又不失娇俏的人物形象。

The video recommended in this book is the 2012 version performance by in the Jingju Theater Company of Beijing, which was broadcast in the *CCTV Air Theater* column and is still available for viewing. In this version, Sun Yujiao is played by Chang Qiuyue. The actress depicted a graceful character with smart eyes and dexterous gestures through detailed performances such as feeding chickens, doing needlework, organizing clothes and rubbing her eyes. She successfully portrayed the capable and charming character of Sun Yujiao.

五

演出赏析
Performance Appreciation

（一）赶鸡 Driving Chickens

作为卖鸡人家的女儿，喂鸡是孙玉姣每天的功课。她熟练地打开鸡笼，一边叫着"喔嘘、喔嘘"，一边舞动着手臂将鸡从鸡笼里赶出来。她左边赶一下，右边赶一下，将鸡赶到了指定的位置去进食。在这段表演中，角色的步子迈得非常快，描摹了孙玉姣专心致志、心无旁骛的劳动状态，也凸显了她勤劳朴实的人物特点。此外，循着角色的视线，观众甚至能看到赶鸡时，有哪几只鸡一下子就跑远了，又有哪几只总是在角色脚边打转。如此艺术化地在舞台上呈现

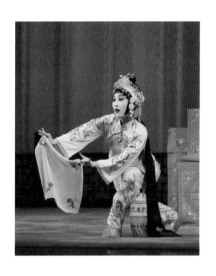

京剧《拾玉镯》，李文文饰孙玉姣（赶鸡）。卢雯 摄

Beijing Opera *The Jade Bracelet*, Li Wenwen as Sun Yujiao (Driving Chickens). Photographed by Lu Wen

生活细节，离不开演员对生活的认真观察、感受与提炼。

As the daughter of a chicken seller, feeding chickens is Sun Yujiao's daily chore. She expertly opened the chickens' coop and shouted "oshi, oshi" while waving her arms to drive the chickens out. She drove the chickens on the left and then on the right, driving the chickens to the designated location to eat. In the performance, the actress moves very fast, depicting Sun Yujiao's concentration and focus on work without interruptions, and highlighting her industrious and simple character features. In addition, the audience can follow the actress's sight line and even see which chickens suddenly run away while being driven, and which ones always circle around the acterss' feet. The artistic presentation of life details on the stage is inseparable from the actress' careful observation, feeling and the rich of daily life.

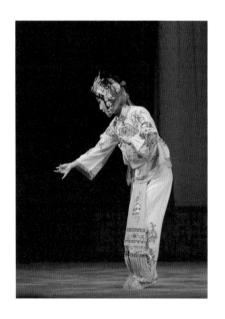

京剧《拾玉镯》，李文文饰孙玉姣（喂鸡）。
卢雯 摄

Beijing Opera *The Jade Bracelet*,
Li Wenwen as Sun Yujiao (FeedingChickens).
Photographed by Lu Wen

（二）喂鸡 Feeding Chickens

将"喂鸡"这样的日常劳作搬上舞台，戏曲演员通常会运用一些细节或"小插曲"来增强戏剧的感染力，提高观众的审美乐趣。"孙玉姣"正是如此。"喂鸡"时，她先是将围裙

里的米一把把地撒在地上，等到围裙里的米还剩最后一点的时候，她索性将围裙往外一抖。没曾想，这"一抖"竟让一粒碎屑飘进了她的左眼，于是她急忙用手绢去擦眼睛，一边擦，还一边忽闪着她的大眼睛。这段"意料之外、情理之中"的细节设计，既丰富了剧情、增加了故事的吸引力，又生动地展现了人物的可爱。

When "feeding chickens", one of the daily tasks, is brought onto the stage, actors of traditional Chinese theater often use stage business and some brief interludes to enhance the appeal of the performance and the aesthetic pleasure of the audience. Sun Yujiao is exactly like

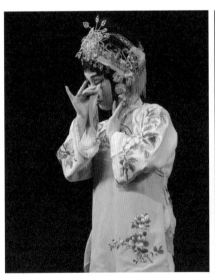 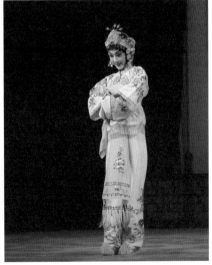

京剧《拾玉镯》，李文文饰孙玉姣。
卢雯 摄
Beijing Opera *The Jade Bracelet*, Li Wenwen as Sun Yujiao.
Photographed by Lu Wen

this. When "feeding chickens", she first scattered the rice from her apron one handful after another on the ground. And when the apron was about to be empty, she simply shook her apron outward. Unexpectedly, this "shaking" caused a piece of debris to float into her left eye. She hurriedly wiped her eyes with a handkerchief, blinking her large eyes as she wiped them. This "unexpected and reasonable" stage business not only enriches the content and plot and increases the story's appeal, but also vividly demonstrates the lovability of the character.

京剧《拾玉镯》，李文文饰孙玉姣（做针线）。
卢雯 摄

Beijing Opera *The Jade Bracelet*, Li Wenwen as Sun Yujiao (Doing Needlework).
Photographed by Lu Wen

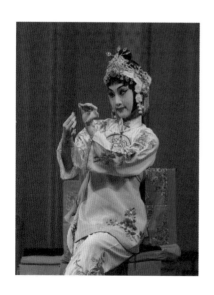

（三）做针线 Doing Needlework

在中国古代，针线活是女性的必备技能，是她们的日常工作。《拾玉镯》将这种生活融入到了艺术表现当中。为了使用方便，古代女子常常将针别在自己的发髻上，戏中的孙玉姣在穿针引线前，也是先从发髻上取针。她先是眼睛向上瞥，同时右手摸针，发现不合适，于是插了回去。接着，她换另一边取针，这次总算合适，便别在了围裙上。为了穿针，孙玉姣用嘴把容易分叉的棉线咬齐、濡湿。穿好后，她又自然地将线对齐，把针别在裤子上。孙玉姣的动作既生活化，又充满美感。

In ancient China, needlework was a necessary skill for women and was their daily work. *The Jade Bracelet* integrates this kind of life into artistic expression. For convenience, ancient women often pinned needles to their hair buns. In the performance, Sun Yujiao also took the needles from her bun. She glanced up first, finding a needle with her right hand, which was inappropriate, so she inserted it back in her bun. Then, she switched sides to take another one, which was finally fitted, and pinned it to her apron. In order to thread the needle, Sun Yujiao bit down and lightly moistened the cotton thread which was easy to fork. After threading the needle, she naturally aligned the thread and pinned the needle to her pants. Sun Yujiao's behaviors are both daily and aesthetically pleasing.

京剧《拾玉镯》，李文文饰孙玉姣（做针线）。

卢雯　摄

Beijing Opera *The Jade Bracelet*, Li Wenwen as Sun Yujiao (Doing Needlework). Photographed by Lu Wen

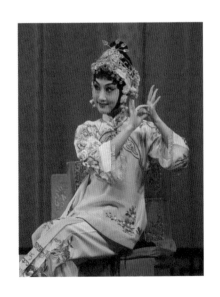

"捻线"同样被表现得活灵活现、惟妙惟肖。孙玉姣一面看着手中的线，一面留意着腿上的针。她先是用手指捻左边的线，再用手心搓，左边的线捻完了再换右边。为了不让线卷到一处，孙玉姣一边抖线，一边用手沾口水去捋线。为了把线捋直，便于缝补，孙玉姣先将线绕在手上，把线绕短，再用牙齿捋线。抖线时，胡琴发出"嘟噜噜"的声音；捋线时，胡琴发出"嗞嗞"的声音；捋线时，胡琴发出"噔噔"的声音。细致的表演与恰当的音乐配合，使这折戏充满生活气息与艺术美。

Twisting thread is also presented vividly. Sun Yujiao looked at the thread in her hand while paying attention to the needle pinned on her pants. She first twisted the left thread with her fingers, then rubbed it with her palm. After twisting the left thread, she began to twist the right thread. In order not to let the threads roll together irregularly, Sun Yujiao shook the threads while rubbing her hand with saliva to smooth them. To straighten the thread and facilitate sewing, Sun Yujiao first wrapped the thread around her hand to shorten it, and then pulled it straight with her teeth. When Sun Yujiao shook the thread, the huqin made a "Dululu" sound. When she stroked the thread, the huqin made a "Zizi" sound. When she pulled the thread straight, the huqin made a "Dengdeng" sound to cooperate with the performance. The precision of the performance and proper music coordination make this play full of life and artistic beauty.

（四）对待生活的态度 Attitude Towards Life

《拾玉镯》运用大量篇幅表现"喂鸡""做针线活"这种看似不起眼的生活片段，主要是为了调动观众的"审美"心理活动。将生活中的行为艺术化地呈现在舞台上具有一定的观赏性。首先，观众可以通过演员的表演感受人物动作的"姿态美"与"韵律美"；其次，观众可以从人物的神态中感受孙玉姣对"琐碎"家务的态度以及由此展现出的对生活的热爱。"生活片段"展现了人物的活泼可爱与热爱生活的"天性之美"，不知不觉间，带领观众进入了舞台世界，与角色共同体悟生活的乐趣。

The Jade Bracelet uses a large amount of performance to display seemingly inconspicuous life scenes such as "feeding chickens" and "doing needlework", to mobilize the audience's aesthetics of psychological intuition. Presenting the performance of everyday life has a certain ornamental value. First, the audience can experience the "posture beauty" and "rhythm beauty" of the characters' movements through their performances. Second, the audience can feel Sun Yujiao's attitude towards trivial household chores and her ardent love for life that she exhibits from her characters. The lively character and her love of life are fully displayed, unconsciously leading the audience into the stage world and experiencing the joy of life with the character.

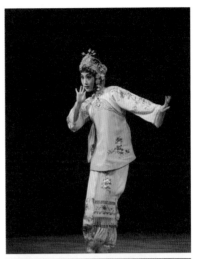

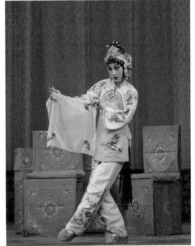

京剧《拾玉镯》，李文文饰孙玉姣。
卢雯 摄

Beijing Opera *The Jade Bracelet*,
Li Wenwen as Sun Yujiao.
Photographed by Lu Wen

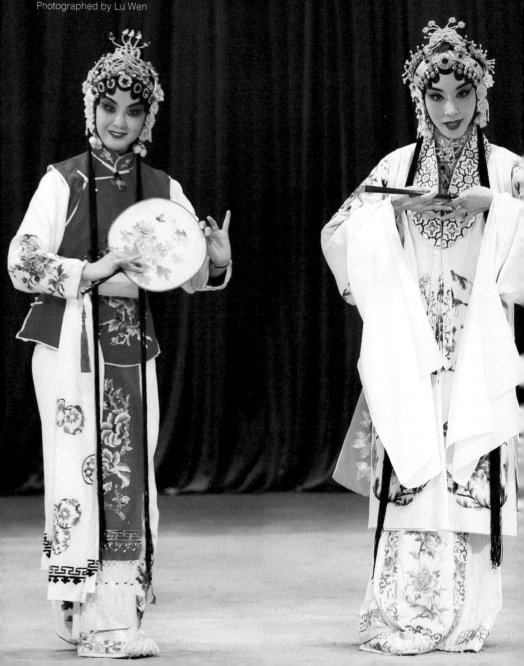

肆

昆曲《牡丹亭·游园》
Kunqu Opera
Peony Pavilion ·
A Stroll in the Garden

剧目简介

Introduction to *A Stroll in the Garden*

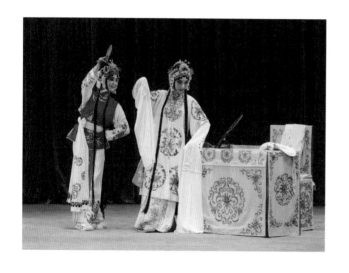

昆曲《游园》，张鑫饰杜丽娘（右），
郜巍饰春香（左）。

卢雯　摄

Kunqu Opera *A Stroll in the Garden*,
Zhang Xin as Du Liniang (right),
Gao Wei as Chunxiang (left).
Photographed by Lu Wen

《游园》是昆曲《牡丹亭》中的一折。《牡丹亭》又名《还魂记》，是明代剧作家汤显祖的代表作，与《紫钗记》《邯郸记》《南柯记》并称为"临川四梦"。该剧创作于 1589 年，被后世誉为中国戏曲史上的浪漫主义杰作。自明代至今，久演不衰，相传明朝有女子看完《牡丹亭》后久久不能释怀，最终郁郁而亡，可见其巨大的感染力。

A Stroll in the Garden is an excerpt from the Kunqu Opera *Peony Pavilion*. The *Peony Pavilion*, also known as *The Record of Returning the Soul*, is a repersentative work of the Ming Dynasty playwright Tang Xianzu. It is known as one of the "Linchuan Four Dreams", the other three are *The Story of Purple Hairpin*, *The Story of Handan* and *The Story of Nanke*. The play was created in 1589 and has been hailed as a masterpiece of romanticism in the history of traditional Chinese theater. Since the Ming Dynasty till present, it has been widely performed. It is said that a woman in the Ming Dynasty was enthralled after watching *The Peony Pavilion* for a very long time, and she eventually died of depression, indicating its enormous appeal.

《牡丹亭》讲的是南安太守杜宝之女杜丽娘的爱情故事。杜丽娘才貌端妍，却长年深居幽闺，跟随迁儒陈最良解读《诗经》。《关雎》之情使得杜小姐自怜不已，于是在丫鬟春香的陪同下第一次来到花园赏花。杜小姐感慨春色无人欣赏时，于梦中见到书生柳梦梅前来求爱，两人在牡丹亭畔幽会。醒来后，杜丽娘怅然若失，一病不起。她在弥留之际要求母亲将自己葬于花园的梅树之下，并嘱咐丫鬟春香将自画像藏于太湖石下。后柳梦梅阴差阳错拾得画像，与杜丽娘再度魂交，并掘墓开棺，杜丽娘起死回生。皇帝感慨于二人的旷世奇缘，排除纠纷，杜、柳二人终成眷属。

The Peony Pavilion tells the love story of Du Liniang, the daughter of Du Bao, the chief governor of Nan'an. Du Liniang is beautiful and talented, but she has lived in a secluded boudoir for many years. She follows the pedantic Chen Zuiliang to interpret *The Book of Songs*. The love of "Guan Ju" made Du Liniang feel so sorry for herself that she came

to the garden to admire flowers for the first time, accompanied by the servant girl Chunxiang. Du Liniang lamented that no one appreciated the spring scenery. And then, in her dream, she saw the scholar Liu Mengmei come and court her. The two of them went on a secret date at the Peony Pavilion. After waking up, Du Liniang felt a bit loss and ill. On her deathbed, she asked her mother to bury her under the prune tree in the garden，and told her maid Chunxiang to hide her portrait under the Taihu Stone by the pavilion. Later, Liu Mengmei picked up the portrait by chance and had an encounter with the soul of Du Liniang. Liu Mengmei dug the tomb and opened the coffin bringing Du Liniang back to life. The emperor was so touched by the extraordinary relationship between the two and ruled out all disputes. Eventually, Du and Liu got married.

《游园》是《牡丹亭》中较为经典的片段，深受观众喜爱。在这一折戏中，杜丽娘借春景自怜，将演唱、动作与人物情感高度结合起来，充分展现了昆曲载歌载舞的特点。

A Stroll in the Garden is a classic segment from *The Peony Pavilion* that the audience deeply loves. In this excerpt, Du Liniang takes advantage of the spring scenery to show herself pity. The actress combined her singing, movements, with character emotions, fully showcasing the characteristics of singing and dancing in Kunqu Opera.

昆曲《游园》，牟元笛饰杜丽娘（左），戴国良饰柳梦梅（右）。

Kunqu Opera *A Stroll in the Garden*, Mou Yuandi as Du Liniang (left), Dai Guoliang as Liu Mengmei (right).

二

人物简介
Character Profile

　　杜丽娘——闺门旦。闺门旦指还未出阁的少女，她们大多受过良好的教育且心思细腻。杜丽娘作为太守之女，自幼受到封建礼教的约束，文静娇羞，但青春少艾，内心不免萌生对爱情的渴望。

Du Liniang plays a Guimen Dan role. Guimen Dan refers to young girls who have not yet married, most of whom are well-educated and attentive. As the daughter of the governor, Du Liniang has been restrained by feudal ethics since childhood. Although she is quiet and shy, she cannot help but develop a desire for love in her youth.

　　春香——花旦，杜丽娘的丫鬟。她活泼聪慧，了解杜丽娘并知晓她的情思，在人物形象上衬托杜丽娘，使舞台表演更加丰满。

Chunxiang plays a Hua Dan role, and she is the maid of Du Liniang. Chunxiang is lively and intelligent. She understands Du Liniang and knows her thoughts. The maid provides an impertant supporting role and reinforces Du's story by providing detail, which makes the feelings and stage performance more fulfilling.

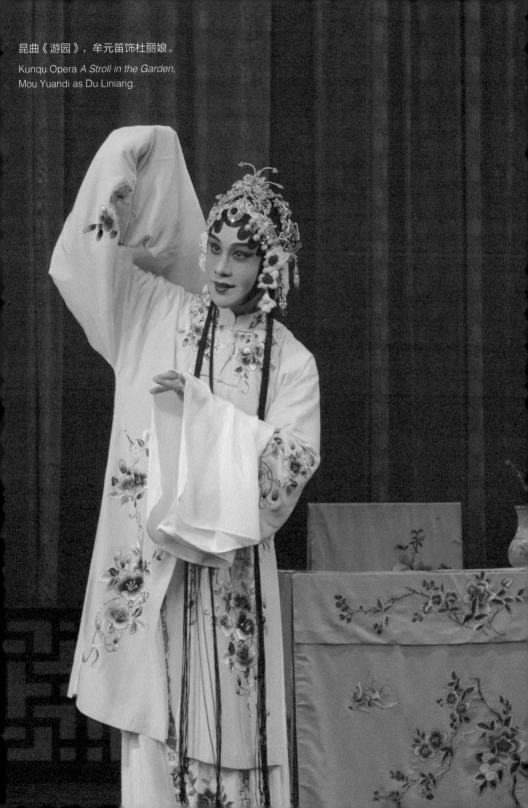

昆曲《游园》，牟元笛饰杜丽娘。

Kunqu Opera *A Stroll in the Garden*,
Mou Yuandi as Du Liniang.

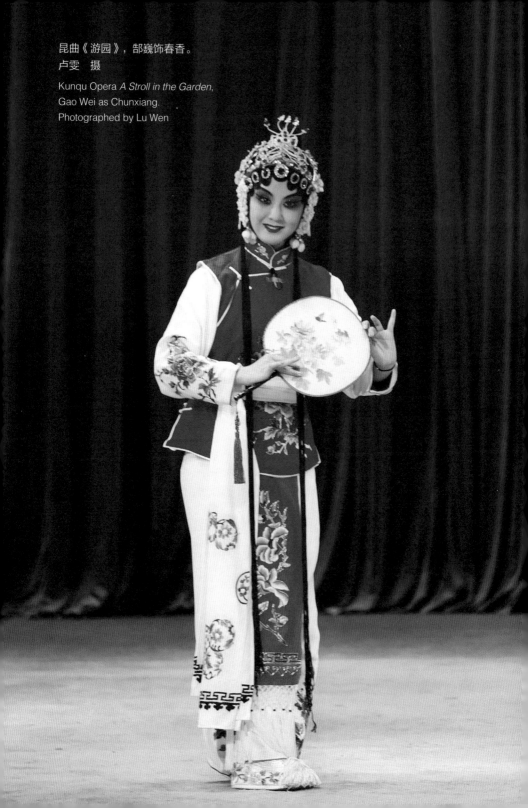

昆曲《游园》，郜巍饰春香。
卢雯 摄

Kunqu Opera *A Stroll in the Garden*,
Gao Wei as Chunxiang.
Photographed by Lu Wen

三

选　段
Selected Scene of *A Stroll in the Garden*

杜丽娘 春香：（合唱）【皂罗袍】

　　原来姹紫嫣红开遍，

　　似这般都付与断井颓垣。

　　良辰美景奈何天，

　　赏心乐事谁家院。

　　朝飞暮卷，云霞翠轩，

　　雨丝风片，烟波画船，

　　锦屏人忒看的韶光贱。

Du Liniang and Chun xiang: (Chorus) [Zaoluopao]

　　Well, flowers in the garden are all blooming with colors.

　　It seems that the beauty like this still turns to devastation.

　　How can we have a good time in this beautiful spring?

　　And who has the pleasure?

　　The clouds fly in and out, and it changes dawn and night, with rosy
　　clouds and pavilions.

　　Rain comes in with the wind. Fog closes in on the boat.

　　Girls in the boudoir could not appreciate the beautiful spring.

四

演出推荐
Performance Recommendation

　　本书推荐两个版本的《游园》供读者欣赏。一个是 1960 年摄制的昆曲《游园惊梦》，该版杜丽娘和春香分别由梅兰芳与言慧珠两位京昆大师饰演，是经典之作。一个是青春版《牡丹亭》，杜丽娘由沈丰英饰演，春香由沈国芳饰演，该版近几年关注度较高。

　　In this book, we recommend two versions of *A Stroll in the Garden* for readers to appreciate. One is a classic and was filmed in 1960, in which Du Liniang and Chunxiang were respectively played by Mei Lanfang and Yan Huizhu, two masters from Beijing Opera and Kunqu Opera. The other is the youth version of *The Peony Pavilion*, in which Du Liniang is played by Shen Fengying and Chunxiang is played by Shen Guofang. This version has received significant attention in recent years.

五

演出赏析
Performance Appreciation

（一）身段表演 Body Performance

载歌载舞是昆曲表演的特点，根据剧情规定，《游园》表演节奏较柔和缓慢，要求演员的动作衔接要流畅，动作与唱词要搭配得当。

Singing and dancing are the characteristics of Kunqu Opera performances. According to the plot regulations, the rhythm of the performance of *A Stroll in the Garden* is relatively gentle and slow, requiring the actress' movements to be smooth and well matched with the lyrics.

杜丽娘一上场，少女娇柔的体态在她第一个伸懒腰的动作中展露无遗，我

昆曲《游园》，牟元笛饰杜丽娘。

Kunqu Opera *A Stroll in the Garden*, Mou Yuandi as Du Liniang.

们能从她身上感觉到一种恰到好处的慵懒。她仿佛就像是一件艺术品，精致而纤细。同时，人物的眼神也传达出她的精神世界。春风拂面，万物都那么柔和、灵动，杜丽娘感受着花园中的春色。在春色的感染下，她眼神略微蒙眬，上身轻微摆动，仿佛徜徉在春色之中，感受着生命萌动的喜悦。杜丽娘的情绪从游园惜春的快乐，渐渐转添了少女浪漫的新愁。

As soon as Du Liniang appears on the stage, the girl's delicacy is fully revealed through her first stretch, and a sense of laziness from her could be catched. She seems like a piece of art work, delicate and slender. At the same time, the character's gaze also conveys her emotional world. The spring breeze is blowing, and everything is so soft and dynamic. Du Liniang feels the beauty of spring in the garden. Under the influence of the beauty of spring, her eyes are slightly dreamy, and her upper body sways slightly, as if she is wandering in spring, feeling the joy of life's sprouting. Du Liniang's mood gradually shifts from the pleasure of enjoying and cherishing the beauty of spring in the garden to the new worry of a young girl's romance.

其次，杜丽娘与春香在动作上有着许多的呼应，两个人的姿态时而整齐划一，时而错落有致，但始终都在流动之中，给人一种势态绵连的美感。通过演员的动作表演，观众形象地感受和了解了人物内心的情感变化。

Besides, Du Liniang and Chunxiang have a lot of echoes in their movements. Their gestures are sometimes neat and uniform, while sometimes are scattered and arranged. Nevertheless, all the movements

are constantly flowing, giving people a continuous feeling of beauty. Through the performance, the audience can vividly experience and understand the emotional changes within the characters.

昆曲《游园》，牟元笛饰杜丽娘（右），陈申越饰春香（左）。
Kunqu Opera *A Stroll in the Garden*, Mou Yuandi as Du Liniang (right), Chen Shenyue as Chunxiang (left).

（二）心灵的描摹 The Tracing of the Mind

由于封建礼教的压迫，杜丽娘从小被约束于闺阁之内，内心十分苦闷。《游园》一折，时值初春，杜丽娘第一次来到自家花园，感受园子中萌动的生命气息，这让她既觉得新鲜又十分高兴。"原来姹紫嫣红开遍"，描述出了花园之内百花盛开的景象，给人一种春色烂漫、

目不暇接的感觉。但是如此美妙的春色却被阻隔于密不透风的围墙之内，少有人来欣赏，只能任凭凋零。杜丽娘由春色联想到自己，难免心中慨叹。

Under the oppression of feudal ethics, Du Liniang had been confined to her boudoir since childhood and was very depressed. In the garden, it was early spring when Du Liniang came to her garden for the first time and felt the breath of life sprouting in the garden, which made her feel fresh and very happy. "Well, flower in the garden are all blooming with colors", which describes the scene of flowers blooming in the garden, giving people a feeling of brilliant spring. But such beautiful spring scenery is blocked by the airtight wall, with few people coming to appreciate it, and can only let it wither. Du Liniang could not help sighing when she was reminded of herself with the spring scenery.

杜丽娘感叹道："良辰美景奈何天，赏心乐事谁家院。""良辰美景""赏心乐事"本来都是美好的事物，但其后"奈何天""谁家院"的出现，就使这些美好的事物都落了空，失去了存在的意义。在这一刻，杜丽娘的自我意识觉醒了，她开始明白什么才是她所向往与憧憬的，但此时的她却无力改变自身的处境，也无法阻止美好年华的流逝，因此心中生出无限感伤。

Du Liniang sighed, "How can we have a good time in this beautiful spring? And who has the pleasure?". "The beautiful spring, the good time and the pleasure" were originally beautiful things, but then the appearance of "how" and "who" made these beautiful things come to nothing and lost the meaning of existence. At this moment, Du Liniang's

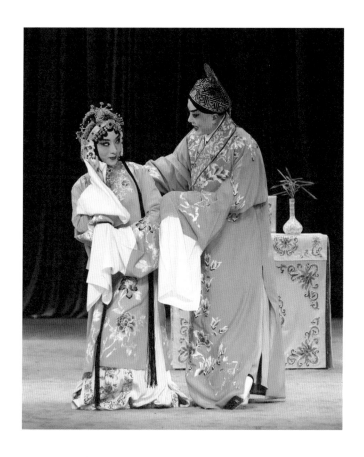

昆曲《惊梦》[1]，张鑫饰杜丽娘（左），杨楠饰柳梦梅（右）。
卢雯　摄

Kunqu Opera *An Interrrupted Dream*[2], Zhang Xin as Du Liniang (left),
Yang Nan as Liu Mengmei (right).
Photographed by Lu Wen

1　《惊梦》是《游园》的下一折，两折戏常常连演，称为《游园惊梦》。

2　*An Interrupted Dream* is the excerpt following *A Stroll in the Garden*, and the two excerpts are often performed in a row known as *A Stroll in the Garden-An Interrupted Dream*.

self-awareness awakened, and she began to realize what she was yearning for. However, at this time, she was unable to change her situation or prevent the passing of good years, so infinite sadness arose in her heart.

（三）灵动的空间 Flexible Space

在传统戏曲中，空间的变化并不依靠舞台布景，而是演员的表演。戏曲强调"移步换景，景随人动"，即通过演员的表演来暗示空间的变化。在《游园》中，杜丽娘梳妆之后，随着春香来到花园门口，这时的舞台上空无一物，但是杜丽娘抬脚的动作，表示她已经跨过门槛，而紧接着的一圈圆场，则表示她已欣赏了园内的风景。两个动作完成了空间的转换，同时未影响表演的流畅性。

In the traditional theater, the changes in space do not depend on the stage setting, but on the performance of actors. Traditional Chinese theater emphasize the concept of "changing scenery with each step, and the scenery move with the people", which means actors use their performance to imply the changes of space. In the *A Stroll in the Garden*, Du Liniang, after dressing up, came to the garden gate with Chunxiang. At this time, there was nothing on the stage, but the movement of raising her foot indicated that she had crossed the threshold. Following that, Du Liniang took a tour around by a circle, which also indicated that she saw the scenery in the garden. Thus, the space transformation was completed without interrupting.

空间与时间是抽象的，戏曲通过这样的手段来体现时空变换，反映出戏曲舞台上对于虚实的认识与处理，是一种独特的智慧。

Space and time are abstract. It is a unique wisdom for traditional Chinese theater that it illustrates the transformation of time and space through such means, reflecting the understanding and handling of reality and virtuality on the stage.

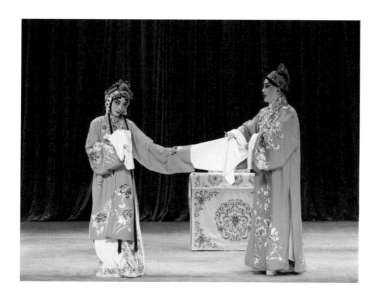

昆曲《惊梦》，张鑫饰杜丽娘（左），
杨楠饰柳梦梅（右）。
卢雯　摄

Kunqu Opera *An Interrupted Dream*,
Zhang Xin as Du Liniang (left),
Yang Nan as Liu Mengmei (right).
Photographed by Lu Wen

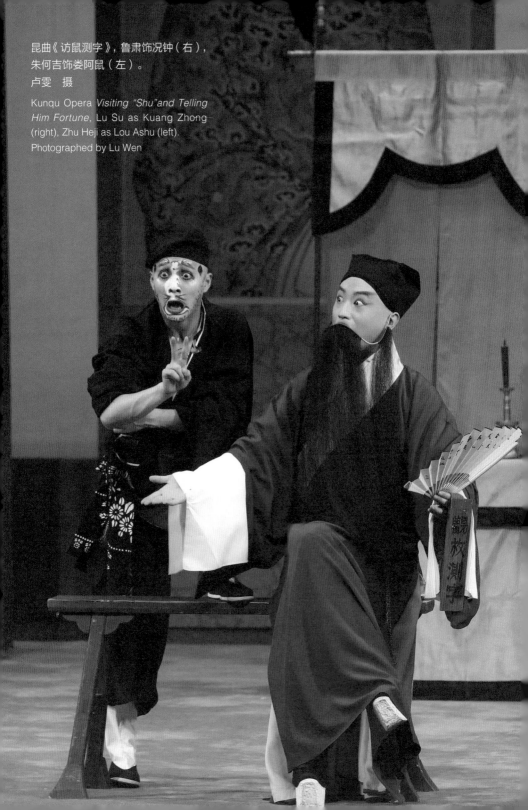

昆曲《访鼠测字》，鲁肃饰况钟（右），
朱何吉饰娄阿鼠（左）。
卢雯 摄

Kunqu Opera *Visiting "Shu" and Telling Him Fortune*, Lu Su as Kuang Zhong (right), Zhu Heji as Lou Ashu (left).
Photographed by Lu Wen

伍

昆曲《十五贯·访鼠测字》

Kunqu Opera

The Fifteen Strings of Coins ·
Visiting "Shu" and Telling Him Fortune

剧目简介

Introduction to *Visiting "Shu" and Telling Him Fortune*

昆曲《访鼠测字》，鲁肃饰况钟（右），朱何吉饰娄阿鼠（左）。
卢雯 摄

Kunqu Opera Visiting "Shu" and Telling Him Fortune, Lu Su as Kuang Zhong (right), Zhu Heji as Lou Ashu (left).
Photographed by Lu Wen

昆曲《十五贯》由清初朱素臣同名传奇《十五贯》（《双熊记》）改编而来。无锡县赌徒娄阿鼠于屠户尤葫芦家中盗得十五贯铜钱被尤发现后，杀人灭口。知县过于执接手此案却未作详查，臆断熊友兰、苏戌娟为杀人凶手，问之死罪。苏州知府况钟奉命监斩，觉察此案疑点重重，遂力求重审，亲至无锡乔装查证，终于查明真凶，昭雪冤案。

The Kunqu Opera *The Fifteen Strings of coins* is adapted from the same name legendary *The Fifteen Strings of Coins* (*Two Bears*) by Zhu Suchen in the early Qing Dynasty. Lou Ashu, a gambler in Wuxi County, who stole fifteen strings of coins from the butcher You Hulu's house. And when he was discovered by You, he killed him. The county magistrate Guo Yuzhi took over the case but did not conduct detailed investigations. He assumed Xiong Youlan and Su Shujuan were murderers and sentenced them to death. Kuang Zhong, the Suzhou magistrate, was ordered to supervise the execution. He realized that the case was full of doubts, so he made every effort to reexamine it and personally went to Wuxi to investigate in disguise. Finally, the true culprit was identified and the unjust case was brought to justice.

昆曲《访鼠测字》，鲁肃饰况钟（右），朱何吉饰娄阿鼠（左）。

卢雯 摄

Kunqu Opera Visiting "Shu" and Telling Him Fortune, Lu Su as Kuang Zhong (right), Zhu Heji as Lou Ashu (left).

Photographed by Lu Wen

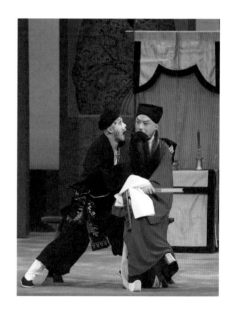

本折讲的是娄阿鼠怕凶案败露逃至无锡乡下，为了打听风声，他到庙中寻人未果，于是求签祈祷。况钟扮作测字先生，假意帮娄占卜，却暗中设下圈套，诈其说出真相，诱其随船同回苏州。

This excerpt is about Lou Ashu, who fled to the countryside of Wuxi

in fear of the murder case being exposed. In order to inquire about the rumbles, he went to the temple to find someone but failed, so he asked for a sign and prayed. Kuang Zhong disguised himself as a fortune teller and pretended to help Lou by making divination, while secretly setting up a trap to deceive him into telling the truth and luring him back to Suzhou with him by boat.

在昆曲历史上,《十五贯》意义重大。由于各种原因,昆曲从清代开始逐步衰落,至 20 世纪 50 年代末,几乎没有昆剧团能正常演出。1956 年 4 月,改编后的新编昆曲《十五贯》晋京演出大获成功,从而使这一门艺术重新进入人们的视野,因此这一出戏被称为"一出戏救活了一个剧种"。

20 世纪 50 年代昆曲《十五贯》电影海报。
The movie poster of Kunqu Opera *Fifteen Strings of Coins* in the 1950s.

In the history of Kunqu Opera, the *Fifteen Strings of Coins* is of great significance. Due to various reasons, Kunqu Opera gradually declined since the Qing Dynasty. By the late 1940s, almost no troupes of Kunqu Opera could normally perform. In April, 1956, the newly adapted Kunqu Opera *The Fifteen Strings of Coins* was performed successfully in Beijing, bringing this art back into people's sight again. Therefore, *The Fifteen Strings of Coins* is known as " the play that has revived a genre of theater".

二

人物简介
Character Profile

娄阿鼠——丑。性情多疑，贪婪狡猾，极其嗜赌成性，终日游手好闲，以诈骗、偷盗为生。

Lou Ashu: plays a Chou role. He is suspicious, greedy and cunning but is extremely addicted to gambling. He idles around doing nothing all day and makes a living by cheating and stealing.

况钟——正生。主要扮演具有刚正气质的中青年男子，现在多由老生应工。况钟担任苏州知府，性格刚正严明，细腻机敏，具有极高的胆识与智慧。历史上确有其人，以刚正清廉著称，其功绩记载于《明史·况钟传》。

Kuang Zhong: plays a Zheng Sheng role. Zheng Sheng mainly plays the role of middle-aged or young men with upright temperament, whom are now mainly played by Lao Sheng. As the Suzhou magistrate, Kuang Zhong is upright, rigorous, delicate and alert, with a high level of courage and wisdom. There is indeed a person in history that is known for being upright and honest. His achievements are recorded in the *Ming History - Kuang Zhong Biography*.

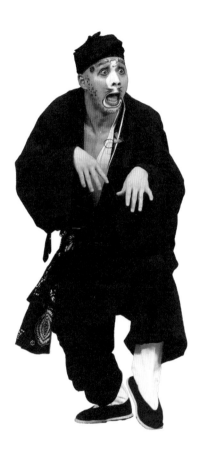

昆曲《访鼠测字》，朱何吉饰娄阿鼠。
卢雯　摄

Kunqu Opera *Visiting "Shu"and Telling Him Fortune*, Zhu Heji as Lou Ashu. Photographed by Lu Wen

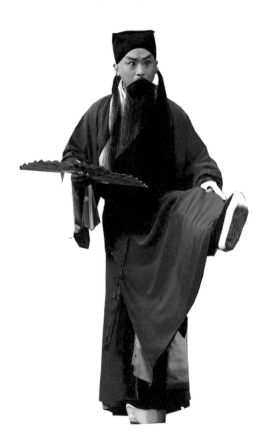

昆曲《访鼠测字》，鲁肃饰况钟。
卢雯　摄

Kunqu Opera *Visiting "Shu" and Telling Him Fortune*, Lu Su as Kuang Zhong. Photographed by Lu Wen

三

选　段

Selected Scene of *Visiting "Shu" and Telling Him Fortune*

况　钟：你测这个字是什么用的？

娄阿鼠：什么用的？官司。

况　钟：哦！官司！

娄阿鼠：轻点！我听得出。

况　钟：你听好。鼠乃一十四画，数目成双，乃属阴爻。这鼠又属阴类，这阴中之阴乃幽晦之象。若占官司，急切还不能明白。

娄阿鼠：这个明白我听说是未曾明白。

况　钟：老兄，你是自己测的，还是代旁人测的？

娄阿鼠：先生，这个字啊，我是代别人测的，代测！代测！

况　钟：嗯，依字理而断只怕不是代测。

娄阿鼠：啊！为什么？

况　钟：喏，鼠乃罪魁祸首。

娄阿鼠：啊！哦，测下去，测下去。

况　钟：鼠乃十二生肖之首，岂不是造祸之端么？依字理而断，一

101

定是偷了人家的东西，才造成这桩祸事来的！老兄，可是吗？

娄阿鼠：好了！好了！你是测字先生，江湖上跑跑，我娄阿鼠，赌场里淘淘。自家人，自家人！你的江湖诀不要用。偷东西也测得出！

况　钟：有个道理在内。

娄阿鼠：什么道理？

况　钟：那老鼠善于偷窃，所以有这样的断法。

娄阿鼠：对啊！这个老鼠喜欢偷东摸西，所以先生你有这样的断法。

况　钟：可是吗？

娄阿鼠：有道理！有道理！

况　钟：还有一说。

娄阿鼠：还有什么说法？

况　钟：偷的那家人家，可是姓尤。

娄阿鼠：啊！和你说江湖诀不要来，怎么又来了！偷东西测得出，连姓也测得出！我不信，我不信！

况　钟：老兄，又有个道理在内。

娄阿鼠：还有什么道理？

况　钟：那老鼠不是最喜偷油么？

娄阿鼠：对啊！老鼠最喜欢偷油。有话说"偷油老鼠，老鼠偷油"。

Kuang Zhong: What is the use of this character's fortune-telling?

Lou Ashu: What is it for? Lawsuit!

Kuang Zhong: Oh! Lawsuit!

Lou Ashu: Keep it down! I can hear it.

Kuang Zhong: Listen carefully. The Chinese character "shu", which means rat has 14 strokes. The number of strokes is in pairs and belongs to Yin. The rat also belongs to Yin. The image of double in Yin is gloomy. If it is used to divine a case, and then the case may not be clear for a while.

Lou Ashu: I heard that this case is still unclear.

Kuang Zhong: Dude, did you test this character for yourself, or for someone else?

Lou Ashu: Sir, this character is tested for someone else! Someone else! Someone else!

Kuang Zhong: Oh, according to the principle of this character, I'm afraid it's not for someone else.

Lou Ashu: Ah! Why?

Kuang Zhong: Here, "shu" is the culprit.

Lou Ashu: Ah! Oh, keep going! Keep going!

Kuang Zhong: The rat is the head of the Chinese zodiac. Isn't it the cause of disaster? Judging by the character, it must have been stealing someone else's belongings that caused this disaster! Dude, am I right?

Lou Ashu: Alright! Alright! You are a fortune teller. In the complicated human world; I, Lou Ashu, am a gambler in the casino. We are all the same. We are all the same. Could you not do these tricks with me? How can stealing things be detected?

Kuang Zhong: It makes sense.

Lou Ashu: What's the point?

Kuang Zhong: The rat is good at stealing, so there is such a ruling.

Lou Ashu: Right! The rat likes to sneak around, so you have such a conclusion.

Kuang Zhong: Am I right?

Lou Ashu: Make sense! Make sense!

Kuang Zhong: One more thing to say.

Lou Ashu: What else?

Kuang Zhong: Is the second name of the stolen family "You[1]"?

Lou Ashu: Ah! I told you never to use your tricks on me. Why did they come again? Even if stealing things can be detected, how can you detect the last name of the stolen family? I don't believe it! I don't believe it!

Kuang Zhong: Dude, it makes sense, too.

Lou Ashu: Again! What's the point?

Kuang Zhong: Isn't the rat most fond of stealing oil?

Lou Ashu: Right! Rats like stealing oil the most. As the saying goes, "Oil-stealing rats and rats steal oil".

1 In chinese,"You" is particularly homophonic with "oil" (油).

四

演出推荐
Performance Recommendation

 本书推荐的《访鼠测字》是 1990 年演出版本。由计镇华扮演的况钟心思缜密且毫不外露，使得娄阿鼠在毫无察觉的情况下一步步走入圈套。演员精准、流畅地展现了况钟过人的机智与巧妙的手段。娄阿鼠由刘异龙扮演。演员通过脸部、肩部的灵活动作表现了娄阿鼠杀人之后的心虚，又刻画出人物的内心层次，真实且活灵活现地呈现出一个油滑、狡诈的人物形象。

The recommended version in this book was performed in 1990. Kuang Zhong, played by Ji Zhenhua, is meticulous and enigmatic, allowing Lou Ashu to gradually step into the trap without noticing it. The actor accurately and fluently showed the extraordinary wit and clever techniques of Kuang Zhong. Lou Ashu is played by Liu Yilong. The actor uses flexibly facial and shoulder movements to portray Lou Ashu's guilty conscience after the murder, depicting the inner world of the character and presenting a slick and cunning character image realistically and vividly.

五

演出赏析
Performance Appreciation

（一）两人的心理博弈 Psychological Battle Between the Two of Them

在《访鼠测字》中，况钟和娄阿鼠两个人的心理变化是比较复杂的。一方面，况钟要隐藏意图，避免多疑的娄阿鼠察觉到自己的真实身份，但又要尽可能地从他口中套取案情真相；另一方面，娄阿鼠既要提防眼前的测字先生，又希望其帮助自己得以从命案中脱身。两人的对手戏是一场精彩的心理战。

In *Visiting "Shu" and Telling Him Fortune*, the psychological changes of Kuang Zhong and Lou Ashu are quite complex. On the one hand, Kuang Zhong must hide his intentions to prevent the suspicious Lou Ashu from realizing his true identity, while trying to extract the truth of the case from Lou Ashu as much as possible. On the other hand, Lou Ashu has to beware of the fortune teller in front of him, while also wanting the fortune teller to help him get out of the murder case. The rivalry between the two presents a wonderful psychological battle.

其实，我们可以看出在这场博弈中况钟已经占据了上风。因为他知道娄阿鼠的心理状态，娄阿鼠对他却全然不了解，甚至根本不认识他。在观赏的过程中，观众在很大程度上也享受着这种全知的掌控感。况钟假装通过测字"算"出了娄阿鼠所隐瞒的实情，实际上却是以案情事实做饵，获得娄阿鼠的信任并套取案情真相。由此我们便看到娄阿鼠是如何自作聪明，却掉进了况钟编织好的罗网中。

In fact, we can see that Kuang Zhong has the upper hand in this game. Because he knew Lou Ashu's mental state, while Lou Ashu didn't understand him, or even know him at all. When watching the performance, the audience also enjoys this omniscient sense of control. Through false fortune telling, Kuang Zhong inferred the truth concealed by Lou Ashu. In fact, he used the facts of the case as bait to gain Lou Ashu's trust and extract the truth of the case. From this, we can see how Lou Ashu pretended to be clever but fell into the net woven by Kuang Zhong.

娄阿鼠与况钟刚见面时，他不时地提防着况钟，而况钟却通过三次测字，准确地"测"出"鼠"偷了尤家的东西造成了祸事，"鼠"就是罪魁祸首。娄阿鼠在三次测字中，心理防线一步步被攻破。作为观众的我们非常清楚事情的来龙去脉，但娄阿鼠的反应依然能够引起我们的兴趣，因为我们关注的不仅是情节的发展，还有角色的心理变化与其所触发的行动。例如，两人第一次在庙中见面，况钟扮作测字先生，夸口能帮人遇难呈祥，逢凶化吉，找人能逢，谋事能成……以此来吸引娄阿鼠的注意，可娄阿鼠正一心门思求签，没有理会他。但

况钟知晓娄阿鼠嗜赌，所以他又强调自己能帮人赌博赢钱，果不其然，娄阿鼠就上钩了。短短的几个来回，娄阿鼠对况钟的态度从拒绝到犹豫，再到主动接近，人物的心理变化层次分明，真实可信。

When Lou Ashu first met with Kuang Zhong, he was always on guard for Kuang Zhong, while Kuang Zhong, through three instances of fortune telling with character "shu (rat)", accurately "said" that "shu (rat)" had stolen something from the family You family and caused a disaster. The "shu (rat)" was the culprit. Lou Ashu's psychological defense was breached step by step in three instances of fortune telling. As the audience, we are very clear about the ins and outs of the process. However, Lou Ashu's reaction can still arouse our interest, because we are concerned not only about the development of the plot, but also about the psychological changes of the characters and the actions arising from them. For example, when the two met in the temple for the first time, Kuang Zhong pretended to be a fortune teller. He boasted that he could help people in many aspects, such as turning danger into auspiciousness, finding people to meet, making things happen successfully, etc. to attract Lou Ashu's attention but Lou Ashu was seeking a sign and ignored him. But Kuang Zhong knew that Lou Ashu was addicted to gambling, so he emphasized that he could help people win money by gambling, and Lou Ashu took the bait unexpectedly. In just a few rounds, Lou Ashu's attitude towards Kuang Zhong changed from rejection to hesitation and then to a proactive approach. The character's psychological changes are distinct and authentic.

（二）丑角的表演 Performance of Chou

娄阿鼠这个角色是一个典型的"恶人"。他贪婪嗜赌，为了钱财入室盗窃、毁人性命。但如何准确刻画这一典型人物，又不使其过于刻板是有一定难度的。

The role of Lou Ashu is a typical "villain". He is greedy and addicted to gambling. He breaks into the house to steal money and commits murder. However, it is difficult to portray this typical character vividly without making it too rigid.

昆曲《十五贯》的表演是细腻的，演员通过抓住程式化表演的细节，将一个生动的娄阿鼠呈现在我们面前。戏一开场，我们就能看到娄阿鼠多疑的一面。他看似悠闲地走在街上，两只手却紧紧地抱在一起；当突然出现一阵声响时，他便立马停住脚步，战战兢兢地回头观望，样子活像一只胆小的老鼠；等被拨浪鼓吓得跳起来之后，他又努力掩饰自己内心的惊慌，装出镇定的样子。这些程式化的细节表演生动展现了娄阿鼠的阴险狡诈。

The performance of Kunqu Opera *The Fifteen Strings of Coins* is delicate, and the actor captures the details of the performance through stylized performances, presenting a vivid Lou Ashu. From the beginning of the play, we can see Lou Ashu's suspicious side. He seemed to be walking leisurely on the street, but his hands were tightly held together. When he suddenly heard a sound, he immediately stopped and looked back cautiously, looking like a timid rat. After being frightened by the

rattle, he still tried to conceal his inner panic and pretended to be calm. These of stylized performances details vividly demonstrate Lou Ashu's cunning.

　　在测字的过程中，演员以夸张的动作呈现了娄阿鼠大起大落的心境。当况钟测出遇害人姓"尤"时，娄阿鼠内心深藏的秘密顿时被揭露出来，吓得仰身后翻，一下子从椅子上摔了下去，但他马上又从椅子下钻了出来，一系列动作将他心虚却又极力掩饰的情状表现得淋漓尽致；当况钟将娄阿鼠搀扶着坐下后，娄阿鼠将右手伸进衣服中，不停地鼓动衣服，仿佛他的心脏正在剧烈地跳动。这样夸张的手法呼应了娄阿鼠的"惊魂未定"。演员利用丰富的表演细节，成功展示了娄阿鼠的惊魂未定与欲盖弥彰。

During the process of fortune telling, the actor presented Lou Ashu's mood ups and downs with exaggerated movements. When Kuang Zhong detected that the victim's surname was "You", the secret hidden in Lou Ashu's heart was revealed, causing him to roll back and fall off the chair. However, he immediately crawled out of the chair again, and a series of movements fully expressed his feelings of guilt but tried to conceal them. When Kuang Zhong helped Lou Ashu to sit down, Lou Ashu put his right hand into his clothes and kept stirring as if his heart was beating fiercely. This exaggerated way of performance echoes Lou Ashu's "suffering from shock". The actor utilized rich performance details to successfully showcase Lou Ashu's restlessness and desire to cover up.

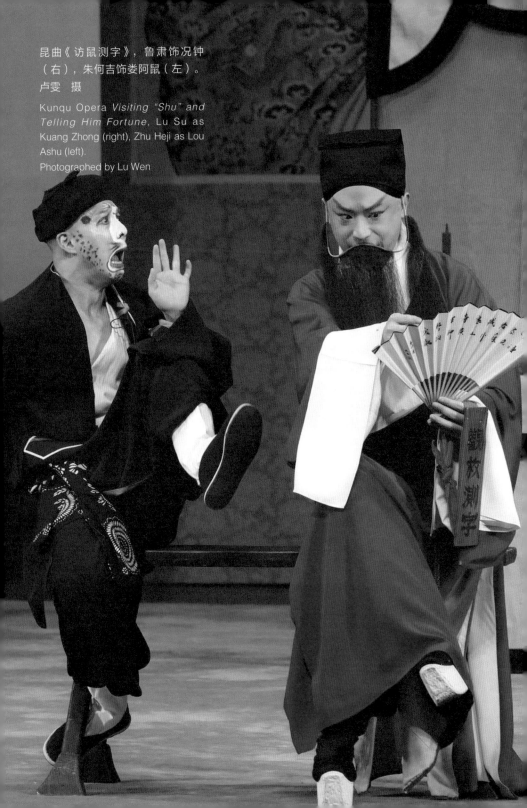

昆曲《访鼠测字》，鲁肃饰况钟
（右），朱何吉饰娄阿鼠（左）。
卢雯 摄

Kunqu Opera *Visiting "Shu" and Telling Him Fortune*, Lu Su as Kuang Zhong (right), Zhu Heji as Lou Ashu (left).
Photographed by Lu Wen

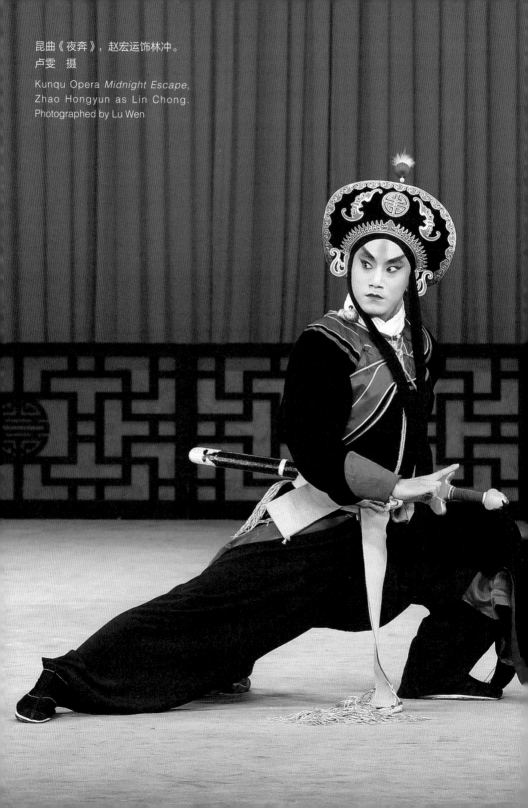

昆曲《夜奔》，赵宏运饰林冲。
卢雯 摄

Kunqu Opera *Midnight Escape*,
Zhao Hongyun as Lin Chong.
Photographed by Lu Wen

陆

昆曲《宝剑记·夜奔》
Kunqu Opera
A Precious Sword ·
Midnight Escape

一

剧目简介
Introduction to *Midnight Escape*

昆曲《夜奔》，赵宏运饰林冲。
卢雯 摄

Kunqu Opera *Midnight Escape*, Zhao Hongyun as Lin Chong.
Photographed by Lu Wen

《夜奔》全名《林冲夜奔》，出自明代李开先传奇剧本《宝剑记》。宋徽宗时期，禁军教头林冲因朝廷腐败，直言上谏，得罪权臣高俅，受其陷害，被流放沧州看管草料场。为置其于死地，高俅命陆谦等人纵火焚烧草料。无奈之下，林冲杀死陆谦等人，投靠柴进，并在其推介下，夜奔梁山。

The full title of *Midnight Escape* is *Midnight Escape of Lin Chong*, which comes from the Ming play of *A Precious Sword* by Li Kaixian in the Ming Dynasty. During the reign of Emperor Huizong in the Song Dynasty, Lin Chong, the leader of the imperial guards, handed in a report exposing the corruption of some high-

ranking officials openly in the court, offending the powerful minister Gao Qiu. Gao Qiu framed up him and exiled him to Cangzhou to take care of the grasslands. To put him to death, Gao Qiu ordered Lu Qian and others to set fire on the grasslands. Helplessly, Lin Chong killed Lu Qian and others. Afterwards, Lin Chong had to join Chai Jin and run to the Liangshan Mountain at night under Chai's recommendation.

《夜奔》是昆曲中传统的小生戏，也是昆曲演出中最重要、最受欢迎的折子戏之一。小生戏在京剧中归属于武生戏。受京剧影响，昆曲也出现以武生应工的情况。京剧《夜奔》为昆曲的改编之作，剧情有所丰富，表演上沿袭昆曲特色。

Midnight Escape is a traditional Xiao Sheng play in Kunqu Opera and also one of the most important and popular excerpts. Xiao Sheng play belongs to Wu Sheng play in Beijing Opera. Influenced by Beijing Opera, Lin Chong in Kunqu Opera *Midnight*

昆曲《夜奔》，贾喆饰林冲。
贾喆提供

Kunqu Opera *Midnight Escape*, Jia Zhe as Lin Chong.
Provided by Jia Zhe

Escape is sometimes performed by Wu Sheng. The Beijing Opera *Midnight Escape* is an adaptation of Kunqu Opera, which has a rich plot and follows the characteristics of Kunqu Opera in performance.

昆曲《夜奔》这场戏要求演员从头到尾边唱边做，其中许多唱段的高音部分更需要演员配合剧烈的动作一起完成，对演员的基本功和体力要求较高。因此中国戏曲界素来剧情有"男怕《夜奔》，女怕《思凡》"一说。同时京剧《夜奔》也因其技术全面，表演难度大，成为每一位京剧武生必学的剧目。

Kunqu Opera *Midnight Escape* requires actors to sing and act from beginning to the end, and many of the high-pitched parts of the aria require actors to cooperate with intense movements. The performance of Kunqu Opera *Midnight Escape* requires high levels of basic skills and physical strength. Therefore, there has always been a saying in the Chinese theater industry that "Actors are afraid of *Midnight Escape*, while actresses are afraid of *Thinking of the World*". Meanwhile, the Beijing Opera *Midnight Escape* has increased its number of performances, it has also become a must-learn play for every Beijing Opera Wu Sheng due to its comprehensive technical skills and high difficulty in performing.

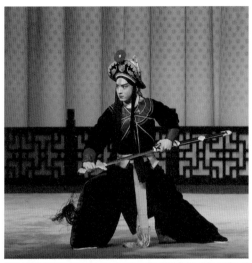

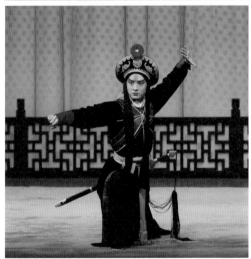

京剧《夜奔》，郝帅饰林冲。
卢雯　摄

Beijing Opera *Midnight Escape*,
Hao Shuai as Lin Chong.
Photographed by Lu Wen

二

人物简介
Character Profile

林冲——武生。林冲虽然与《三岔口》中任堂惠同属一个行当，但差别明显。林冲是一个悲剧人物，他同情下层人民，为人正直却屡次受到奸臣陷害。《夜奔》中逃往梁山寻求庇护的林冲，心中积郁着英雄末路的悲凉。

Lin Chong: plays a Wu Sheng role. Although Lin Chong and Ren Tanghui in *Cross Roads* are both Wu Sheng, there is a clear difference between the two. Lin Chong is a tragic figure who sympathizes with the lower class and is upright but has repeatedly been framed by treacherous officials. In *Midnight Escape*, Lin Chong, who fled to Liangshan Mountain to seek refuge, was filled with the sadness of the hopeless hero ended in his heart.

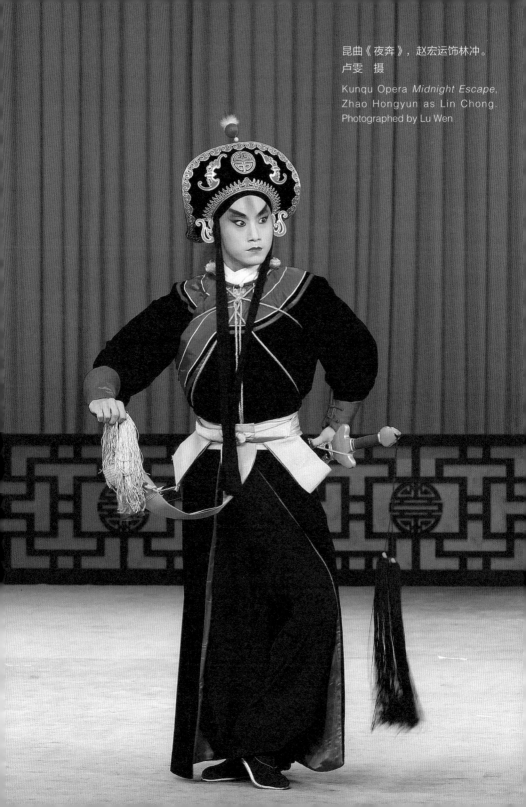

三

选 段

Selected Scene of *Midnight Escape*

林冲：（唱）【双调·新水令】

按龙泉血泪洒征袍，

恨天涯一身流落。

专心投水浒，

回首望天朝。

急走忙逃，

顾不得忠和孝。

【驻马听】

凉夜迢迢，凉夜迢迢，

投宿——

（接唱）休将门户敲。

遥瞻残月，暗渡重关，

急走荒郊。

俺的身轻不惮路迢遥，

心忙又恐怕人惊觉。

吓！

（接唱）吓得咱魄散魂消，魄散魂消，

红尘误了五陵年少。

Lin Chong: (Singing) [Shuang Diao: Xin Shui Ling]

My blood and tears covered my armor.

With too much regret and hatred, I fled alone.

Then I was determined to go to the Liangshan Mountain,

Looking back to the capital,

With my hurried escape, I lost my chance for loyalty and filiality.

[Zhu Ma Ting]

It is a long, long night.

Finding accommodation——

(Continued Singing) How could I knock on unknown doors?

With a waning moon hung in the sky faraway, I passed by many places.

I walked alone in the wild,

Not afraid of the long road ahead.

But I feared that somebody might find me.

Ah!

(Continued Singing) I was so terrified, terrified!

Those events had taken away my best time.

四

演出推荐
Performance Recommendation

　　本书推荐的视频为《CCTV 空中剧院》栏目 2020 年播出版本。演出单位：上海京剧院。赵宏运饰演林冲，高峰饰演徐宁，孙伟饰演杜迁，吴宝饰演宋万。该版动作造型规范，且画面清晰。

The recommended video in this book is the 2020 broadcast version of the *CCTV Air Theater* column, performed by the Shanghai Jingju Theater Company. Zhao Hongyun plays Lin Chong, Gao Feng plays Xu Ning, Sun Wei plays Du Qian, and Wu Bao plays Song Wan. This version has standardized action styling and clear graphics.

五

演出赏析
Performance Appreciation

（一）紧张气氛的营造 Creating a Tense Atmosphere

《夜奔》节奏鲜明，从开头的念白到最后一支曲牌【点绛唇】，层层递进的节奏变化凸显出林冲夜奔梁山时的紧迫形势和英雄末路的复杂心情。

The rhythm of *Midnight Escape* is distinct. From the beginning of the recitation to the last piece of the tune [Dianjiang Chun], the gradual changes in rhythm highlight the urgent situation and the complex emotions of Lin Chong when he escaped to the Liangshan Mountain and thought he was at his wit's end.

林冲刚出场时，锣鼓用慢撕边[1]打起，烘托出逃跑时的紧张气氛。林冲不时环顾四周，提防是否有追兵，同时又要保持英雄的威严，因此他的上身要拎直，头摆动的幅度不能太大，尤其是他的眼神一定要

1　慢撕边：以鼓签轮流、连续敲击单皮鼓形成的一种鼓点。在此处用于烘托紧张的气氛。

昆曲《夜奔》, 赵宏运饰林冲。
卢雯 摄

Kunqu Opera *Midnight Escape*, Zhao Hongyun as
Lin Chong.
Photographed by Lu Wen

"凝"住, 要始终跟着"云手"[1] 走。警惕又威严的神情精准地描画了林冲所处环境的危险, 以及他内心的剧烈波动。

When Lin Chong first appeared, the gongs and drums were played with "Slow Tearing Edges"[2] to highlight the tense atmosphere during his escape. From time to time, Lin Chong looked around to see if there were pursuers while maintaining the dignity of a hero. Therefore, his upper body should be lifted straight, and his head should not swing too much. In particular, his eyes must be "frozen" and always follow the "cloud hand"[3]. The vigilant and majestic expression accurately depicted the danger of Lin Chong's environment and the intense fluctuations in his heart.

1　云手: 一种程式动作, 因双手相交旋转似中国画中画云的笔法而得名, 主要用于表现人物的神韵, 无具体含义。

2　Slow Tearing Edge: It is a type of drumbeat formed by rotating and continuously hitting single skin drums with drum tags. It is used here to highlight the tense atmosphere during the escape.

3　Cloud Hand: It is a program action named after the brush technique in Chinese painting where his hands intersect and rotate, mainly used to express the charm of characters, without specific meaning.

戏曲人物上场时，通常是正面亮相，直接传达人物的神态。但在个别京剧流派的演出版本中，林冲是背对着观众，一边看着后台的方向，一边缓缓后退着出场。这样的出场方式，能调动观众的观赏热情。当林冲屏气凝神，警惕地眺望着黑压压的远方时，沿着他的目光，观众仿佛看到了远处追兵的身影，听到了草丛中的响动，瞬间走进了这位英雄的内心世界。因此，在《夜奔》的演出中，背对着观众出场，也是营造紧张氛围的一种手段。

When the traditional theater characters appear on the stage, they usually appear directly to convey their demeanor. But in some versions of Beijing Opera *Midnight Escape*, Lin Chong appeared with his back facing the audience, looking towards the direction of the backstage, and slowly retreated to the stage. This type of appearance can stimulate the audience's enthusiasm. As Lin Chong held his breath and gazed warily into the dark distance, the audience along with his gaze seemed to see the silhouettes of the pursuers in the distance, hear the sound in the grass, and instantly enter the inner world of the hero. Therefore, in the performance of *Midnight Escape*, it is also a means of creating a tense atmosphere by having a backward appearance.

（二）表演形式 Performance Form

昆曲《夜奔》具有载歌载舞的特点。唱腔与身段动作的融合，带来了良好的观剧体验。与音乐剧中唱、舞并重的一些剧目类似，具有很高的观赏性。

The Kunqu Opera *Midnight Escape* has the characteristics of singing and dancing. The integration of singing style and body movements makes watching it a good experience. Like some plays in musicals, the Kunqu Opera *Midnight Escape* emphasizes both singing and dancing, having a high level of ornamental value.

与节奏比较自由的散板曲¹不同，【折桂令】是上板曲，一板三眼，节奏鲜明，而且板眼一定要唱准。这段是《夜奔》的中心唱段，此段要求演员一句一个动作，甚至是一个字一个动作，集中体现了昆曲载歌载舞的特点。比如，唱到"脱扣苍鹰"时的"脱"字时，演员同时抬起左腿，做射雁式²。【折桂令】这段非常有难度，《夜奔》演出是否成功很大程度上取决于这一段。

Unlike the relatively freer rhythm of the Sanban tune[3], [Zhegui Ling] is a Shangban tune with one strong beat and three weak beats. Its rhythm is distinct, and the strong and weak beats must be sung accurately. This is the central aria of *Midnight Escape*, which requires actors to perform one movement per sentence, or even one action per word, highlighting the characteristics of Kunqu Opera's singing and dancing. For instance, when singing the first word of "release the eagle", the actor simultaneously raises his left leg and performs a shooting wild geese pose[4]. The scene [Zhegui Ling] is very difficult, and the success of the performance of *Midnight Escape* largely depends on it.

唱词中"似这鬓发焦灼，行李萧条"中的"焦灼"形容很急躁，"行

1　散板曲：音乐术语，指一种速度缓慢、节奏不规则的音乐。

2　射雁式：一种程式动作。

3　Sanban tune: a musical term that refers to music with a slow and irregular pace.

4　Shooting Geese: A program movement.

昆曲《夜奔》，赵宏运饰林冲。
卢雯　摄

Kunqu Opera *Midnight Escape*, Zhao Hongyun as
Lin Chong.
Photographed by Lu Wen

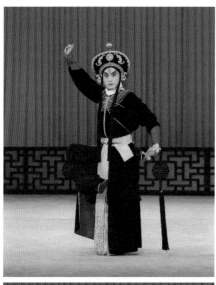

京剧《挑滑车》中的"射雁式"，
郝帅饰高宠。
卢雯　摄

Beijing Opera *Thrusting Over a
Pulley*, Hao Shuai as Gao Qiu
(Shooting Geese).
Photographed by Lu Wen

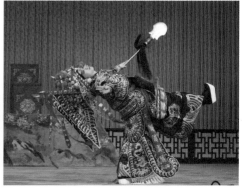

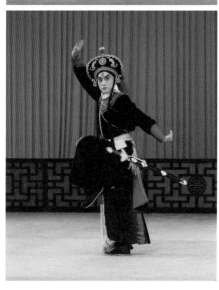

李"则指的是落叶的乔木，这里是说林冲的心情万分焦急。看到周围满眼的凄凉景象，他不禁联想到自己的处境。

The words "burning" and "sluggish" in the lyrics "as if the hair on the temples was burning and the deciduous trees were sluggish" describe Lin Chong's impatience and his mood as extremely anxious. Moreover, he can't help but think of his own situation when he sees the desolate scenery around him.

当唱到"此一去博得个斗转天回"时，演员用三四个转身形容北斗星转动。"斗"指北斗，"斗转天回"是命运转变之意，北斗的柄转向东边，表示春天就要到了，暗指林冲遭遇的黑暗即将过去，希望就在眼前。紧接着念"高俅"的时候，演员的声音要掷地有声，同时踢腿、亮相。这里的动作要干脆有力，以凸显林冲嫉恶如仇的性格。

When singing "I am going to fight for the Dou Zhuan Tian Hui", the actor used three or four turns to describe the rotation of the Big Dipper. "Dou" refers to the Big Dipper. "Dou Zhuan Tian Hui" means a change in fate. The handle of the Big Dipper turns to the east, indicating that spring is coming and implying that the darkness Lin Chong has encountered is passing by. The hope is right in front of him. When reciting "Gao Qiu", the actor's voice should be strong and powerful, while kicking and making an appearance. The movements here need to be straightforward and powerful to highlight Lin Chong's hatred for evil.

林冲决心扭转命运，有所作为。于是接唱【雁儿落带得胜令】。演员要唱出林冲的恋乡和义愤难平。同时双手上下移动作波浪状。林冲虽然惦念家人，但如果不能自救，则根本无法照料家人，更谈不上

报答母亲的养育之恩。林冲在感叹之下做出了一系列高踢腿和翻身的动作，贴切地传达了"叹英雄气怎消"的人物情绪。

However, Lin Chong was determined to turn the wheel of fate and make a difference. Then the songs "Yan Er Luo" and "De Sheng Ling" came, and these two songs shows Lin Chong's indignation and his reluctance to leave his hometown. His hands were making wave-like movements. Although he missed his family, he couldn't look after them if he couldn't save himself, not to mention repaying his mother's upbringing. Lin Chong sighed and did some high kicks and rolling movements, aptly conveying the character's emotions of "sighing over a hero".

（三）英雄的苦楚 The Sufferings of the Hero

《夜奔》的价值不仅在于高难度的表演，还在于细致地刻画了林冲复杂的内心世界。在刻画人物方面，《夜奔》是武戏中少有的巅峰之作。

The value of *Midnight Escape* lies not only in its difficult performance but also in its meticulous portrayal of Lin Chong's complex inner world. In terms of portraying the character, *Midnight Escape* is one of the few pinnacle works in martial arts plays.

在唱【双调·新水令】的"按龙泉血泪洒征袍"一句时，林冲拔出宝剑。宝剑是荣誉的象征。回想曾经威风凛凛，再到如今连夜奔逃，林冲的心里产生了巨大的落差，他愤愤地又将宝剑收回剑鞘之中。

As Lin Chong sang the line "My blood and tears covered my armor" in [Shuang Diao: Xin Shui Ling], he pulled out his sword. The sword is a symbol of his honor. He recalled his once majestic demeanor, but now he is fleeing overnight, causing a huge gap in Lin Chong's heart. He angrily puts his sword back into its scabbard.

"恨天涯，一身流落"，是林冲孤身出逃，流落他乡的写照。唱"专心投水浒"时，演员望着汴梁的方向，一步一步倒退着走向梁山；"回首望天朝"是林冲对过去的眷恋，对朝廷的不舍。这段表演集中凸显林冲被逼上梁山的矛盾心情。

"With too much regret and hatred, I fled away alone" is a portrayal of

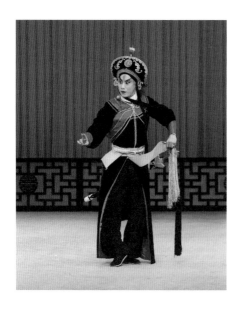

昆曲《夜奔》，赵宏运饰林冲。
卢雯　摄
Kunqu Opera *Midnight Escape*, Zhao Hongyun as Lin Chong. Photographed by Lu Wen

Lin Chong's solitary escape and exile. When singing "Then I am determined to go for the Liangshan Mountain", the actor looks towards the direction of Bianliang and walks backwards to Liangshan mountain step by step; "Looking back to the capital" shows Li Chong's attachment to the past and his reluctance to the imperial court. This part of the performance highlights Lin Chong's conflicting emotions when he is forced to go to the Liangshan Mountain.

当唱最后一句"急走忙逃，顾不得忠和孝"时，双手弹泪，脚下蹉步亮相，是昆曲的特色。"凉夜迢迢，凉夜迢迢，投宿休将他门户敲。"意思是"漫漫长夜，我不敢敲门投宿，因为没人敢留我住宿"。这也象征着林冲至今为止依然没有找到自己的归宿，内心非常孤独。

When singing the last line "With my hurried escape, I lost my chance

昆曲《夜奔》，赵宏运饰林冲。
卢雯　摄

Kunqu Opera *Midnight Escape*, Zhao Hongyun as Lin Chong.
Photographed by Lu Wen

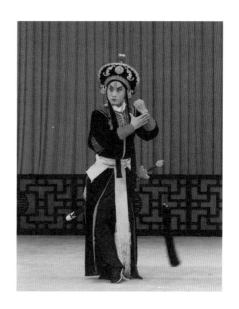

for loyalty and filiality", it is a characteristic of Kunqu Opera to flick tears with both hands and step on the feet. "It is a long, long night. How can I knock on unknown doors?" It means it's a long night, and I dare not knock at the door to stay because no one dares to stay with me. It also symbolizes that Lin Chong has not yet found his destination and he is very lonely.

"残月"表面说月亮，实则暗指林冲不能和家人团圆的悲惨境遇。"俺的身轻不惮路途遥"是孤身一人不怕路途遥远的意思。这段写林冲从八十万禁军教头沦落成逃犯的心酸遭遇，暗含他已割舍世间羁绊，不怕世间任何艰险。

Although the word "waning moon" superficially refers to the moon, in reality, it implies the tragic situation of Lin Chong, who is unable to reunite with his family. "Not afraid of the long road ahead" means Lin Chong is not afraid of the long journey alone. This part depicts Lin Chong's heartbreaking experience of becoming a fugitive from the leader of the Royal Guard with 800 thousand imperial guards, implying that he has abandoned the shackles of the world and is not afraid of any difficulties or dangers in the world.

《夜奔》以【煞尾】结束，第一句"一宵儿奔走荒郊，穷性命定把你奸臣扫"，前面要唱出林冲熬过一夜的精疲力尽，后面又要显出他因梁山近在眼前的高涨情绪。本戏最后的"赶上前去"更是铿锵有力，引起人们对林冲复仇的期待情绪。

Midnight Escape ends with the scene [Sha Wei]. The first line is "Running in the wilderness all night, use my reputation to take the treacherous officials down". At the beginning, it is necessary to sing about Lin Chong's exhaustion through the night. At the same time, it is necessary to highlight his high spirits due to the proximity of the Liangshan Mountain. At the end of the play, "catching up" is even more forceful, people looking forward to Lin Chong's revenge.

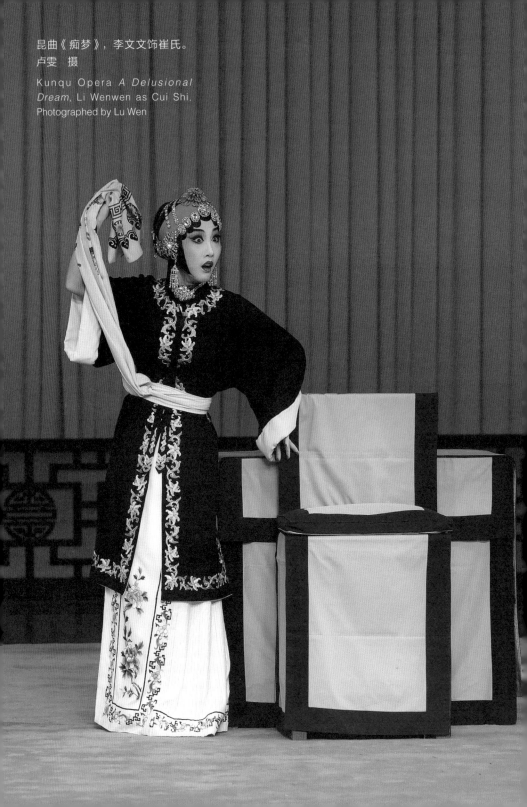

柒

昆曲《烂柯山·痴梦》
Kunqu Opera
Lanke Mountain·
A Delusional Dream

一

剧目简介
Introduction to *A Delusional Dream*

昆曲《痴梦》改编自明代无名氏所撰写的传奇《烂柯山》。《烂柯山》整本已失传，仅存《痴梦》《泼水》两折。经后人整合编排，遂成大戏《烂柯山》，又称《朱买臣休妻》。这出戏讲的是朱买臣与其妻崔氏的故事。会稽书生朱买臣家徒四壁、无米可炊，其妻崔氏不甘于穷苦生活，逼其写下休书，遂改嫁木匠张西乔。休妻后朱买臣发奋苦读，得中状元，衣锦荣归。崔氏恳求破镜重圆，叩于朱买臣马前，但朱买臣泼水于地，寓意覆水难收，最终崔氏羞愧自尽。

The Kunqu Opera, *A Delusional Dream*, is adapted from the play *Lanke Mountain* written by an anonymous author in the Ming Dynasty. The entire play has been lost, with only two excerpts remaining: *A Delusional Dream* and *Splashing Water*. After being rewritten and rehearsed by later generations, it became a famous play called *Lanke Mountain*, also known as *Zhu Maichen's Divorce*. This play tells the story of Zhu Maichen and his wife, Cui Shi. In Kuaiji, a scholar named Zhu Maichen had a humble family, even with no rice to cook. His wife, Cui Shi, was unwilling to live in poverty and forced him to write a divorce

letter so that she could marry the carpenter Zhang Xiqiao. After divorcing with his wife, Zhu Maichen studied hard and became the Number One Scholar. He returned home in wealth and glory. Cui Shi begged to reunite with him, kowtowing to Zhu Maichen in front of his horse. However, Zhu Maichen splashed water on the ground, symbolizing that it was difficult to recover. In the end, Cui Shi was ashamed and committed suicide.

《痴梦》一出重在叙述崔氏改嫁张木匠后的生活。改嫁后，崔氏发现张木匠是个无赖之徒，便不愿与其继续度日，于是逃至媒婆家中暂住。一日，崔氏得知朱买臣官拜太守，即将荣归故里，心情十分复杂。不知不觉坠入梦境，梦中朱买臣派随从送来凤冠霞帔，意欲和好，崔氏大悦。不料此时张木匠手持利斧闯了进来，崔氏猛从梦中惊醒，心中怅然若失。

The main focus of *A Delusional Dream* is on Cui Shi's life after she married Carpenter Zhang. After remarriage, Cui Shi discovered that Carpenter Zhang was a rogue and refused to continue living with him. Therefore, she fled to the matchmaker's house for a temporary stay. One day, Cui Shi learned that Zhu Maichen was about to return in glory to his hometown, with mixed feelings. Unconsciously, Cui Shi fell into a dream in which Zhu Maichen sent his attendants to bring a phoenix coronet and robes of rank (Traditional Chinese Women's Wedding Clothes), intending to reconcile with her. Cui Shi was exceptionally pleased. Unexpectedly, Carpenter Zhang rushed in with a sharp axe, and Cui Shi suddenly woke up from her dream, feeling a sense of loss.

二

人物简介
Character Profile

　　崔氏——正旦。正旦是旦行中最主要的一门行当，因所扮演的角色多出身贫苦，故常穿黑色服装，中国旧时常把黑色称为青色，因而又名青衣、青衫。崔氏出生于寻常人家，十六岁时嫁与朱买臣，度过了二十几年的贫穷生活，最后因实在无法忍受没有希望的日子，才逼迫朱买臣写下休书。不料改嫁张木匠半年后，虽然物质生活有所改善，但是夫妻感情并不融洽，张木匠更是对她殴打辱骂，使她不得不离家出走。因为身边没有一个可以依靠的人，于是暂住在当初唆使她逼迫朱买臣写休书的媒婆王妈妈家中。

Cui Shi: plays a Zheng Dan role. Zheng Dan is the most important profession in the Dan industry. Because most of the characters they play come from poor families, they often wear black clothing. In ancient China, black was often referred to as cyan; hence it was also known as Qing Yi or Qing Shan (Yi and Shan mean costume). Cui Shi was born into an ordinary family and married Zhu Maichen at the age of sixteen. She lived in poverty for over twenty years, but finally forced Zhu Maichen to write

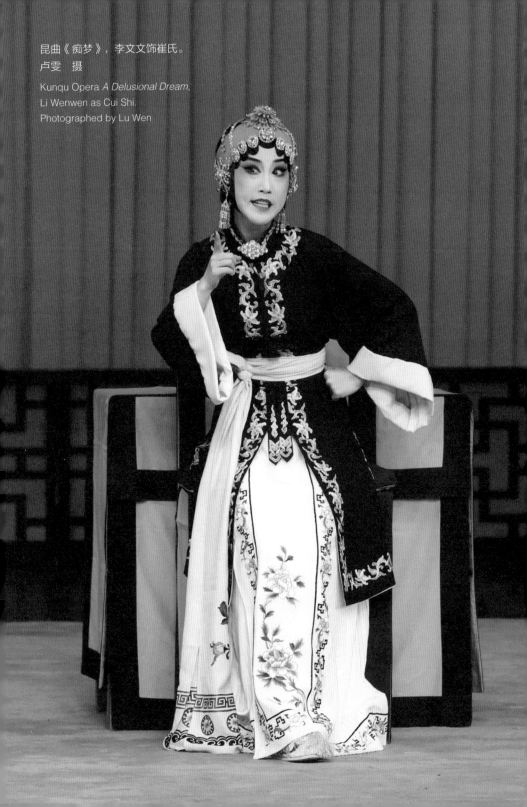

昆曲《痴梦》，李文文饰崔氏。
卢雯 摄

Kunqu Opera *A Delusional Dream*,
Li Wenwen as Cui Shi.
Photographed by Lu Wen

a divorce letter because she couldn't bear the hopeless days anymore. Unexpectedly, half a year after marrying Carpenter Zhang, although her material life was improved, the relationship between she and Zhang was not harmonious. Carpenter Zhang even beat and insulted her, so she had to flee home. Because there was no one to rely on around her, she temporarily stayed at the home of Wang Mama, who had instigated her to force Zhu Maichen to write the divorce letter.

三

选　段
Selected Scene of *A Delusional Dream*

院公：我们奉了朱老爷之命，特来迎接夫人上任的。

崔氏：哦，你们奉了朱老爷之命。特来迎接我上任的。

院公：正是。

崔氏：真个？

衙役：真个。

崔氏：果……果然？

衙役：果然。

衙婆：现有凤冠霞帔在此。

崔氏：咦，咦……哈哈哈。（对着凤冠）

崔氏：嗯，嗯……哈哈哈。（对着霞帔）

崔氏：我好喜也！（唱）【锦中拍】这的是令人喜悦做甚等铺设。

众人：（接唱）我们奉恩官命特来打叠，小人们不劳言谢。

院公：戴了凤冠。

崔氏：（接唱）哎呀妙呀。这凤冠似白雪哪些辨别。啊呀呀，有趣呀，一片片金铺翠贴。

众人：（接唱）一桩桩交还尽也，绣幕香车在门外迎接。

崔氏：（接唱）啊呀朱买臣哪！越叫人着疼热。

张木匠：杀……杀……杀唔个背夫逃走的臭花娘。

崔氏：（唱）【锦后拍】只见他手持斧怕些些，怎不叫人袖遮遮。

张木匠：臭花娘，唔想逃脱哉。身上著仔红红绿绿的衣裳，快点脱下来。

崔氏：（接唱）吓得人来半截。待我脱呀。我只得急忙脱卸。无徒家有什么豪杰。苦切切将身拦阻。

张木匠：杀……杀……

崔氏：住了，你是杀不得他们的呀！

张木匠：为啥杀勿得？

崔氏：你若杀了他们是……喏喏喏……

【众人下。】

崔氏：（接唱）有一个官儿来捉你癫头鳖。

张木匠：杀杀杀，我杀你个臭花娘。

【张木匠下。】

【崔氏梦醒。】

崔氏：喂，从人们。无徒去了。你们快取凤冠来，霞帔来，来呀，哈哈哈哈……呀。霞帔，原来是一场大梦。（唱）【尾声】津津冷汗流不歇，塌伏着枕边出血，崔氏啊崔氏。只有破壁残灯零碎月。

Head of the Yamen Servants: Ordered by Master Zhu, we are here to welcome you, Madam, back to reunite with Master Zhu.

Cui Shi: Oh, you have been ordered by Master Zhu. You are here to welcome me back.

Head of the Yamen Servants: Exactly.

Cui Shi: Really?

Yamen Servant: Really.

Cui Shi: Sure?

Yamen Servant: Sure.

Female Yamen Servant: Here are the Phoenix coronet and robes of rank[1].

Cui Shi: Eh, Eh...Hahaha. (In front of the Phoenix coronet)

Cui Shi: Hmm, um...Hahaha. (Facing the robes of rank)

Cui Shi: I'm so happy! (Singing) [Jin Zhong Pai] It's really delightful that you came and picked me up. You didn't have to prepare the phoenix coronet and the robes of rank.

ALL Servants: (Singing) We are ordered by the Master Zhu to do so, and it is our pleasure.

Head of the Yamen Servants: Please put on the phoenix coronet.

Cui Shi: (Singing) Ah! Wonderful! How can I tell the white beads on this phoenix coronet from the snow? Ah, ah, ah! Interesting! The phoenix coronet is covered with pieces of gold and jade.

All Servants: (Singing) Now everything has been given to you one by one, and the fragrant sedan chair with embroidered curtains

1 The phoenix coronet and robes of rank: traditional Chinese women's wedding clothes. The phoenix coronet is a headdress, and robes of rank are a garment.

is waiting outside to carry you home.

Cui Shi: (Singing) Ah, I'm fond of Zhu Maichen more and more.

Carpenter Zhang: Kill you! Kill you! Kill you! Cui Shi, you are a stinky woman, having an affair with another man and fleeing your husband.

Cui Shi: (Singing) [Jin Hou Pai] At the sight of him holding an axe, I covered my face with my sleeve out of fear.

Carpenter Zhang: (Speaking) Stinky woman! You cannot get rid of me. Take off your red and green clothes immediately.

Cui Shi: (Singing) I'm scared to death. He asks me to take off my wedding clothes, so I have to take them off in a hurry. Carpenter Zhang is a rogue, and I can only painstakingly use my body to stop him from killing the Yamen servants.

Carpenter Zhang: Kill you! Kill you! Kill you!

Cui Shi: Stop! You can't kill them.

Carpenter Zhang: Why can't I?

Cui Shi: If you kill them, you will...

(All Servants get off the stage.)

Cui Shi: (Singing) You are a mangy turtle. There is an official coming to catch you.

Carpenter Zhang: Kill you! Kill you! Kill you! You are a stinky woman. I will kill you.

(Carpenter Zhang gets off the stage.)

(Cui Shi wakes up from the dream.)

Cui Shi: Hello, servants. The rogue has left. You, quickly bring me the phoenix coronet and the robes of rank. Hurry up! Hahahaha... Ah! It's just a big dream. (Singing) [Ending] Bits of cold sweat keepflowing. Lying on my pillow feebly, I am weeping with bloody tears. Cui Shi, Cui Shi, you only have broken walls and lamps as well as the waning moon.

昆曲《痴梦》，李文文饰崔氏。
卢雯 摄

Kunqu Opera *A Delusional Dream*, Li Wenwen as Cui Shi.
Photographed by Lu Wen

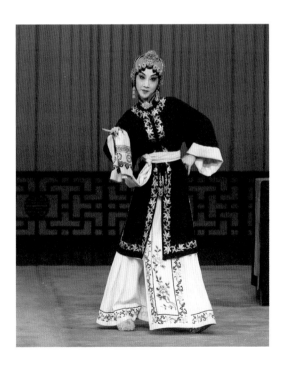

四

演出推荐
Performance Recommendation

　　本书推荐的视频为 2004 年江苏省昆剧院的演出版本。张继青饰演崔氏。张继青的代表作有《烂柯山》中的《痴梦》与《牡丹亭》中的《惊梦》《寻梦》，人称"张三梦"。

The recommended video in this book is performed by Jiangsu Kunju Theater in 2004. Zhang Jiqing plays Cui Shi. Zhang Jiqing's representative works include *A Delusional Dream* in *Lanke Mountain*, *An Amazing Dream* and *A Seeking Dream* in *Peony Pavilion*. She is known as "Zhang Sanmeng (three dreams in Chinese)".

五

演出赏析
Performance Appreciation

（一）笑 Laughs

　　《痴梦》的"痴"描述的不仅是崔氏在得知朱买臣做官后的情态，更点明了她期盼与朱买臣破镜重圆是痴心、是妄想。在本折戏中，崔氏的"痴"是通过几次昆曲笑声来体现的。一般来说，旦角应该笑不露齿，体现含蓄之美。但崔氏是昆曲中的特殊人物，正旦中的特例，她性格刚强，敢逼迫朱买臣休了自己。因此演员选择用适当夸张的方式来表现崔氏的性格特征，于是我们看到了开口放声狂笑的正旦崔氏。正是这些笑，将崔氏的"痴"刻画得淋漓尽致。

　　The "delusion" in *A Delusional Dream* not only describes Cui Shi's demeanor after learning that Zhu Maichen had become an official, but also highlights her obsession and delusion in hoping to reunite with Zhu Maichen. In this excerpt, Cui Shi's "delusion" is reflected through several laughs. Generally speaking, Dan characters should smile without showing their teeth, reflecting the beauty of implication. But Cui Shi is a unique character in Kunqu Opera, a special case in Zheng Dan. She

has a strong personality, so she dared to force Zhu Maichen to divorce her. Therefore, the actress performed with appropriate exaggeration to express the personality traits of Cui Shi, that was why we saw the actress laughed wildly. It is these laughs that vividly depict Cui Shi's "delusion".

得知朱买臣做官后，崔氏第一次笑。她不禁幻想如果当初没有逼迫朱买臣休妻，她现在已经荣升太守夫人了。她嘴上说着："崔氏啊！崔氏！你当初若没有这节事做出来嘛，方才那报喜的到来，何等欢喜，何等快活！"接着又装模作样地端起玉带[1]，迈了几下官步模仿官夫人的样子。学着学着她得意地笑了出来。紧接着一边加大动作的幅度，一边唱"这夫人么，稳稳是我做的"，做足了官夫人的派头。这是第一次笑，也是她一厢情愿的笑。此时，她觉得喜讯是属于她的。

After learning that Zhu Maichen had become an official, Cui Shi laughed for the first time. She couldn't help but imagine that if she had not forced Zhu Maichen to divorce her, she would have been an official's wife. She spoke, "Cui Shi! Cui Shi! If you hadn't done this, how happy and joyful you would have been at the news!" Then she pretended to hold up the jade belt[2] and took a few official steps, imitating the appearance of an official's wife. After imitating, she laughed proudly, while increasing the amplitude of the movements. She sang, "This official's wife, is certainly me", and maintained her official demeanor. This is her first and only wishful laugh. At this point, she felt that the good news belonged to her.

1　玉带：一种用以区分官员官位的腰带，在此处可看作身份的象征。

2　Jade belt: It is a belt used to distinguish official positions and can be seen as a symbol of status here.

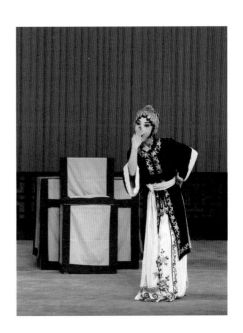

转念间，崔氏又想到是自己逼迫朱买臣休妻，抛下了本属于她的荣华富贵，于是又痛苦起来。这里的痛苦是由之前的笑来作衬托的。

But in a blink of an eye, Cui Shi remembered that she had forced Zhu Maichen to divorce her, leaving her glory and wealth behind, so she began to suffer again. The pain here is set off by the previous laugh.

崔氏梦见朱买臣派人接她回家，并送来凤冠霞帔时，开心地狂笑起来。之后，她一个转身，又发出一阵笑声。前面的笑是反复确认后，期待得到满足的大笑。后面的笑是细细咂摸后，自顾自回味的窃笑。正是这些不同意味的笑成功塑造了崔氏的可怜形象。

When Cui Shi dreamed that Zhu Maichen had sent his attendants to pick her up and bring her a phoenix coronet and robes of rank, she burst into a wild laugh with joy. Afterwards, she turned around and let out another burst of laughter. The previous laugh was the one that the expectation was satisfied after repeated confirmation. The second one was a snicker that lingered on after a careful smack. It is precisely these different meanings of laughter that have successfully shaped the pitiful image of Cui Shi.

（二）梦境的营造 The Creation of Dreaming World

本折戏主要描述的是崔氏梦到自己做官夫人的情境。既然是梦，如何才能让观众意识到角色此时是在做梦呢？其他艺术舞台可能会采取灯光、布景变换等方式区分现实与梦境，但在中国传统戏曲舞台上，通常是依靠演员的表演来区分两者。虽然表现手法看似简单，但是演员精湛的表演足以以假乱真。从崔氏入睡的那一刻起，演员便带领观众一起由现实进入了梦境。

This excerpt mainly describes the scene where Cui Shi dreams of becoming an official's wife. Since it is a dream, how can we make the audience realize that the character is dreaming at this moment? On other art stages, actors may rely on lighting, scenery changes, and other methods to help the audience distinguish the reality from dreams. But in traditional Chinese theater, the distinction between the reality and dreams is usually based on the performance of actors. Although the technique seems relatively simple, the exceptional performance of actors can make the fake real. From the moment Cui Shi fell asleep, the actress led the audience from the reality to a dreaming world immediately.

崔氏睡着后，台上响起二更，随后一段古筝音乐缓缓飘来，缥缈的梦幻感被烘托了出来。梦境中，院公、衙婆带着众皂隶，踏着缓慢的步子上场。院公要用气"托"住声音往外送，让叫门声"有气无力"，既不能声音太轻令人听不清，又不能声音太响打破梦幻感。敲门的动作也要带动上身缓缓而动，呈现出一种敲而不实的感觉。动作、声音都在营造梦的气氛。

After Cui Shi fell asleep, a second watch sounded on the stage, and then a piece of guzheng music slowly floated in, highlighting the ethereal, dreamlike feeling. In the dream, the Yamen servants, walked slowly onto the stage. The Yuangong, the head of the servants, should use his breath to "hold" his voice and send it out, making the knocking-door sound "weak". The sound should not be inaudible or too loud to break the illusion. The action of knocking on the door should also cause the upper body to move slowly, creating an unreal feeling of the knocking. The actions and sounds are all creating a dreamy atmosphere.

听到叫门声，崔氏从桌子后面走了出来，她将脚高提轻放，仿佛在慢镜头下踩棉花一般。她想去开门，步子却怎么也迈不开，只能在桌子边原地踏步。这里演员借鉴了做梦时的生活体验：梦中越是想走动，就越是难以迈开步子。此外，梦中崔氏在面对众人时并未看他们的脸，而是将目光落在他们的脚上。这同样也来源于生活经验，因为人在梦中总是看不清别人的脸，往下看会显得更为合理。如果盯着对方的脸看就与现实中没什么差别了。这两处细节完美地营造了梦境的"真实"感。

昆曲《痴梦》，李文文饰崔氏。
卢雯　摄

Kunqu Opera *A Delusional Dream*, Li Wenwen as Cui Shi.
Photographed by Lu Wen

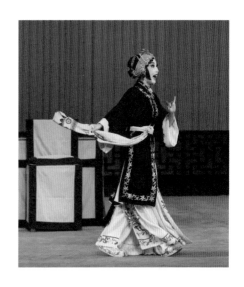

Hearing the call at the door, Cui Shi walked out from the table. She lifted her feet high and put them down gently, as if stepping on cotton in slow motion. She wanted to open the door, but couldn't take a step and could only stand still by the table. Here the actress' performance is based on the life experience of dreaming: the more you want to move in your dream, the harder it is to move forward. In addition, Cui Shi did not look at their faces when facing the crowd in the dream but instead set her sight on their feet. This also comes from life experience because people always can't see other people's faces clearly in their dreams and it seems more reasonable to look down on others' feet. So, if the actress stares at other person's feet, it is no different from the reality. These two performing details perfectly create a "real" dream feeling.

（三）现代视角 Modern Perspective

"雌大面"是昆曲正旦的别称，指的是正旦的端庄贞烈，不可侵犯，与唱腔的阳刚喷薄。《痴梦》中崔氏的人物特征突出地体现了"雌大面"的特色，故演员在表演、唱念上运用了比较夸张的方式。

"Ci (Female) Damian" is a nickname for zheng Dan in Kunqu Opera, referring to the Dan character with dignified, virtuous, inviolable and masculine singing style. The characteristics of Cui Shi in *A Delusional Dream* prominently reflect the characteristic of "Ci (Female) Damian", using exaggerated methods in the actress' performance and singing.

端庄、忠贞、隐忍是一般正旦的特征，也是男权社会对女性的要求与定义，因此崔氏的"虚荣"无可避免地使她成为众矢之的，她被

认为是个嫌贫爱富、不配拥有温饱生活，更不配回到前夫身边的坏女人。久而久之，人们对崔氏的看法也多趋于负面。事实上，在中国古代，已婚女子的生存状态完全取决于丈夫，她们没有独立的社会地位。

Dignity, loyalty and forbearance, the requirements and definitions of women in the patriarchal society, are the characteristics of ordinary Zheng Dan. Therefore, Cui Shi's "vanity" inevitably makes her a target of public criticism. She is considered an evil woman who dislikes the poor and loves the rich, is unworthy of having a subsistence life or even doesn't deserve to return to her ex-husband. For a long time, people's views of Cui Shi have tended to be negative. In fact, the living conditions of married women depended entirely on their husbands, and they had no independent social status in ancient China.

在现代观众看来，崔氏随朱买臣受穷二十余年，已到了不堪忍受的地步，她谋求改嫁只为温饱，这是她的不得已。从现代视角出发，张继青重新刻画了崔氏的人物形象，打破了历史的偏见，使崔氏更加生动立体、有血有肉，这也是她获得成功的主要原因之一。《烂柯山》对崔氏的坎坷经历和痛苦心理作出的真实描写，成为张继青塑造崔氏的依据。怀着对崔氏命运的同情和悲悯，张继青在创造人物的过程中剔除了丑化崔氏的表演，在传统程式动作中填充了自己对生活的体验。她的表演深刻地揭示了社会造成崔氏痛苦的真相，真实地剖析了崔氏矛盾的心理与卑微的灵魂。观众在此触动下能够重新客观地理解崔氏这一戏曲人物。

In the eyes of modern audiences, Cui Shi had been poor with Zhu Maichen for over 20 years, and it had reached an unbearable level. She sought to remarry only for food and clothing, which was her last resort. From a modern perspective, Zhang Jiqing re-portrayed the character of Cui Shi, breaking the historical prejudice and making Cui Shi more vivid, three-dimensional and flesh-and-blood. This is also one of the main reasons for Zhang Jiqing's success. The true description of Cui Shi's bumpy experience and painful psychology in *Lanke Mountain* has become the basis for Zhang Jiqing's portrayal of Cui Shi. With sympathy and compassion for Cui Shi's destiny, Zhang Jiqing eliminated the performance that vilified Cui Shi in the process of creating the character and filled it with Zhang Jiqing's own experience of life in traditional stylized action. Zhang Jiqing's performance deeply revealed the truth that the society indeed caused Cui Shi's suffering while truly analyzing Cui Shi's contradictory psychology and humble soul. Under this touch, the audience could re-recognize the characteristics of Cui Shi.

同一个作品在不同的时代，会产生不同的回音。张继青并没有将关注点放在崔氏是婚姻的背叛者这一传统层面上，她关注的是一个人最基本的尊严——吃饱穿暖。这部作品的变化，使我们可以一窥新时代的风貌。

The same work will produce different reflections in different eras. Zhang Jiqing did not focus on the traditional level of Cui Shi's betrayal of marriage. She focused on a person's most basic dignity–having enough to eat and wearing warm clothes. The changes in this work provide us with a glimpse of the new era.

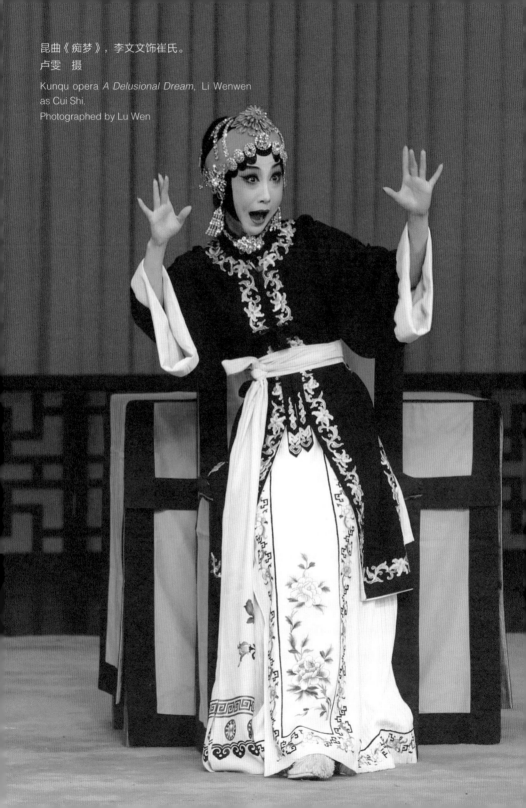

京剧《断桥》，熊明霞饰白素贞
（中），金喜全饰许仙（左），
毕玺玺饰小青（右）。
卢雯　摄

Beijing Opera *Broken Bridge*,
Xiong Mingxia as Bai Suzhen
(center), Jin Xiquan as Xu Xian
(left), Bi Xixi as Xiao Qing (right).
Photographed by Lu Wen

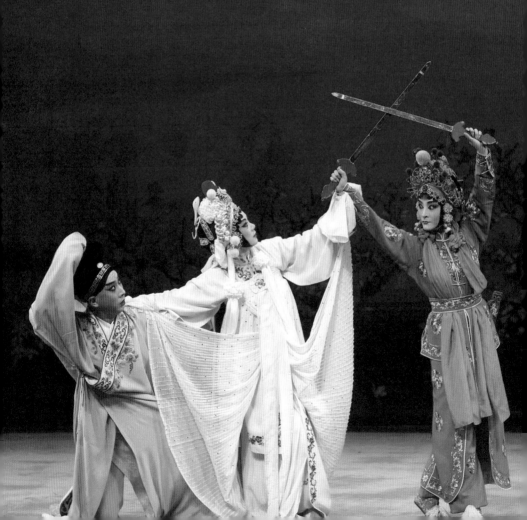

捌

京剧《白蛇传·断桥》

Beijing Opera

Legend of the White Snake ·

Broken Bridge

剧目简介
Introduction to *Broken Bridge*

京剧《断桥》，熊明霞饰白素贞（右），毕玺玺饰小青（左）。
卢雯 摄

Beijing Opera *Broken Bridge*, Xiong Mingxia as Bai Suzhen (right), Bi Xixi as Xiao Qing (left). Photographed by Lu Wen

民间故事《白蛇传》在中国家喻户晓，讲的是白素贞与许仙之间的爱情。峨眉山上的两位蛇仙——白素贞与小青在游西湖时，经同舟、借伞与许仙相识。白素贞对许仙起了爱慕之心，并与之结为夫妻。金山寺僧人法海闻知此事，执意阻挠。他诓许仙劝白素贞饮下雄黄酒，不料白素贞酒后显出原形，吓

死了许仙。为了救活许仙，白赴仙山，历经万难盗得灵芝。此后许仙上金山寺还愿，却被法海强行扣留。白素贞与小青追至金山，求法海放了许仙，却遭到法海的拒绝，白素贞一怒之下，水漫金山。

京剧《断桥》，熊明霞饰白素贞（中），金喜全饰许仙（左），毕玺玺饰小青（右）。
卢雯 摄

Beijing Opera *Broken Bridge*, Xiong Mingxia as Bai Suzhen (center), Jin Xiquan as Xu Xian (left), Bi Xixi as Xiao Qing (right).
Photographed by Lu Wen

The *Legend of the White Snake* is a well-known Chinese folk love story between Bai Suzhen and Xu Xian. Two snake immortals on Mount Emei, Bai Suzhen and Xiao Qing, struck up an acquaintance with Xu Xian by sharing a boat and borrowing an umbrella from him during the visit to the West lake. Bai Suzhen fell in love with Xu Xian and married him. When Fa Hai, a monk at the Jinshan Temple, learned about this, he insisted on obstructing the marriage. He tricked Xu Xian into persuading Bai Suzhen to drink realgar wine. After drinking, Bai Suzhen showed her true form, which scared Xu Xian to death. In order to revive Xu Xian, Bai Suzhen went through countless hardships to steal the glossy ganoderma on the Spirit Mountain. Afterwards, Xu Xian went to Jinshan Temple to fulfill his wish, but was forcibly detained by Fa Hai. Bai Suzhen and Xiao Qing raced to Jinshan Temple and begged Fa Hai to release Xu Xian, but Fa Hai rejected them. In a fit of anger, Bai Suzhen flooded the Jinshan Temple.

《断桥》一折讲的是白素贞与法海斗法之后的故事。白素贞斗法失败后来到杭州。许仙在小沙弥的帮助下，逃出金山，来到杭州，追至断桥的与白素贞相遇，却被怒不可遏的小青拦住，险些丧命。最终，许仙受白素贞真情所感，认错谢罪，获得了白素贞与小青的谅解，三人重归于好。

Broken Bridge tells the story after the battle of Bai Suzhen and Fa Hai. After flooding the Jinshan Temple, Bai Suzhen failed the fight and came to Hangzhou. With the help of the little monk, Xu Xian escaped from Jinshan and also came to Hangzhou. Xu Xian looked for Bai Suzhen and met her on the Broken Bridge, but he was stopped by Xiao Qing, who was furious and almost killed Xu Xian. In the end, Xu Xian was

deeply moved by Bai Suzhen's true feelings for him and confessed his mistake. He gained an understanding of Bai Suzhen and Xiao Qing, and they reconciled with each other.

京剧《断桥》是《白蛇传》的高潮所在，最富有戏剧性，是人物情感在长期积累后的一次爆发。该折戏因为广受欢迎，经常单独演出。

The Beijing Opera *Broken Bridge* is the climax of *Legend of the White Snake*, which is the most dramatic and an explosion of the characters' emotions after long-term accumulation. Due to its popularity, this part of the play is often performed separate.

"断桥"位于杭州西湖，虽然名叫断桥，桥却未断，而其名称的由来有两种说法，一说是因为孤山之路到此而断，一说是段桥（"段家桥"简称）的谐音。今天，因为《白蛇传》，断桥已成为中国人心中的爱情圣地。

The Broken Bridge is located over the West Lake, Hangzhou. Although it is called "Broken Bridge", the bridge remains unbroken. There are two explanations for its name. One is that the road to the Gushan Mountain was broken here; the other is a homophonic term for "Duanjia Family Bridge". Today, due to the *Legend of the White Snake*, the "Broken Bridge" has become a holy land of love in the hearts of Chinese people.

<center>

二

人物简介
Character Profile

</center>

　　白素贞——花衫[1]。花衫是 20 世纪 20 年代以后，综合青衣、花旦、刀马旦的艺术特点发展而成的新的旦角类型。白素贞原为一条修炼千年的白蛇，她化为人形，来到人间游玩，后与许仙结为夫妇。婚后与许仙共同经营药铺，悬壶济世。白素贞的身上汇集了"善良、宽容、无私"等诸多美德，是理想的人物，是真善美的化身。

　　Bai Suzhen: plays a Hua Shan[2] role. Hua Shan is a new type of Dan developed after the 1920s, combining the artistic characteristics of Qing Yi, Hua Dan and Daoma Dan. Bai Suzhen was originally a white

1　京剧"新的花衫"行当创始人王瑶卿为了丰富旦角的表演艺术，充实艺术表现能力，所以提出融和青衣沉静端庄的风格、花旦活泼灵巧的表演、刀马旦的武打工架，创作出一种唱、念、做、打并重的旦角行当，人们把它命名为花衫（花旦和青衫的结合）。

2　In order to enrich the performance art of Dan characters and enhance their artistic expression abilities, Wang Yaoqing, the founder of the new "Hua Shan"charater industry in Beijing Opera proposed a combination of the calm and dignified style of Qing Yi, the lively and agile performance of Hua Dan, and the martial arts style of Daoma Dan. He created a Dan character industry that emphasizes singing, reciting, acting, and performing equally. People named it Hua Shan (a combination of Hua Dan and Qing Shan).

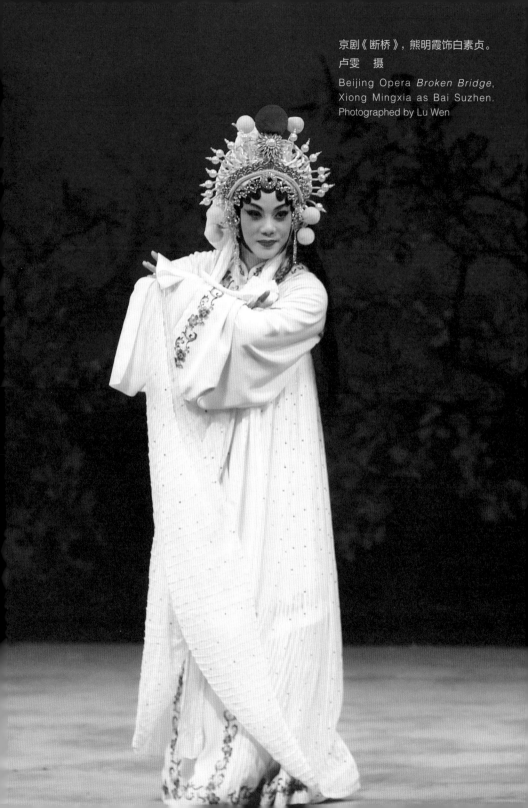

snake who had practiced for thousands of years. She transformed into a human and came to the human world to play. Later, she married Xu Xian. After their marriage, they jointly operated a pharmacy to treat patients. Bai Suzhen embodies many virtues, such as kindness, tolerance, and selflessness, making her an ideal figure and an embodiment of truth, goodness, and beauty.

许仙——小生。小生指的是年轻男性角色，多为清秀、英俊的青年形象。许仙原为一名药铺伙计，他既有朴实、善良的一面，也有缺乏主见、软弱无能、容易轻信他人的一面。

Xu Xian: plays a Xiao Shen role. Xiao Sheng refers to young male characters, often portrayed as young and handsome figures. Xu Xian was originally a pharmacy clerk. On the one hand, he is simple and kind; on the other hand, he lacks judgment and is doubtful and gullible.

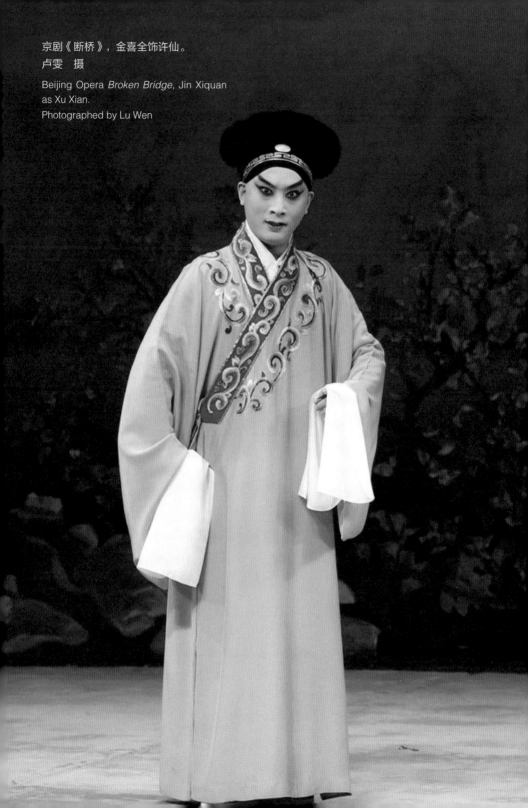

京剧《断桥》，金喜全饰许仙。

卢雯 摄

Beijing Opera *Broken Bridge*, Jin Xiquan
as Xu Xian.

Photographed by Lu Wen

小青——武旦。武旦多指性格勇武的女性形象，以武打见长。小青是一个爱憎分明、果敢决绝的角色，这与该行当的气质相符。她与白素贞情同姐妹，安乐与共，患难相扶。

Xiao Qing: plays a Wu Dan role. Wu Dan often refers to a brave and powerful woman known for her martial arts skills. Xiao Qing is a character who dares to experss love and hate and make up her mind, which is in line with the temperament of Wu Dan. She and Bai Suzhen have sisterly friendship, sharing happiness and helping each other in adversity.

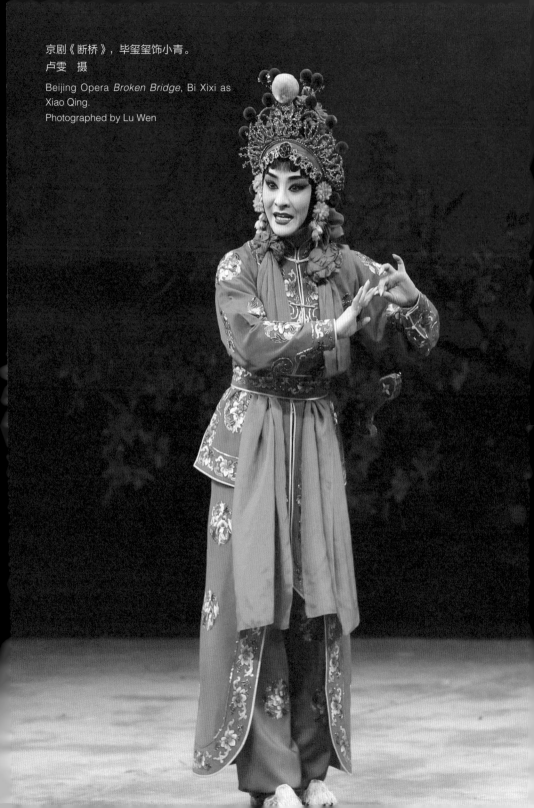

京剧《断桥》，毕玺玺饰小青。
卢雯 摄

Beijing Opera *Broken Bridge*, Bi Xixi as
Xiao Qing.
Photographed by Lu Wen

三

选段
Selected Scene of *Broken Bridge*

白素贞：（唱）

　　小青妹且慢举龙泉宝剑，

　　妻把真情对你言。

　　素贞我本不是凡间女，

　　妻原是峨眉一蛇仙。

　　只为思凡把山下，

　　与青儿来到西湖边。

　　风雨途中识郎面，

　　我爱你神情惓惓，风度翩翩。

　　我爱你常把娘亲念，

　　我爱你自食其力不受人怜。

　　红楼交颈春无限，

　　怎知道良缘是孽缘。

　　到镇江，你离乡远，

　　我助你卖药学前贤。

端阳酒后你命悬一线，

我为你仙山盗草受尽了颠连。

纵然是异类，

我待你恩情非浅，

腹内还有你许门的儿男。

你不该病好把良心变，

上了法海无底船。

妻盼你回家你不转，

哪一夜不等你到五更天。

可怜我枕上的泪珠都湿遍，

可怜我鸳鸯梦醒只把愁添。

寻你来到金山寺院，

只为夫妻再团圆。

若非青儿她拼死战，

我腹内的娇儿也命难全。

莫怪青儿她变了脸，

谁的是，谁的非，你问问心间。

Bai Suzhen: (Singing)

Sister Xiao Qing, please put down your sword,

(facing Xu Xian)

I, your wife, want to tell you the truth.

Suzhen, I am not an ordinary woman,

But a snake immortal on Mount Emei.

Because I admired of pleasure in the human world,

I went to the West Lake with Xiao Qing.

I met you in the wind and rain,

And I love you for your charisma.

I also love you because you always miss your mother,

And make your living on your own.

We lingered side by side at that time,

But who knows it is a devastating marriage, not a happy one.

When we came to Zhenjiang, far from your hometown,

I helped you sell drugs like the predecessors.

When you were dying after the Dragon Boat Festival,

I went to steal the cure-all herb to save your life and suffered a lot.

Although I am different from you,

I treat you so well and love you so much,

And I also have had our child already.

Why do you change your mind after your illness,

And board Fa Hai's evil boat?

I have been looking forward to your coming back these days,

Not to sleep until just before dawn every day.

How pitiful I was when I wet my pillow with my tears,

And when I woke up from the happy dream, I only felt sadder.

When I went to Jinshan Temple,

I just wanted to get together with you.

Without Xiao Qing's desperate help,

Our unborn child would have died.

You shouldn't complain to Xiao Qing,

Because you should know who is right and who is wrong.

四

演出推荐
Performance Recommendation

 本书推荐的视频为 1984 年梅兰芳 90 周年诞辰纪念演出版本，由国家京剧院、战友京剧团联合出演。杜近芳饰演白素贞，叶少兰饰演许仙，单体明饰演小青，是不可错过的演员阵容。

The recommended video in this book is a 1984 commemorative version performed for Mei Lanfang's 90th birthday, co-starred by the National Peking Opera Company and Comrade-in-Arm Peking Opera Troupe. Du Jinfang plays Bai Suzhen, Ye Shaolan plays Xu Xian, and Shan Timing plays Xiao Qing, which is a must-have cast.

五

演出赏析
Performance Appreciation

（一）层次丰富的人物情感 Rich Levels of Character Emotions

在剧场吸引观众的注意力，离不开剧情的精心编排。因此，剧作者首先需要在戏剧的开端安排冲突性事件，来凸显出剧中人物的性格，并紧扣事件，逐步推进情节，直至故事的高潮。《断桥》便极佳地体现了这种结构。戏一开始，许仙就遇上了怒不可遏的小青，他的"无情无义"让小青愤怒，以小青的性格，当然想杀之而后快。可是白素贞拦下了小青高举的宝剑，保护了许仙，拯救了他的性命。不仅如此，白素贞还对许仙晓之以理，动之以情，让其认识到自己的错误。以"冲突"开场，便能紧紧抓住观众的注意力，与剧中人物产生情感共鸣。

Attracting the audience's attention in the theater is inseparable from the careful arrangement of the plot. Therefore, the playwright needs to arrange conflicting events at the beginning of the play to highlight the characters' personalities, closely follow the events and gradually advance the plot until the climax of the story. *Broken Bridge* perfectly

embodies this structure. At the beginning of the play, Xu Xian met Xiao Qing, who was furious due to his heartlessness. In Xiao Qing's personality, she naturally wants to kill Xu Xian and be happy. However, Bai Suzhen stopped Xiao Qing, protected and saved Xu Xian's life. Not only that, but Bai Suzhen also reasoned with Xu Xian using emotions, and let him realize his mistakes. Starting with conflict can tightly capture the audience's attention and let the audience create emotional resonance with the characters in the play.

　　断桥是白素贞与许仙初次相遇的地方，两个人在这里定情，留下了美好的回忆。如今重临故地，两人之间的关系却发生了微妙的变化。看着苦苦哀求自己的丈夫，白素贞此时的心情十分复杂。虽然她对许仙有怨愤，可是对他的爱还是那样深，那样炽热。她真正恨的是欺骗丈夫的法海。因此，在这场戏中演员不仅要抓住白素贞对许仙始终不变的真心、真情，又要展现出白素贞在感情上受到的伤害，恰到好处地表现出她对许仙的爱与埋怨。

The Broken Bridge is the place where Bai Suzhen and Xu Xian first met, fell in love and made beautiful memories. Now that they are returning to their old place, their relationship has undergone subtle changes. Looking at her husband pleading bitterly, Bai Suzhen feels very complicated at this moment. Although she resented Xu Xian, she still loved him deeply and passionately. What she really hates is Fa Hai, who deceives her husband. Therefore, in this play, the actress should not only seize Bai Suzhen's unchanging sincerity and true feelings towards Xu Xian, but also show what she has suffered emotionally and accurately express Bai Suzhen's love and resentment towards Xu Xian.

三人共处断桥的这段戏展现出了极强的戏剧张力与人物之间浓烈的情感。白素贞对许仙的爱，在这场矛盾冲突中得到深刻的体现。经过金山寺苦战，白素贞虽然埋怨许仙，但心中更多的是不解，她急于见到许仙，将事情问个明白；小青则是爱憎分明，她既心疼姐姐受了那么多苦，又痛恨许仙的软弱，想要将许仙千刀万剐；许仙了解了事情的真相，意识到自己有负于白素贞，因此内心充满愧疚与悔恨。

京剧《断桥》，熊明霞饰白素贞（左），金喜全饰许仙（右）。
卢雯 摄

Beijing Opera *Broken Bridge*, Xiong Mingxia as Bai Suzhen (left), Jin Xiquan as Xu Xian (right). Photographed by Lu Wen

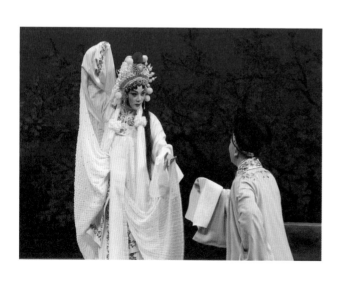

The scene of three people at the Broken Bridge demonstrates a strong dramatic tension and intense emotions among the characters. Bai Suzhen's love for Xu Xian is deeply reflected in this conflict. After the brutal fight in Jinshan Temple, Bai Suzhen complained about Xu Xian, but she was puzzled. She was eager to see Xu

Xian and asked him for a clear explaination; Xiao Qing, had a clear sense of love and hate. She loved her sister so much and hated Xu Xian's weakness. She wanted to cut Xu Xian into pieces. Xu Xian learned the truth and realized that he had betrayed Bai Suzhen, so he was filled with guilt and regret.

　　三人的情感在经过了前几场的铺垫，在断桥见面时得到了爆发与升华。许仙见到怀孕的妻子恨不得立马冲上前，但转而意识到妻子这样憔悴都是因为自己，不由放缓了脚步。等到定睛一看，发现小青双手叉腰，怒目圆睁，吓得他立马停了下来，人物情感的层次变化非常鲜明。等许仙再次鼓起勇气靠近白素贞，并满怀爱意地喊了一声"娘子"时，白素贞立马发现了狼狈的许仙，她又惊又喜，急忙上前，却被小青拦下，小青不由分说就给了许仙一个巴掌，这

京剧《断桥》，熊明霞饰白素贞（左），金喜全饰许仙（右）。卢雯　摄

Beijing Opera Broken Bridge, Xiong Mingxia as Bai Suzhen (left), Jin Xiquan as Xu Xian (right). Photographed by Lu Wen

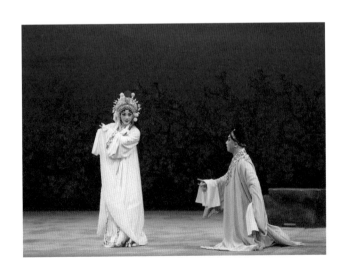

一巴掌打在许仙身上，却疼在白素贞的心里。当小青唱到"无义的人儿吃我的龙泉"，拔剑要追杀许仙时，白素贞一方面要护着许仙，一方面又要顾及小青，体现了她对许仙又怨又恨又怜惜的心态。

京剧《断桥》，熊明霞饰白素贞（中），金喜全饰许仙（左），毕玺玺饰小青（右）。

卢雯 摄

Beijing Opera *Broken Bridge*, Xiong Mingxia as Bai Suzhen (center), Jin Xiquan as Xu Xian (left), Bi Xixi as Xiao Qing (right). Photographed by Lu Wen

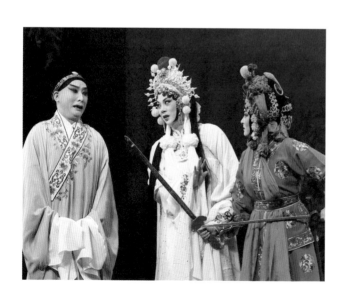

With the foreshadowing of the previous scenes, the feelings of the three people exploded and sublimated when they met at Broken Bridge. When Xu Xian saw his pregnant wife, he couldn't wait to rush forward, but then he realized that his wife's haggard appearance was all due to him. His urgent pace slowed down again. When he looked closely, Xiao Qing put her hands on her hips and glared him, which made him stop at once. The emotional changes of the characters were very distinct. When Xu Xian gathered the courage to approach Bai Suzhen again

and called out "Niangzi" (my wife) with love, Bai Suzhen immediately found the embarrassed Xu Xian. She was surprised and pleased. She hurried forward, but stopped by Xiao Qing. Xiao Qing could not help but slap Xu Xian. The slap not only hit Xu Xian but also hurt Bai Suzhen's heart. When Xiao Qing sings that "an unjust man will be hurt by my dragon spring sword" and pulls out her sword to pursue Xu Xian, Bai Suzhen should protect Xu Xian on the one hand and consider Xiao Qing on the other hand, which reflects her attitude of resentment, hatred and pity towards Xu Xian.

这出戏的人物感情是非常复杂的，尤其是白素贞。三人做出多种造型，用肢体表达情感，体现人物关系，唱、做结合出了别样的美感。

In this play, the emotions of the characters are very complex, especially Bai Suzhen's. The three actors make various poses with their bodies to express their feelings and reflect the relationship among the characters, combining a unique aesthetic through "singing and acting".

《断桥》以白素贞的一段唱腔结尾，这一结尾既是核心唱腔，也是《断桥》这折戏的精华所在。唱词中，白素贞向许仙坦白了自己的过往，倾诉了自己的衷情。她从两人在西湖初遇开始回忆，想到两个人在一起平淡却恩爱的日子，感到无限的欢欣，继而想到法海的出现，导致他们之间出现了重重风波。随着唱词情感的变化，白素贞的行腔越来越低回婉转，感情越来越徘恻缠绵，忍耐许久的悲愤、委屈，终于在此时面对这个"冤家"时决堤了。白素贞的真情流露，让许仙深深地自责、后悔，于是在白素贞和小青面前发誓永不负心，心地柔软的白素贞宽恕了他，但小青却依然忿忿不平。白、许二人在默契的眼

神交流后，一起说服了小青，三人重归于好。

Broken Bridge ends with an aria by Bai Suzhen, which is not only the core aria but also the essence. In the lyrics, Bai Suzhen confessed her true identity and shared her sincere feelings with Xu Xian. She began to recall their first encounter in the West Lake. She felt infinite joy when she thought of their life ordinary but full of love. Then she thought of the appearance of Fa Hai, who caused many troubles between them. With the emotional changes in the lyrics, Bai Suzhen's tone became lower and more tactful, and her emotions became more and more compassionate and lingering. After enduring a long period of grief, indignation and grievance, she finally broke down when facing this "feud". After Bai Suzhen's true feelings were revealed, Xu Xian felt regret and deeply blamed himself. He swore never to betray Bai Suzhen and Xiao

京剧《断桥》，熊明霞饰白素贞（中），金喜全饰许仙（右），毕玺玺饰小青（左）。

卢雯 摄

Beijing Opera *Broken Bridge*, Xiong Mingxia as Bai Suzhen (center), Jin Xiquan as Xu Xian (right), Bi Xixi as Xiao Qing (left).

Photographed by Lu Wen

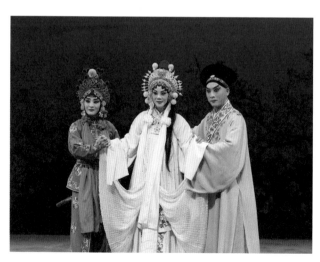

Qing in front of them. Bai Suzhen, who was soft hearted, forgave him, but Xiao Qing remained resentful. After the tacit eye contact, Bai and Xu persuaded Xiao Qing together, and the three were reconciled.

（二）表演细节 Performing Details

在《断桥》中，无论哪一个版本都保留了一个"推"的动作。当面对跪在自己面前，向自己苦苦哀求的许仙时，白素贞要用一根手指轻轻地推一下许仙的脑门，表示责怪。而当许仙被推得往后一仰时，白素贞又需立马扶住许仙，两人双目对视，之后，白素贞又嗔怪地轻轻一推许仙。这一套动作非常鲜明地体现出白素贞对许仙那又爱又恨的复杂心理，是两人重归于好的标志。然而，这样精彩的处理却来源于一次小小的表演失误。

In *Broken Bridge*, regardless of which version, a "push" movement is retained. When facing Xu Xian, who was kneeling in front of her and pleading with her, Bai Suzhen gently pushed Xu Xian's forehead with one finger to show her blame. When Xu Xian was pushed back, Bai Suzhen immediately held Xu Xian. The couple looked at each other, and Bai Suzhen gently pushed Xu Xian with anger again. This set of movements clearly reflects Bai Suzhen's complex psychology of love and hate towards Xu Xian and is a sign of their reunion. However, this outstanding handling stemmed from a small performance error.

京剧名旦梅兰芳先生早年演出昆曲《白蛇传》时，不小心因为推的力气过大，导致饰演许仙的演员重心不稳，差点摔倒。好在梅兰芳及时扶住了他，才没有出现演出事故。但是此时白素贞正在生许仙的气，怎么会去扶他呢？想到这里，梅兰芳又将许仙推开。没想到这一推、一拉，又一推的动作精准地体现了白素贞对许仙的复杂情感。因此这个动作被保留下来，成为《白蛇传》中的经典动作。

During his early performance in the Kunqu Opera The *Legend of the White Snake*, Mei Lanfang, a renowned Beijing Opera actor, accidentally caused the actor playing Xu Xian to lose his center of gravity and almost fall due to Mei Lanfang's excessive pushing force. Fortunately, Mei Lanfang helped Xu Xian in time, not causing a performance accident. But at this moment, Bai Suzhen was angry with Xu Xian, so how could she help him? Thinking of this, Mei Lanfang pushed Xu Xian away again. Unexpectedly, these push-pull-push movements accurately reflected Bai Suzhen's complex emotions towards Xu Xian. Therefore, these movements have been preserved and become a classic in The *Legend of the White Snake*.

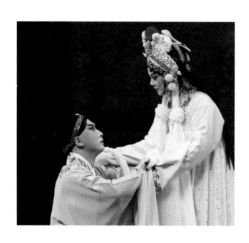

京剧《断桥》，熊明霞饰白素贞（右），金喜全饰许仙（左）。
卢雯　摄

Beijing Opera *Broken Bridge*, Xiong Mingxia as Bai Suzhen (right), Jin Xiquan as Xu Xian (left). Photographed by Lu Wen

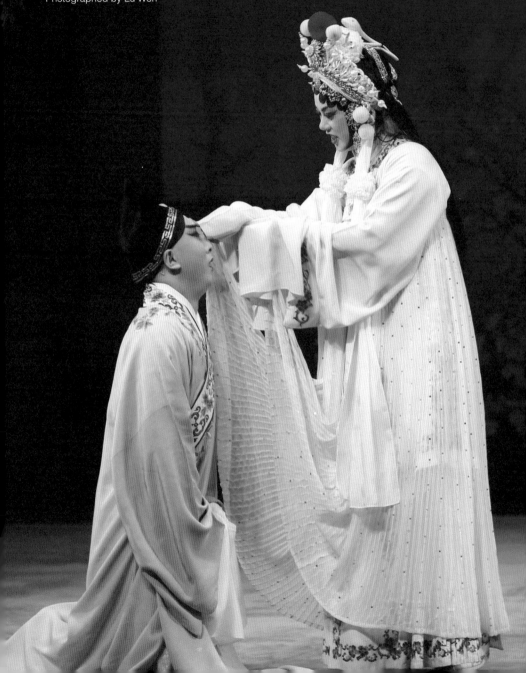

京剧《断桥》，熊明霞饰白素贞（右），金
喜全饰许仙（左）。
卢雯　摄

Beijing Opera *Broken Bridge*, Xiong Mingxia as
Bai Suzhen (right), Jin Xiquan as Xu Xian (left).
Photographed by Lu Wen

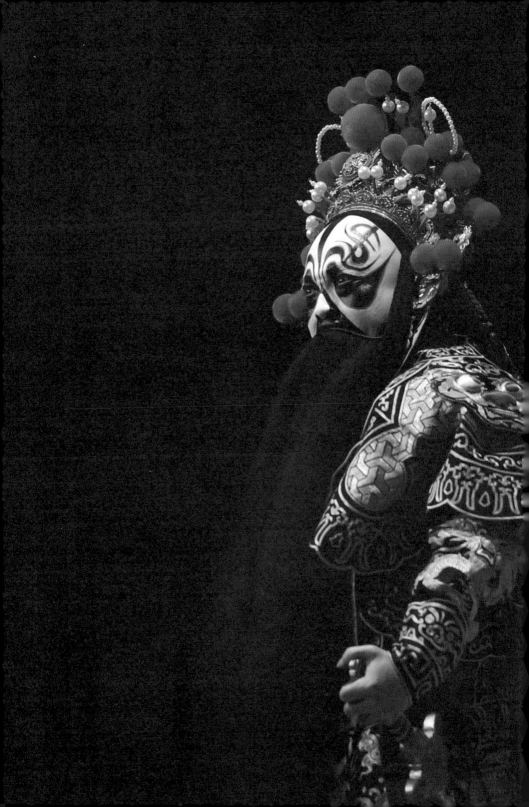

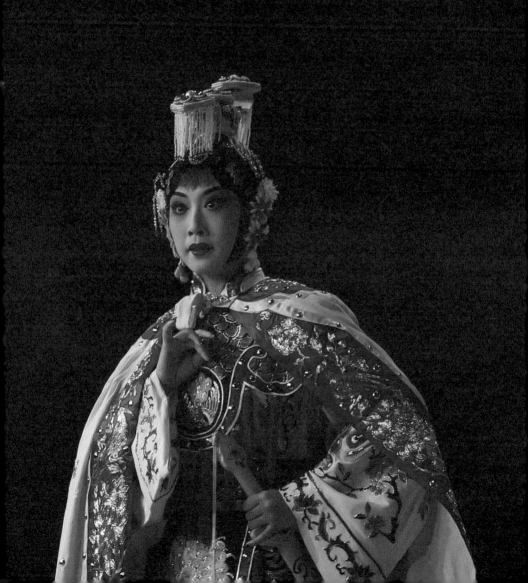

京剧《霸王别姬》，炼雯晴饰虞姬
（右），杨东虎饰项羽（左）。

卢雯　摄

Beijing Opera *Farewell My Concubine*,
Lian Wenqing as Yu Ji (right), Yang
Donghu as Xiang Yu (left) .
Photographed by Lu Wen

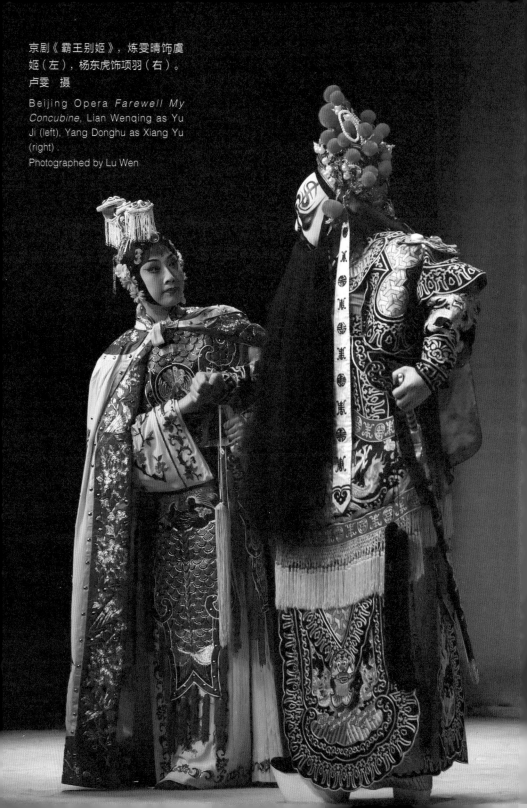

京剧《霸王别姬》，炼雯晴饰虞
姬（左），杨东虎饰项羽（右）。

卢雯 摄

Beijing Opera *Farewell My Concubine*, Lian Wenqing as Yu Ji (left), Yang Donghu as Xiang Yu (right).

Photographed by Lu Wen

玖

京剧《霸王别姬》
Beijing Opera
Farewell My Concubine

剧目简介

Introduction to *Farewell My Concubine*

　　《霸王别姬》是京剧梅派的经典名剧，最早由明代传奇《千金记》改编而来，原名为《楚汉争》。《楚汉争》最早由杨小楼与尚小云合演。后由梅兰芳与杨小楼重新排演，经修改后，命名为《霸王别姬》。秦朝末年，汉王刘邦与西楚霸王项羽定下不战之约。汉军元帅韩信却命令谋士李左车向项羽诈降，引诱其进兵。项羽刚愎自用，不听众人劝阻，率军进攻，在途中遭遇埋伏，被困垓下。夜半听见四面楚歌，项羽怀疑汉军已攻下楚地，于是与虞姬饮酒作别。虞姬为避免拖累项羽，拔剑自刎。项羽带兵突围，却败走至乌江，自觉无颜面对江东父老，自刎江边。

Farewell to My Concubine is a classic theater piece of the Mei Lanfang School in Beijing Opera. It was originally adapted from the legend of the Ming Dynasty, *Qianjin Ji*, and is called *The Battle Between Chu and Han*. *The Battle Between Chu and Han* was first staged by Yang Xiaolou and Shang Xiaoyun. Later, it was revised and rehearsed by Mei Lanfang and Yang Xiaolou, and after modifications, it was named

Farewell My Concubine. The play is mainly happened in the late Qin Dynasty, when Liu Bang, the founding emperor of Han, made a no-war pact with Xiang Yu, the emperor of Western Chu. Han Marshal Han Xin ordered the counselor Li Zuoche to feign surrender to Xiang Yu and lure him into advancing. Xiang Yu was headstrong and led the army to attack the Han army, refusing to accept his followers' advice to stop it. During the march, Xiang Yu was ambushed and trapped in Gaixia. In the middle of the night, Xiang Yu heard the song of Chu from all sides. He suspected that the Han army had captured Chu territory, so he drank wine and bid farewell to Yu Ji. To avoid dragging Xiang Yu down, Yu Ji pulled out her sword and committed suicide. Xiang Yu led his troops to break through the encirclement but was defeated and fled to the Wujiang River. He felt ashamed to face his compatriots on the other side of the Wujiang River and committed suicide by the river.

《霸王别姬》的首演在京剧界引起了轰动，杨小楼先生与梅兰芳先生的共同演绎，完美地展现出项羽与虞姬的爱情绝唱，使人为之动容。这出戏在服饰装扮与唱念等方面进行了许多改造与创新。尤其是在核心"别姬"中，梅兰芳先生加入了"剑舞"，开创了京剧表演史的新篇章，而剑舞也成为了"别姬"的精华之所在。后来四大名旦中的其他三位，也在自己的表演中加入了"剑舞"，可见"剑舞"这一表演形式的影响之大。此外，杨小楼与梅兰芳两位先生也设计了许多相互配合的演出细节，成功塑造了霸王的悲壮陌路，与美人虞姬的以死求生。

The premiere of *Farewell My Concubine* caused a sensation in the Beijing Opera industry. The joint performance of Master Yang Xiaolou and Master Mei Lanfang perfectly portrayed the love between Xiang

Yu and Yu Ji, making people empathize. This play has undergone a lot of transformations and innovations in terms of costumes, accessories, singing, and so on. Especially in the core of *Farewell My Concubine*, Master Mei Lanfang added the "sword dance", creating a new chapter in the history of Beijing Opera performance. The sword dance has become the essence of *Farewell My Concubine*. Later, the other three of the Four Great Dans also added the "sword dance" to their performances, indicating the significant influence of this performance. In addition, Master Yang Xiaolou and Master Mei Lanfang also designed complementary performing details, successfully shaping the tragic and heroic path of the overlord and the touching beg for Xiang Yu's life with Yu Ji's own death.

《霸王别姬》流传至今，一般只演出《别姬》一折，原因在于这部戏约为一般传统戏的四倍长，体量过大，且结构松散。因此后人在搬演此剧时，仅仅撷取《别姬》这段较为精彩的部分。《霸王别姬》这一出剧目的流变也反映出戏曲中存在大量"折子戏"的原因。

Farewell My Concubine, spreads to this day, generally only one part, *Farewell to My Concubine* is performed. The reason is that this play is about four times the length of traditional plays, making it too long and loosely structured. Therefore, later generations only picked up the more remarkable part of *Farewell My Concubine* when performing this play. The change of *Farewell My Concubine* can also reflect the reason why there are a lot of excerpts in traditional theater.

京剧《霸王别姬》，炼雯晴饰虞姬（左），杨东虎饰项羽（右）。
卢雯 摄

Beijing Opera *Farewell My Concubine*, Lian Wenqing as Yu Ji (left), Yang Donghu as Xiang Yu (right).
Photographed by Lu Wen

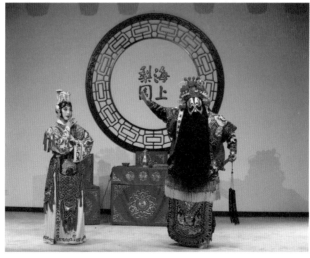

二

人物简介
Character Profile

 虞姬——花衫。花衫是综合青衣、花旦等的行当特点而形成的新的旦角类型。花衫既有青衣的端庄沉稳，又有花旦的灵巧活泼，通常采用"唱、念、做、打"并重的方式塑造人物。虞姬是霸王项羽的爱妃，端庄静婉，坚贞忠毅。

Yu Ji: plays a Hua Shan role. Hua Shan is mainly a new type of Dan character formed by integrating the characteristics of Qing Yi, Hua Dan, and other professions. Hua Shan combines the dignified and steady demeanor of Qing Yi with the dexterity and liveliness of Hua Dan. It usually uses a combination of "singing, reciting, acting, and fighting" to shape characters. Yu Ji, the beloved concubine of the overlord Xiang Yu, is dignified and gentle, steadfast and loyal.

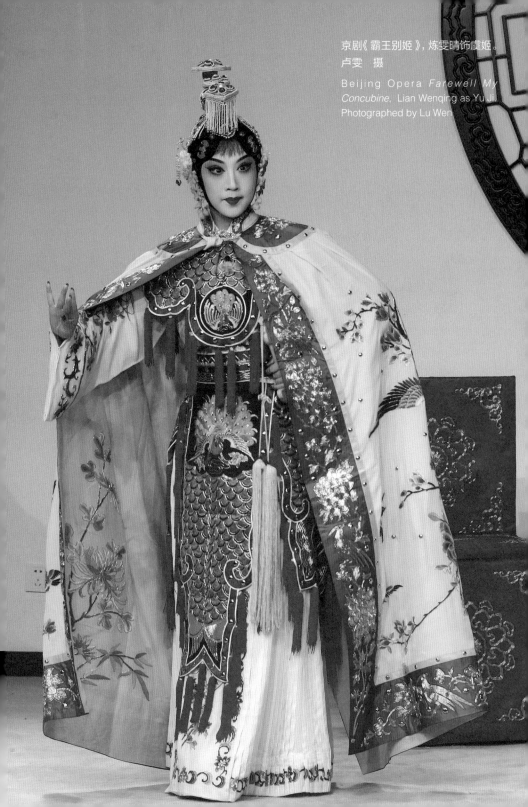

霸王——花脸，武生。花脸主要扮演在性格、品质或相貌等方面具有突出特点的男性人物。面部勾画脸谱，表演动作幅度大，以突出其性格、气度和声势。霸王早先主要由花脸演绎，后因杨小楼创造了武生担纲的范例，因此目前该角色多由武生担当。历史上，西楚霸王项羽虽然雄才大略，却刚愎自用，是中国文化中英雄人物的代表。

Bawang (the overlord): plays a Hua Lian role or a Wu Sheng role. Hua Lian mainly plays a male character with prominent personality, quality, or appearance characteristics. Hua Lian sketches facial makeup, performing with large amplitude movements to highlight his personalities, demeanor and momentum. Initially, the role of overlord was mainly played by Hua Lian. However, due to Yang Xiaolou's creation of an example that Wu Sheng takes on the role, the role is currently played mainly by Wu Sheng. In history, although Xiang Yu, the hegemon of Western Chu, had great talent and strategy, he was stubborn and self-righteous and was a representative of heroic figures in Chinese culture.

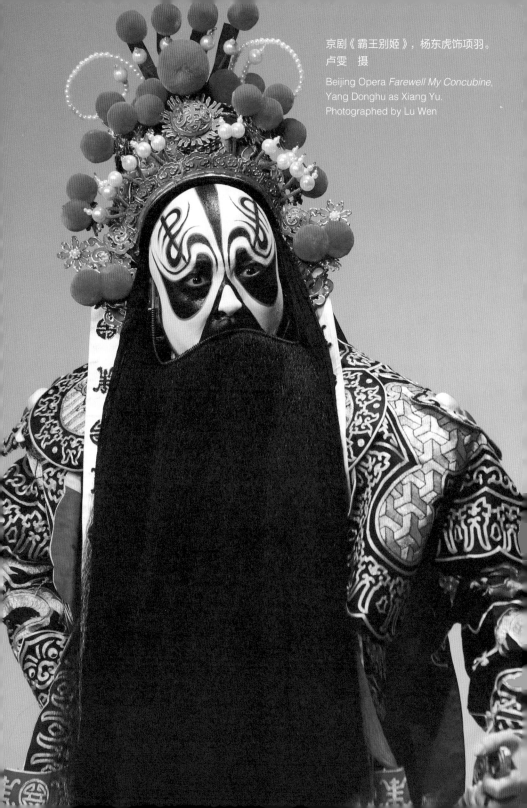

京剧《霸王别姬》，杨东虎饰项羽。
卢雯 摄

Beijing Opera *Farewell My Concubine*,
Yang Donghu as Xiang Yu.
Photographed by Lu Wen

三

选　段
Selected Scene of *Farewell My Concubine*

虞姬：（唱）

　　劝君王饮酒听虞歌，

　　解君忧闷舞婆娑。

　　嬴秦无道把江山破，

　　英雄四路起干戈。

　　自古常言不欺我，

　　成败兴亡一刹那。

　　宽心饮酒宝帐坐！

　　【夜深沉】曲牌起，虞姬舞剑。

Yu Ji: (Singing)

My king, please listen to my song.

I intend to relieve you from your worries with my dance.

The king of Qin is ruthless in tearing apart our country.

Brave people from all over the country went to war.

It is always said that it is better not to bully.

Success or failure can be decided in a moment.

Just relax and drink your wine in this tent.

As the song [Yeshenchen] begins, Yu Ji starts a sword dance.

四

演出推荐
Performance Recommendation

本书推荐摄制于 1955 年的京剧电影《霸王别姬》。该版由梅兰芳与刘连荣分别扮演虞姬与项羽，是梅派经典名剧之一。

The recommended movie of the Beijing Opera *Farewell My Concubine* was filmed in 1955. This version, played by Mei Lanfang and Liu Lianrong, as Yu Ji and Xiang Yu, respectively, is one of the classic dramas of the Mei Langfang School.

五

演出赏析
Performance Appreciation

（一）开创性的剑舞表演
A Ground-breaking Performance of Sword Dance

在《别姬》一折中，剑舞是其精华所在。剑舞展示了表演者过人的技巧，与情节和人物情感紧密相连，是用来塑造这一人物的不二之选。

In the excerpt of *Farewell My Concubine*, the sword dance is its

京剧《霸王别姬》，炼雯晴饰虞姬。
卢雯　摄

Beijing Opera *Farewell My Concubine*, Lian Wenqing as Yu Ji. Photographed by Lu Wen

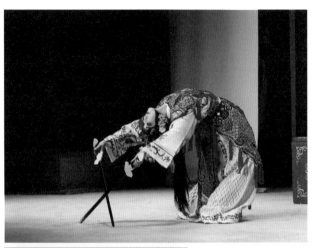

essence. This dance not only showcases the performer's exceptional skills, but also closely connects the dance content with the plot and the characters' emotions, making it the perfect choice for shaping this character.

在梅兰芳先生之前，京剧中的女性角色从没有表演过"剑舞"。梅兰芳先生在吸收了中国传统武术中太极剑的基础上，开创了女性角色表演"剑舞"的先例，这是一次珍贵的艺术创作与创新。

Before Master Mei Lanfang, female characters in Beijing Opera had never performed "sword dance". Master Mei Lanfang, on the basis of the traditional Chinese martial arts of Tai Chi Sword, has set a precedent for female character performance in "sword dance", which is a

precious artistic creation and innovation.

通常情况下，人们并不习惯于将女性与杀人兵器联系在一起，但是在《霸王别姬》中，这样的搭配却非常妥帖。虞姬不仅具有端庄静婉、持重隐忍等中国传统女性的特质，而且在关键时刻更是表现出坚贞忠毅的品格，这一看似矛盾的性格特质使得女性和剑的搭配很是契合。缓慢的剑舞既能展现虞姬面临危难时的沉着冷静，又暗含着她决定自刎的决绝。

Usually, people are not accustomed to associating women with murder weapons, but in *Farewell My Concubine*, this combination is very appropriate. Yu Ji not only possesses the characteristics of traditional Chinese women, such as modesty, calmness, prudence and tolerance, but also has a steadfast and loyal character at critical moments. This seemingly contradictory personality trait makes the combination of women and swords very consistent. The slow sword dance showcases Yu Ji's composure when facing danger, but also implies her decision to commit suicide.

京剧《霸王别姬》，炼雯晴饰虞姬。
卢雯　摄

Beijing Opera *Farewell My Concubine*,
Lian Wenqing as Yu Ji.
Photographed by Lu Wen

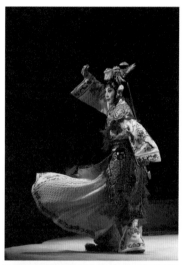

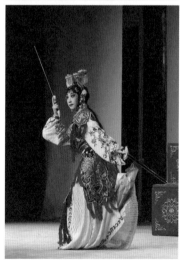

因此当我们欣赏这一段剑舞时，不仅要着眼于人物柔中带刚、富有节奏感的身段动作，也要注意人物浓烈、丰沛的情感。这是一种看似矛盾，实则阴阳相济的和谐之美。

Therefore, when appreciating this sword dance, we should not only focus on the character's gentle and rhythmic movements but also pay attention to her strong and rich emotions. This is a harmonious beauty that appears contradictory but actually combines *Yin* and *Yang*.

（二）丰富的情感层次 Rich Emotional Layers

在这折戏中，虞姬的情感突然非常浓烈，却不是一蹴而就的。她的情感变化有着一层层向上递进的趋势，层次分明。梅兰芳先生将虞姬的表演分为了五个阶段：

In this excerpt, Yu Ji's emotions are very strong, but they are not achieved at one stroke. Her emotional changes have a clear upward trend with distinct layers. Master Mei Lanfang divided Yu Ji's performance into five stages.

第一个阶段，虞姬在刚出场时是沉稳端庄的。她隐隐地为项羽感到担忧，手不自觉地捏着宝剑上的穗子。人物动作幅度不大，主要通过眼神向观众传达情感。以上表演奠定了人物的基调，让观众了解虞姬的性格与此时的心理状态。

In the first stage, Yu Ji was calm and dignified when she first

appeared. She was vaguely worried about Xiang Yu and unconsciously pinched the tassels on her sword. The character's movements are not significant; she mainly conveys emotions to the audience through her eyes. The above performances set the tone for the character, allowing the audience to understand Yu Ji's personality and psychological state at this moment.

第二个阶段，当虞姬听说项羽战败了，她内心越发不安，但为了不影响项羽，她故作镇定，甚至反过来安慰项羽"自古道兵胜负乃是常情"。

In the second stage, when Yu Ji heard that Xiang Yu had been defeated, she became even more uneasy. However, in order not to affect Xiang Yu, she pretended to be calm and even comforted him by saying, "Since ancient times, it has been said that it is natural for soldiers to win or lose."

第三个阶段，虞姬在项羽入睡后，独自一人来到帐外。局势的紧张，让她愈发担心项羽。虞姬同情远离家乡随项羽到处征战的士兵，而且出于对秦国发动战争的痛恨，她开始对战争表现出深深的怀疑与厌恶。本想外出排遣苦闷，可如今内心却更加痛苦。

In the third stage, Yu Ji arrived outside the tent alone after Xiang Yu fell asleep. The tense situation made her even more worried about Xiang Yu. Yu Ji sympathized with the soldiers who were far away from their hometowns and marched with Xiang Yu everywhere. And out of hatred for the war launched by the Qin, she began to show deep suspicion and disgust towards the war. She originally wanted to go out to relieve her

depression, but now her heart was even more painful.

正在此时，敌营突然传来楚国歌声。"难道敌军已经攻占了楚国吗？"虞姬非常紧张，于是她赶紧跑去禀报项羽。这是虞姬心态发展的第四个阶段。

At this moment, the song of Chu suddenly came from the enemy camp. "Has the enemy captured Chu?" Yu Ji was very nervous, so she hurried to report to Xiang Yu. This is the fourth stage of Yu Ji's psychological development.

最后一个阶段，"垓下歌"唱出了项羽面对汉军重重包围时的无奈与悲愤，是一曲英雄无力回天的挽歌。当虞姬听到项羽唱"垓下歌"时，她知道失败已不可挽回，于是为了不在最后的突围中拖累项羽，

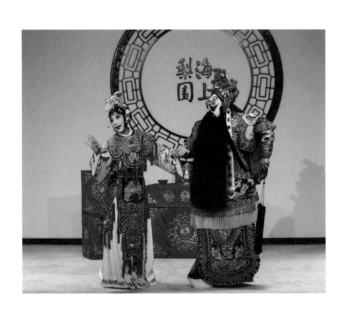

京剧《霸王别姬》，炼雯晴饰虞姬（左），杨东虎饰项羽（右）。
卢雯 摄

Beijing Opera *Farewell My Concubine*, Lian Wenqing as Yu Ji (left), Yang Donghu as Xiang Yu (right).
Photographed by Lu Wen

她甘愿赴死，"以自己的死，求霸王的生"。

In the final stage, "Gaixia Song" is the elegy of Xiang Yu's helplessness and indignation when facing the heavy siege of the Han army and a hero's inability to regain victory. When Yu Ji heard Xiang Yu sing the "Gaixia Song", she knew that his failure was irreparable. Therefore, in order not to drag Xiang Yu down in the final breakthrough, she was willing to go to her death and "seek the life of the Overlord through her own death".

演员通过表演展现了虞姬的情感变化，让我们走进了她的世界，随着她的哀伤而哀伤，悲愤而悲愤，从而获得了情感的洗涤与宣泄。

The actress showcased Yu Ji's emotional changes through her performances, allowing us to enter her world. With her sadness, we mourn and become angry, thus obtaining emotional cleansing and venting.

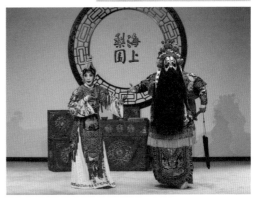

京剧《霸王别姬》，炼雯晴饰虞姬（右），杨东虎饰项羽（左）。
卢雯 摄

Beijing Opera *Farewell My Concubine*, Lian Wenqing as Yu Ji (left), Yang Donghu as Xiang Yu (right), Photographed by Lu Wen

六

服饰赏析
Appreciation of Costume and Accessory

戏曲服饰是用来表现人物身份与性格的重要的元素，极其考究，因此在塑造新的人物形象时，造型设计既需要体现人物特征，又要符合戏曲美学，这并不容易。梅兰芳先生为虞姬设计的造型之所以取得成功，就是因为兼顾到了这两个方面。

The costume in traditional Chinese theater is an important element used to express the identity and personalities of the characters, which is extremely meticulous. Therefore, when shaping new character images, the styling design needs to reflect the characteristics of the characters and conform to the aesthetics of traditional Chinese theater, which is not easy. The success of Master Mei Lanfang's design for Yu Ji is due to the balance between these two aspects.

虞姬的头部造型在结合京剧头饰已有元素的基础上，根据古画资料进行了艺术化的处理。她的"如意冠"[1]与京剧美学相融，既具有

1　如意冠：为虞姬独有的头饰，因形似中国传统工艺品——如意而得名。

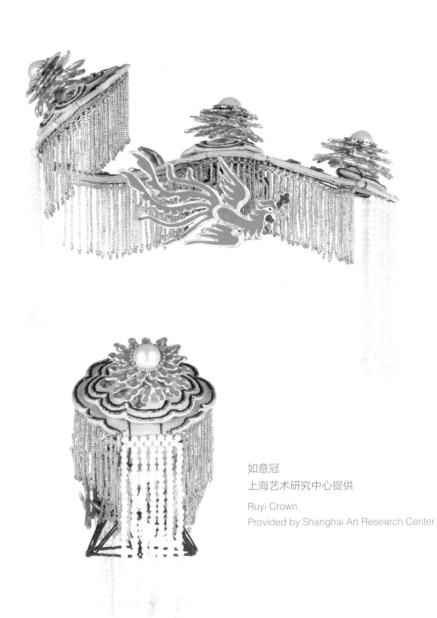

如意冠
上海艺术研究中心提供

Ruyi Crown.
Provided by Shanghai Art Research Center

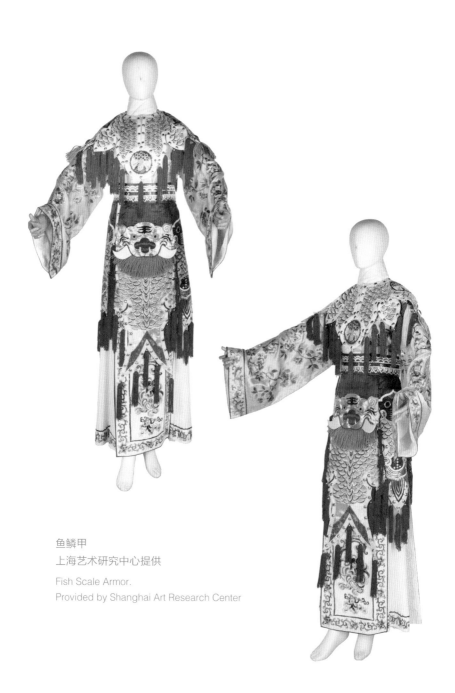

鱼鳞甲

上海艺术研究中心提供

Fish Scale Armor.

Provided by Shanghai Art Research Center

京剧头饰原本的视觉元素，又能体现出虞姬的身份以及其所处的战争环境。

Yu Ji's head image combines the existing elements of Beijing Opera headwear and has been artistically processed based on ancient painting materials. Her "Ruyi Crown"[1] not only embodies the original visual elements of a Beijing Opera headwear, but also reflects the identity of Yu Ji and the war environment she is in, blending with Beijing Opera aesthetics.

虞姬是随军的妃子，文武双全，在原有的京剧造型中很难找到突出其身份的服饰。因此设计师在京剧武将穿的"靠"[2]上寻找灵感，设计出了"鱼鳞甲"。这件有鱼鳞纹路的铠甲兼具了"靠"的特征，又不失美感。而且在汉语中，虞姬的"虞"和"鱼鳞甲"的"鱼"读音相同，这也与人物暗合。

Yu Ji is an imperial concubine. She is proficient in both literature and martial arts, and it is difficult to find costumes that highlight her identity in the original design of Beijing Opera. Therefore, the designer sought inspiration from the armor ("Kao")[3] worn by military generals in Beijing Opera and designed the "Fish Scale Armor". This armor with a fish scale pattern combines the characteristics of "Kao" without losing its beauty. Moreover, in Chinese, Yu Ji and "Fish Scale Armor" have the same pronunciation as in Chinese "Fish"(yu), which also coincides with the character.

1 Ruyi Crown: It is a unique headdress of Yu Ji, named after its resemblance to traditional Chinese handicraft–Ruyi, Ruyi means realizing one's intention in Chinese culture.

2 靠：传统戏曲中武生所穿着的盔甲。

3 Kao: The armor worn by martial artists in traditional Chinese theater.

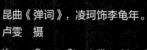

昆曲《弹词》，凌珂饰李龟年。
卢雯　摄

Kuqun Opera *Storytelling*, Ling Ke
as Li Guinian.
Photographed by Lu Wen

拾

昆曲《长生殿·弹词》

Kunqu Opera

The Palace of Longevity ·

Storytelling

一

剧目简介
Introduction to *Storytelling*

　　《弹词》选自清代剧作家洪昇所作的剧本《长生殿》。《长生殿》全本共有五十折，取材于唐代诗人白居易所作长诗《长恨歌》以及元代剧作家白朴所作剧本《梧桐雨》，主要讲的是唐明皇李隆基和贵妃杨玉环的爱情故事。杨玉环因天生丽质被选召入宫，独得唐明皇的恩宠。两人终日玩乐，唐明皇无暇理会政事。安禄山乘机起兵谋反，唐明皇带着杨贵妃西逃。将士们因不满皇帝耽于声色，途中爆发兵变，唐明皇在将士们的逼迫下赐杨贵妃自尽。叛乱平息后，唐明皇苦苦思念杨贵妃，感动了上天，得以到天上与杨贵妃重逢。

Storytelling is selected from *The Palace of Longevity* script written by playwright Hong Sheng in the Qing Dynasty. The complete edition of *The Palace of Longevity* has 50 excerpts, based on the long poem *Everlasting Regret* written by Bai Juyi, a poet in the Tang Dynasty, and the play *Indus Rain* written by Bai Pu, a playwright in the Yuan Dynasty. It mainly tells the love story between Li Longji, the emperor of the Tang pynasty, and Yang Yuhuan, the imperial consort. Due to her natural beauty, Yang Yuhuan was summoned to the palace and was uniquely

favored by the emperor. The two of them had fun all day long, and the emperor had no time to pay attention to political affairs. An Lushan took the opportunity to rebel and the emperor fled west with his consort Yang. The soldiers, dissatisfied with the emperor's indulgence, erupted in a mutiny on the way to escape. Under the pressure of the soldiers, the emperor granted his consort Yang permission to commit suicide. After the rebellion was subdued, the emperor longed for his consort Yang distressingly and moved gods, who allowed him to reunite with her in heaven.

《弹词》为《长生殿》其中一折，讲的是唐代玄宗末年（755 年）爆发了"安史之乱"，百姓流离失所，宫廷供奉李龟年也流落江南，以卖唱为生。某日，李龟年在一寺庙的大会上为众人弹唱，因感慨国家兴衰，把唐明皇宠爱杨贵妃、无心于朝政以致战乱的经过编为唱词，唱得声泪俱下，深深地打动了众人[1]。

Storytelling is one excerpt from *The Palace of Longevity*, which tells the story of the An-Shi Rebellion that broke out in the late years of Emperor Xuanzong of the Tang Dynasty (755 AD), causing people to be destitute and homeless. Li Guinian, who was worken in by the palace, also wandered to the south of the Yangtze River and made a living by telling stories. One day, Li Guinian played and sang for everyone at a temple assembly. Feeling about the rise and fall of the country, he composed the lyrics of the emperor Li Longji's love for his consort Yang and his lack of interest in government affairs, causing the war. He sang the lyrics in tears, which deeply moved everyone.

1　计镇华口述，郑培凯主编.《青山今古何时了——计镇华艺术传承记录》[M]. 上海：文汇出版社，2020.9.

在昆曲鼎盛的年代，有人以"家家收拾起，户户不提防"来描述当时昆曲风靡的盛况。这句话的意思就是每家每户都会传唱"收拾起"和"不提防"这两段。其中"不提防"的出处便是《弹词》中第一支曲牌【南吕一枝花】的第一句唱"不提防余年值乱离"。这段唱曲调动听，充满了人生的况味与对兴亡的慨叹，所以广为传唱。

In the heyday of Kunqu Opera, some people described its popularity as "every family packs up, and everyone is not cautious" at that time. The meaning of this sentence is that everyone could sing the phrases of "Picking Up" and "Not Being Cautious". "Not Being Cautious" is the first line of "Not being cautious about the chaos of the remaining years", from the first song [Nanlv Yizhihua] in *Storytelling*. This singing piece has a beautiful melody, full of the flavor of life and the sighs about the rise and fall, so it is widely sung.

在《长生殿》全本的五十五折戏中，《弹词》位于第三十八折，发生在杨贵妃自缢于马嵬坡之后，此时，唐明皇与杨贵妃的爱情故事已近尾声。本折戏是李龟年——一个盛极一时的宫廷乐师以弹唱的方式重新讲述了这一段凄美的爱情故事。将之前的情节再唱一遍似乎显得重复、啰嗦，但戏曲的"美"不仅在于情节的跌宕，也在于对人物情感的描摹。由于李龟年感怀于唐明皇对他的知遇之恩，又因为曾经的光耀和当下的困窘所产生的巨大差异，使他不能忘怀这一段往事与国家曾经的昌盛。李龟年的情感随着音乐的演绎层层递进，这也是本折戏所蕴含的特殊价值。

In the 50 or 55 excerpts of the complete book of *The Palace Longevity*, *Storytelling* is the 38th. It took place after consort Yang hanged herself in Maweipo, and the love story between the emperor and his concubine Yang was ending. This excerpt is about Li Guinian, a once popular palace musician who retold this poignant love story through playing the musical instrument and singing. Singing all the previous excerpts again seems to be repetitive and long-winded, but the "beauty" of traditional theater lies not only in the ups and downs of the plot but also in the depiction of the characters' emotions. Due to Li Guinian's gratitude to the emperor for his understanding of him as well as the huge difference between his past glory and the current difficulties, he could not forget his and the country's past prosperity. The emotions of Li Guinian gradually progress with the interpretation of the music, which is also the special value contained in this play.

二

人物简介
Character Profile

李龟年——外。外末、外旦、外净等元代戏曲的脚色行当大致指末、旦、净等的次要脚色。明清以来"外"多扮演成熟稳重、性格正直刚毅的老年男性人物。李龟年在历史上确有其人，为开元初年梨园伶工，专门创作音乐，为当时的达官贵人表演，尤其受到唐明皇的赏识与器重。安史之乱后流转于江南各地，以卖唱糊口，晚年在贫病交加中逝世。

Li Guinian: plays a Wai role. The roles and professions of traditional Chinese theater in the Yuan Dynasty, such as Wai Mo, Wai Dan and Wai Jing, roughly refer to the secondary roles and professions of Mo, Dan, and Jing. Since the Ming and Qing dynasties, "Wai" has often played the role of mature and stable, upright and resolute elderly male characters. Li Guinian is indeed a person in history. He was a performer in the early years of the Kaiyuan Era, specializing in composing music and performing for high-ranking officials at that time. He was particularly appreciated and valued by the emperor of the Tang Dynasty. After the An-Shi Rebellion, he traveled throughout the south of the Yangtze River and made a living by singing. In his later years, he passed away in poverty and illness.

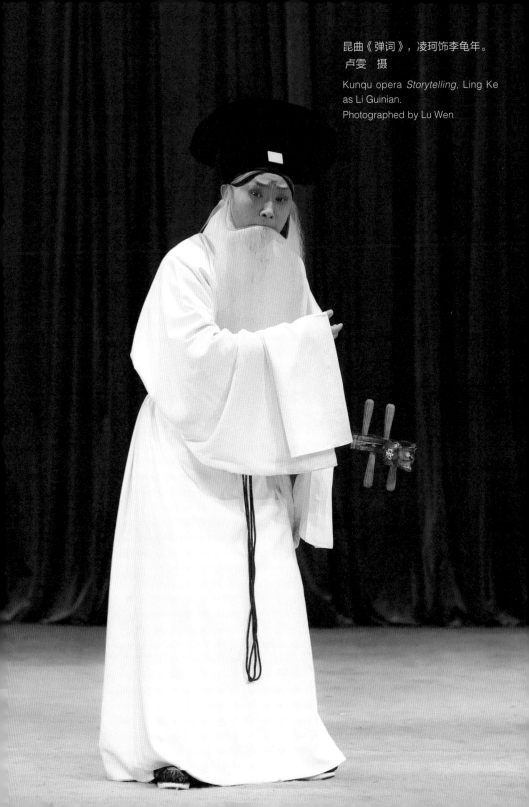

昆曲《弹词》，凌珂饰李龟年。
卢雯 摄

Kunqu opera *Storytelling*, Ling Ke
as Li Guinian.
Photographed by Lu Wen

三

选 段
Selected Scene of *Storytelling*

李龟年：（唱）

【一枝花】不提防余年值乱离，逼拶得歧路遭穷败。

受奔波风尘颜面黑，叹雕残霜雪鬓须白。

今日个流落天涯，只留得琵琶在！

揣羞脸上长街，又过短街。

哪里是高渐离击筑悲歌？

吓哈，倒做了伍子胥吹箫也那乞丐！

Li Guinian: (Singing)

[A Flower] In my last years, I am unexpectedly experiencing turbulence and displacement, which forces me to go astray in poverty and defeat.

Enduring all the hardships, my face is dark, while my hair is white on both my sideburns and beard.

Now I am wandering around with nothing but a lute.

With shame, I bury my face in my arms, but still have to walk through the streets to play the lute and sing.

It's totally different from Gao Jianli, who plays the zhu[1] and sings mournful songs for the sake of righteousness.

Aha! I am Wu Zixu, who plays the vertical flute for begging.

1　Zhu: one of the traditional Chinese instruments.

四

演出推荐
Performance Recommendation

本书推荐的视频为 2001 年"跨世纪千禧精英大汇演"的版本，由国际新象文教基金会主办，浙江昆剧团出演。该版的李龟年由程伟兵饰演，李暮由李公律饰演。该版包含了共十支曲（原版为十二支），为目前唱段较齐全的演出版本，值得观赏。

The recommended video in this book is the 2001 version for the "Cross Century Millennium Elite Performance", hosted by the International New Aspect Cultural and Educational Foundation and starred by the Zhejiang Kunqu Opera Troupe. In this version, Li Guinian is played by Cheng Weibing, and Li Mu is played by Li Gonglv. This version includes a total of ten songs (the original version includes twelve), which is currently the complete performance version with complete arias and is worth watching.

五

演出赏析
Performance Appreciation

（一）唱段 Arias[1]

《弹词》共有十二支曲，如今多演唱其中的十支，每一支都有其亮点。从【南吕一枝花】的落魄失意到【六转】的紧张、富有戏剧性，再到最后【煞尾】的兴奋、慰藉，基本上都遵循了"起承转合"的原则，让一个故事"唱"得有滋有味、动人心弦。这里借【六转】、【七转】，浅谈《弹词》唱段的魅力。

In *Storytelling*, there are twelve songs, and now ten of them are sung often, and each has its own highlights. The frustration of [Nanlv Yizhihua], the tension and dramatics of [Liu Zhuan] (the Sixth Turn)and the excitement and comfort of the ending [Sha Wei] are basically following the principle of "opening, developing, changing and concluding", making a story "sing" with flavor and heartstrings moving. Here we take [Liu Zhuan] and [Qi Zhuan] (the Seventh Turn) as examples to interpret the charm of the aria in *Storytelling*.

1 An aria is a complete singing in a Chinese theater.

【六转】之前的唱主要描述杨贵妃天生丽质，以及她与唐明皇的恩爱之情。但到了【六转】，先前美好的气氛急转直下。"安史之乱"爆发了，李龟年越唱越激动，他情不自禁地站了起来，仿佛看到叛兵的铁蹄扬起漫天沙尘，山雨之势扑面而来！唱词运用的"惊惊恐恐""仓仓促促""挨挨挤挤"等大量叠词，渲染出了大敌当前，京城内外惊恐无措、如鸟兽般逃窜的紧张气氛。这一支曲子在整组唱中起到了烘托氛围的作用，若是没有这些叠词营造氛围，在后面的唱段中，人物浓烈的情感会大打折扣。在演唱这些极其富有表现力的叠词时，好的演员能够将节奏处理得张弛有度，通过快慢轻重的对比刻画出兵荒马乱的战争场面。

The previous song before [Liu Zhuan] mainly describes concubine Yang's natural beauty and the affection between her and the emperor. But when it comes to [Liu Zhuan], the beautiful atmosphere before suddenly declines. When singing the An-Shi Rebellion, Li Guinian became more and more excited as he sang. He stood up uncontrollably, as if seeing the iron hooves of the rebels raising dust in the sky and the momentum of the mountain rain rushing towards him! A large number of repetitions such as "jingjingkongkong", "cangcangcucu", "aiaijiji," and other overlapping words are used in the lyrics to render the nervous atmosphere among shuddering people inside and outside the capital, who are panicking and fleeing like birds and beasts when they encounter the enemy. This piece of music plays a role in setting the atmosphere for the entire singing group. Without the atmosphere created by these overlapping words, the strong emotions of the characters in the subsequent aria will be greatly reduced. When singing these extremely

expressive overlapping words, a good actor can handle the rhythm with ease and precision and depict the chaotic war scenes of soldiers and horses through the contrast of speed and severity.

与【六转】相比，【七转】的节奏放缓了许多，之前的紧张、激烈的氛围瞬间缓和下来，甚至仿佛"凝固"了一般。这样，【七转】冷清的底色逐渐泛出。因为【六转】主要描述当时危急的情况，无暇抒情，到了【七转】便可以充分抒发演唱者的感叹了。曲文通过破败的驿舍，倒了的佛塔，沾血的罗巾及枯树等荒凉的景物，描写出杨贵妃死后的悲惨凄凉，与之前的繁华形成鲜明的对照。节奏是该段表演的重点之一，如演唱"那抱着悲怨的孤魂冷啼月"一句时，演员通常将最后一个"月"字放慢半拍才唱出口，目的就在于表现李龟年不忍说出口的情态。这样恰当、妥帖的演唱和表演节奏能够激发观众想象，带领观众走进李龟年描述的意境中，感受人物的内心世界。

昆曲《弹词》，凌珂饰李龟年。
卢雯 摄

Kunqu Opera *Storytelling*, Ling Ke as Li Guinian.
Photographed by Lu Wen

Compared with [Liu Zhuan], the rhythm of [Qi Zhuan] has slowed down a lot, and the tense and intense atmosphere has instantly

eased, even as if it had "solidified". In this way, the deserted background of [Qi Zhuan] gradually emerged. Because [Liu Zhuan] mainly describes the critical situation at the time and there is no time to express personal emotions. When it comes to [Qi Zhuan], the singer can fully express his sigh. Through dilapidated post houses, fallen Buddhist pagodas, blood-stained silk scarves, withered trees and other desolate scenery, the verse depicts the tragic and desolate scense of concubine Yang's death, in stark contrast to the prosperity before. Rhythm is one of the critical points of the performance, such as when singing "With sorrow and resentment, the lonely soul Crying on the moon", actors often slow down the last word "Moon" to half a beat before singing it out, aims of express Li Guinian's reluctance to speak out. The appropriate rhythm of singing and performance can stimulate the audience's imagination, lead them into the artistic conception described by Li Guinian, and experience the inner world of the character.

（二）咬字 Word Biting

咬字指的是演员在演唱或说白的过程中，以字为单位，对其声母和韵母进行准确地呈现。因此在戏曲的表演中，要求演员要咬清"字头""字腹""字尾"。这样不仅能将信息准确地传达给观众，更能突出语句中的重点，进而生动地刻画人物的内心世界。

The word biting refers to the accurate presentation of the initials and vowels of actors in the process of singing or speaking. Therefore, in Chinese theater performances, actors are required to speak or sing the

"head", "belly", and "suffix" of each word clearly. In this way, not only can the information be accurately conveyed to the audience, but also the key points in each sentence can be highlighted so that the inner world of the characters can be vividly portrayed.

（三）意蕴 Implication

《弹词》的情节所反映的不只是一位艺术家对过往的留恋，更是人对世间万物俱都"无常"的感叹。同所有优秀的文艺作品一样，好的折子戏体现的是人的精神世界，值得反复体味。中国大诗人杜甫的诗被称为"诗史"，原因是其诗多反映具有历史意义的重大社会事件。在他创作的数千首诗中，有一首就与李龟年以及这段历史有关。

The plot of *Storytelling* reflects not only an artist's nostalgia but also people's sighs at the impermanence of everything in the world. Like all excellent literary and artistic works, a good excerpt shows the spiritual world of human beings and is worth experiencing repeatedly. The poems of the great Chinese poet Du Fu are called "Poetry History" because his poems reflect major social events of historical significance at that time. Among the thousands of poems he created, one is related to Li Guinian and that period of history.

杜甫曾与李龟年有过接触，也多次看过他的演出。像李龟年这样杰出的艺术家，既是时代的产物，也是时代的标志和象征。在杜甫心中，李龟年和鼎盛的开元时代紧紧联系在一起。杜甫在"安史之乱"爆发后四处漂泊，虽然不像李龟年那样凄惨，但与李龟年困苦贫穷的遭遇

相似。在杜甫人生中的最后一年，他与李龟年在潭州久别重逢。杜甫在《江南逢李龟年》里这样说道："岐王宅里寻常见，崔九堂前几度闻。正是江南好风景，落花时节又逢君。"开头两句虽然是在追忆昔日与李龟年的相处，流露出的却是对开元盛世的深情怀念。

Du Fu had contact with Li Guinian and watched his performances many times. An outstanding artist like Li Guinian is not only a product of that time but also a sign and a symbol. In Du Fu's mind, Li Guinian is closely linked to the heyday of the Kaiyuan Era. Similar to Li Guinian's experience, Du Fu wandered around after the An-Shi Rebellion broke out. Although not as miserable as Li Guinian, he was also very poor. In the last year of Du Fu's life, Du and Li reunited in Tanzhou after a long absence. Du Fu said in "Coming Across Li Guinian in the South of the Yangtze River"."It is common to see you in the mansion of Lord Qi. And I heard you a few times in the lobby of Cui Jiu's house. It is the beautiful scenery in the south of the Yangtze River, and I will meet you again in the season of falling flowers." The first two sentences are reminiscent of the contacts with Li Guinian in the past, which genuinely reveals Du Fu's deep feelings for the prosperity of the Kaiyuan Era.

岐王是唐明皇李隆基的弟弟，名叫李范；崔九为当时的殿中监，深得皇帝宠幸。两人都为王公贵族，且都爱好文艺，能够频繁进入如此显赫之人的府邸去演唱，是何等的荣耀！李龟年更是在《弹词》中如此感叹："想当日天上清歌，如今沿门鼓板，好不颓气人也！"昔日的美好已经成为可望不可及的梦境，恍如天上人间之别。对国家的衰败、往事的眷恋、颠沛流离的感慨都只能饱含在深深的叹息里，如烟般消散。

Lord Qi is the younger brother of Emperor Li Longji, named Li Fan; and Cui Jiu is the palace supervisor and is thoroughly favored by the emperor. They are both nobles and fond of literature and art. What an honor it should be to frequently enter the mansion of such two prominent persons to sing! Li Guinian even exclaimed in *Storytelling*: "I once sang in the sky, and now do art on the street. What a frustration!" The beauty of the past has become an unattainable dream, just like the difference between heaven and earth. The feeling of the country's decline, the nostalgia and the vagrant life away can only be contained in a deep sigh, which disappears like smoke.

昆曲《弹词》, 凌珂饰李龟年。
卢雯 摄

Kunqu opera *Storytelling*, Ling Ke as Li Guinian.
Photographed by Lu Wen

附录一：剧目信息
Appendix 1: Information of the Repertoire of this Book

	剧名 Name	演出单位 Acting entity	演员 Actors	演出时间 Performance time
1	京剧《三岔口》 Beijing Opera *Cross Roads*	上海京剧院 Shanghai Jingju Theatre Company	郝帅饰任堂惠 郝杰饰刘利华 Hao Shuai as Ren Tanghui, Hao Jie as Liu Lihua	2011
2	京剧《玉簪记·秋江》 Beijing Opera *A Jade Hairpin · The Autumn River*	国家京剧院 National Peking Opera Company	张火丁饰陈妙常 张春华饰艄翁 Zhang Huoding as Chen Miaochang, Zhang Chunhua as the boatman	1996
3	京剧《法门寺·拾玉镯》 Beijing Opera *Famen Temple · The Jade Bracelet*	北京京剧院 Jingju Theater Company of Beijing	常秋月饰孙玉姣 Chang Qiuyue as Sun Yujiao	2012
4	昆曲《牡丹亭·游园》（电影）一 Kunqu Opera *Peony Pavilion · A Stroll in the Garden* I (film)	北京电影制片厂 Beijing Film Studio	梅兰芳饰杜丽娘 言慧珠饰春香 Mei Lanfang as Du Liniang, Yan Huizhu as Chunxiang	1960
5	昆曲《牡丹亭·游园》二 Kunqu Opera *Peony Pavilion · A Stroll in the Garden* II	江苏省苏州昆剧院 Suzhou Kunqu Opera Theater of Jiangsu	沈丰英饰杜丽娘 沈国芳饰春香 Shen Fengying as Du Liniang, Shen Guofang as Chunxiang	2004

6	昆曲《十五贯·访鼠测字》 Kunqu Opera *Fifteen Strings of Coins · Visiting "Shu" and Telling Him Fortune*	上海昆剧团 Shanghai Kunqu Opera Troupe	计镇华饰况钟 刘异龙饰娄阿鼠 Ji Zhenhua as Kuang Zhong, Liu Yilong as Lou Ashu	1990
7	昆曲《宝剑记·夜奔》 Kunqu Opera *A Precious Sword · Midnight Escape*	上海京剧院 Shanghai Jingju Theatre Company	赵宏运饰林冲 Zhao Hongyun as Lin Chong	2020
8	昆曲《烂柯山·痴梦》 Kunqu Opera *Lanke Mountain · A Delusional Dream*	江苏省昆剧院 Jiangsu Kunju Opera Theatre	张继青饰崔氏 Zhang Jiqing as Cui Shi	2004
9	京剧《白蛇传·断桥》 Beijing Opera *Legend of the White Snake · Broken Bridge*	国家京剧院、战友京剧团 National Peking Opera Company and Comrade-In-Arm Peking Opera Troupe	杜近芳饰白素贞 叶少兰饰许仙 单体明饰小青 Du Jinfang as Bai Suzhen, Ye Shaolan as Xu Xian, Shan Timing as Xiao Qing	1984
10	京剧《霸王别姬》（电影） Beijing Opera *Farewell My Concubine* (film)	北京电影制片厂 Beijing Film Studio	梅兰芳饰虞姬 刘连荣饰项羽 Mei Lanfang as Yu Ji, Liu Lianrong as Xiang Yu	1955
11	昆曲《长生殿·弹词》 Kunqu Opera *The Palace of Longevity · Storytelling*	浙江昆剧团 Beijing Film Studio	程伟兵饰李龟年 Cheng Weibing as Li Guinian	2001

附录二：参考文献

1. 赵景深．戏曲笔谈 [M]．上海：上海古籍出版社，1962.11.

2. 周贻白．中国戏曲发展史纲要 [M]．上海：上海古籍出版社，1979.10.

3. 上海艺术研究所，中国戏剧家协会上海分会编．中国戏曲曲艺词典 [K]．上海：上海辞书出版社，1981.9.

4. 上海文艺出版社．中国古典悲剧喜剧论集 [M]．上海：上海文艺出版社，1983.5.

5. 张庚，郭汉城．中国戏曲通史 [M]．北京：中国戏剧出版社，1992.4.

6. 周育德．中国戏曲文化 [M]．北京：中国友谊出版公司，1995.12.

7. 孙玫．东西方戏剧纵横 [M]．南京：江苏文艺出版社，1996.11.

8. 王国维著，叶长海导读．宋元戏曲史 [M]．上海：上海古籍出版社，1998.12.

9. 陈多，叶长海等主编．中国京剧 [M]．上海：上海古籍出版社，1999.10.

10. 叶长海，张福海．中国戏剧史（插图本）[M]．上海：上海古籍出版社，2004.4.

11. 叶长海．中国戏剧学史稿 [M]．北京：中国戏剧出版社，2005.10.

10. 王次炤．艺术学基础知识 [M]．北京：中央音乐学院出版社，2006.5.

11. 赵山林．中国戏曲传播接受史 [M]．上海：上海人民出版社，2008.8.

12. 俞为民．中国戏曲艺术通论 [M]．南京：南京大学出版社，2009.1.

13. 黄钧，徐希博主编．京剧小辞典 [K]．上海：上海辞书出版社，2009.04.

14. 宋光祖主编．折子戏赏析 [M]．上海：上海书店出版社，2011.4.

15. 郑培凯．春心无处不飞悬——张继青艺术传承记录 [M]．北京：北京大学出版社，2013.10.

16. 俞平伯，萧涤非，周汝昌，等．唐诗鉴赏辞典 [M]．上海：上海辞书出版社，2017.04.

17. 姜凌．京剧花旦表演训练 [M]．北京：中国戏剧出版社，2019.6.

18. 王立新，阙艳华．中英文对照 京剧行当术语 [M]．北京：文化艺术出版社，2019.10.

19. 计镇华口述，郑培凯主编．青山今古何时了——计镇华艺术传承记录 [M]．上海：文汇出版社，2020.9.

20. 欧阳予倩．再看川剧《秋江》[J]．戏剧报，1959(08): 27.

21. 陈国福．《秋江》荡舟世界 [J]．四川戏剧，1994(06): 27-29.

22. 刘秀荣．谈《拾玉镯》的表演 [J]．中国戏剧，1995(04): 36-38.

23. 郑向农，周松龄．剑舞——一剧之精魂——兼谈《霸王别姬》的艺术创造与魅力 [J]．上海戏剧，2001(04): 31-33.

24. 李玫．《长生殿》中的《弹词》[J]．名作欣赏，2010(19): 35-39.

25. 张继超．昆剧丑脚研究 [D]．中国艺术研究院，2014.

26. 俞丽伟．梅兰芳版《霸王别姬》的虞姬形象溯源 [J]．中北大学学报（社会科学版），2016(05)：116-120.

27. 宋岩．从经典剧目《霸王别姬》浅谈虞姬的人物形象塑造 [J]．戏剧之家，2017(18): 4-6.

28. 刘晓红．倪瓒的"画境"与《秋江》的"戏境"——中国传统绘画与戏曲艺术表现形式的共性浅议 [J]．中国书画，2018(10): 11-15.

29. 寄滇．恰三春好处无人见——析《牡丹亭·惊梦》之【步步娇】【醉扶归】[J]．中国京剧，2020(05): 82-85.